Volume 12, Number 3 / 1985
ALASKA GEOGRAPHIC®

Alaska Native Arts and Crafts

by Susan W. Fair

"In Search of Ancient Man"

by Robert Shaw

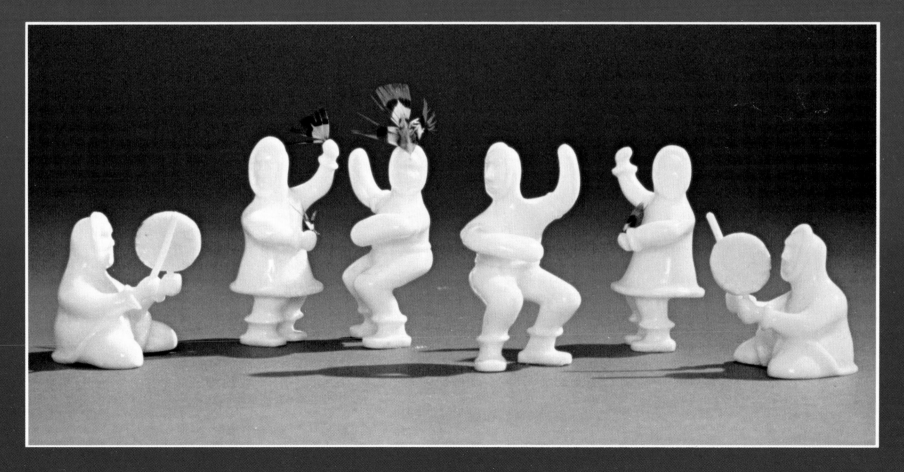

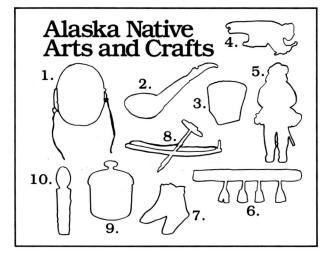

Alaska Native Arts and Crafts

Previous page — *Isaac Koyuk, originally from King Island, created this group of ivory dancers with feather headdress and dance fans. This scene won a prize in the ivory division in the 1977 Alaska Festival of Native Arts at the Anchorage Museum. (Anchorage Museum)*

Table of Contents

The Alaska Geographic Society

To teach many more to better know and use our natural resources

Editor: Penny Rennick
Associate Editor: Kathy Doogan
Designer: Sandra Harner
Cartographer: Jon.Hersh

ALASKA GEOGRAPHIC®, ISSN 0361-1353, is published quarterly by The Alaska Geographic Society, Anchorage, Alaska 99509-6057. Second-class postage paid in Edmonds, Washington 98020-3588. Printed in U.S.A. Copyright© 1985 by The Alaska Geographic Society. All rights reserved. Registered trademark; Alaska Geographic, ISSN 0361-1353; Key title Alaska Geographic.

THE ALASKA GEOGRAPHIC SOCIETY is a nonprofit organization exploring new frontiers of knowledge across the lands of the polar rim, learning how other men and other countries live in their Norths, putting the geography book back in the classroom, exploring new methods of teaching and learning — sharing in the excitement of discovery in man's wonderful new world north of 51°16'.

MEMBERS OF THE SOCIETY RECEIVE *Alaska Geographic*®, a quality magazine which devotes each quarterly issue to monographic in-depth coverage of a northern geographic region or resource-oriented subject.

MEMBERSHIP DUES in The Alaska Geographic Society are $30 per year; $34 to non-U.S. addresses. (Eighty percent of each year's dues is for a one-year subscription to *Alaska Geographic*®.) Order from The Alaska Geographic Society, Box 4-EEE, Anchorage, Alaska 99509-6057; (907) 563-5100.

MATERIAL SOUGHT: The editors of *Alaska Geographic*® seek a wide variety of informative material on the lands north of 51°16' on geographic subjects — anything to do with resources and their uses (with heavy emphasis on quality color photography) — from Alaska, northern Canada, Siberia, Japan — all geographic areas that have a relationship to Alaska in a physical or economic sense. We do not want material done in excessive scientific terminology. A query to the editors is suggested. Payments are made for all material upon publication.

CHANGE OF ADDRESS: The post office does not automatically forward *Alaska Geographic*® when you move. To ensure continous service, notify us six weeks before moving. Send us your new address and zip code (and moving date), your old address and zip code, and if possible send a mailing label from a copy of *Alaska Geographic*®. Send this information to *Alaska Geographic*® Mailing Offices, 130 Second Avenue South, Edmonds, Washington 98020-3588.

MAILING LISTS: We have begun making our members' names and addresses available to carefully screened publications and companies whose products and activities might be of interest to you. If you would prefer not to receive such mailings, please so advise us, and include your mailing label (or your name and address if label is not available).

ABOUT THIS ISSUE

Alaska's Natives have long been known for their affinity with the land and its resources. Their survival in this world and the next depended on their ability to make the most of what the land offered. One manifestation of this dependence is through their art. Robert Shaw provides the archaeological framework for Susan Fair's review of the arts and crafts of Alaska's Natives. Formerly general manager of Alaska Native Arts and Crafts Co-op, Susan works as an art appraiser and is a consultant for native arts and crafts projects.

We appreciate the assistance of Barbara Stuckenrath and William Fitzhugh, Smithsonian Institution; Walter Van Horn and M. Diane Brenner, Anchorage Museum; Dinah Larsen, University of Alaska Museum; Suzi Jones, Alaska State Council on the Arts; Laura Bracken, Alaska State Museum; Peter Corey, Sheldon Jackson Museum; Mary Anne Kenworthy, the University Museum, University of Pennsylvania; and Marian Johnson, Kodiak Historical Society.

Editor's note: Approximate sizes for individual pieces of artwork have been given whenever available.

The Library of Congress has cataloged this serial publication as follows:

Alaska Geographic. v.1-
 [Anchorage, Alaska Geographic Society] 1972-
 v. ill. (part col.). 23 x 31 cm.
 Quarterly.
 Official publication of the Alaska Geographic Society.
 Key title: Alaska geographic, ISSN 0361-1353.

 1. Alaska — Description and travel — 1959-
 —Periodicals. I. Alaska Geographic Society.

F901.A266 917.98'04'505 72-92087

 MARC-S

Library of Congress 75[7912]

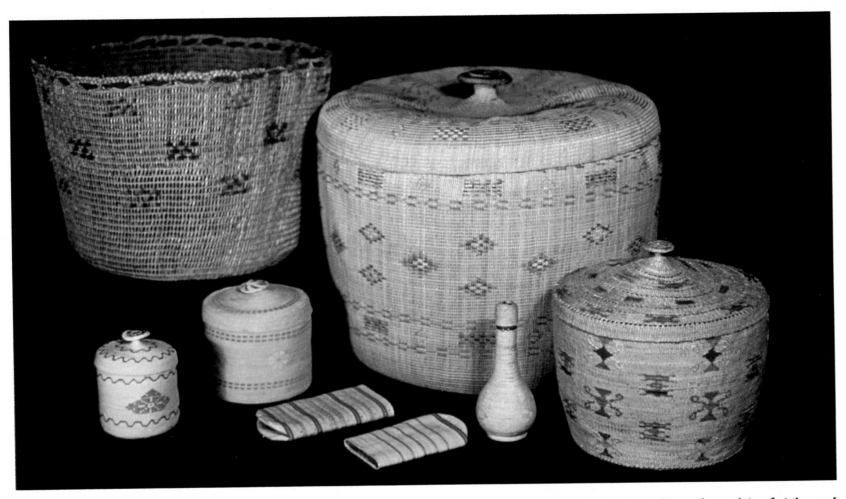

Above — *This group shows the variety of styles and sizes of baskets made in the Aleutian Islands.*
(Alaska State Museum)

Right — *This ceremonial headdress (frontlet) is carved to represent the head of a shark and is topped by sea lion whiskers, woodpecker feathers and trailers of fur. Features on the shark's face are inlaid in abalone shell. High-ranking Tlingits wore frontlets such as this on ceremonial occasions. 7" high (without whiskers). (Sheldon Jackson Museum, an Alaska State Museum; photo by Ernest Manewal)*

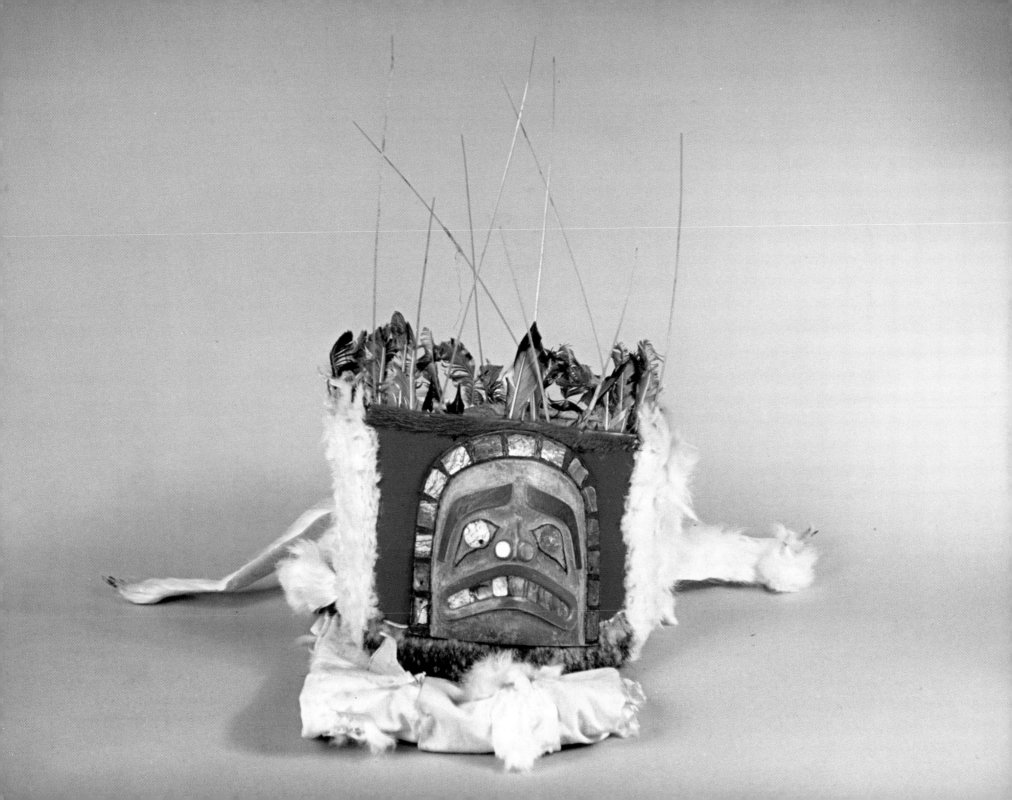

Introduction

Primitive art, like all art, is an important means of expressing both personal creativity and cultural symbolism. Most pieces of historic and probably prehistoric native art were functional parts of the cultures of their origin; visual expressions of an organized and often highly formal system of beliefs. For example, Northwest Coast artists, known as master carvers of wood, carved and ornamented a variety of objects, including masks, bentwood boxes, ladles, hats, pattern boards and totem poles. Though these objects are carefully made and beautifully decorated, they address more than aesthetics. They also record ownership of clan crests for all to see, telling the histories of individual clans and perpetuating the importance of kin groups in Northwest Coast culture.

The function of art has changed through time in Alaskan native cultures. Objects which were once important for daily and ceremonial use are now prized by private collectors and museums, although some major pieces remain in tribal hands. Today many contemporary Alaskan native artists still make traditional art governed by specific cultural rules, but the artwork is no longer made exclusively for traditional purposes. Objects are sometimes made interchangeably for sale and ceremony. Masks and dance fans, for example, are often sold but are still used in many Eskimo ceremonies as well. Much native art today is made strictly for sale, and some of what is made for sale is of dubious quality and cannot rightfully be called art at all.

Nelson Graburn, author of *Ethnic and Tourist Arts,* delineates seven categories of tribal art: extinct art forms; traditional or functional fine arts; commercial fine arts; souvenirs; reintegrated arts; assimilated fine arts and popular arts. An Alaskan example of commercial fine art might be the best of Eskimo ivory

"Many, perhaps all, symbolic systems are implosive, and therefore must be experienced from within. Alaskan tribal arts are no exception. They offer no windows facing in. A detached observer may possess them, even 'know' them, but he will never experience them."

Edmund Carpenter,
The Far North

This walrus ivory Okvik doll was discovered at an archaeological site on Saint Lawrence Island. Okvik dolls generally have large heads in relation to their bodies, and have elegant, carefully sculpted faces. This doll may date as early as 300 B.C. 6¾" high. (Alaska State Museum; photo courtesy of Anchorage Museum)

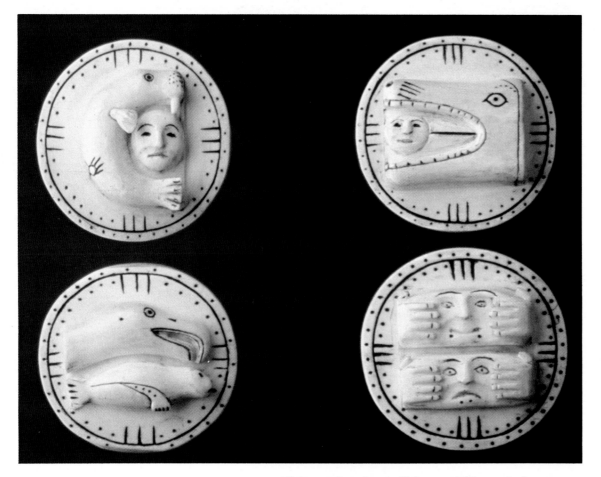

These walrus ivory disks, possibly part of a game, were collected in southwest Alaska in 1901. They are part of a set, and depict motifs which may have symbolic meaning. Male and female faces, as in the lower right example, were usually shown with the man smiling, the woman frowning. 1¼" diameter. (University of Alaska Museum; photo by Barry McWayne)

carvings. These small sculptures are often crafted in the traditional manner, using tools, methods and materials which span a period of more than 1,000 years. Though they are made for eventual sale and incorporate new design elements and technology (such as the use of power tools), many carvings still reflect fragments of the Eskimo way of life, both historic in content and striking in form. At their worst, ivory figurines represent Graburn's souvenir category or what he calls "ethno-kitsch." These trite carvings, of which the billikin is a perfect example, bear no relationship to the cultural heritage, traditional art forms or creativity of their carvers.

Other scholars have coined labels such as market art and airport art in reference to some types of Alaska native art. These terms refer primarily to mass-marketed items, produced mainly as souvenirs. Tribal art, primitive art and non-Western art are also terms used frequently to describe artwork produced by native people, and although none of the terms is perfectly satisfactory, I use several of them occasionally throughout the text.

Just as function and ritual content influenced the creation of visual arts in the past, the marketplace has a powerful influence on what native artists make today. Some create only what sells well, and this is a reasonable approach, as sales of art provide one of the few possible sources of income in many villages. Some artists experiment with non-native techniques such as printmaking and other media. Some, such as Melvin Olanna, John Hoover, Carmen Quinto Plunkett and others have been awarded major public commissions. Traditional native art is changing, being carried forward within broader cultural changes and speaking of the contemporary native artist and his or her culture and personal goals as well as

This whale bone sculpture, with its graceful bottomfish and striking mask, characterizes the imagination and attention to detail of Harvey Pootoogooluk, one of Shishmaref's leading whale bone sculptors. (Alaska Native Arts & Crafts Association)

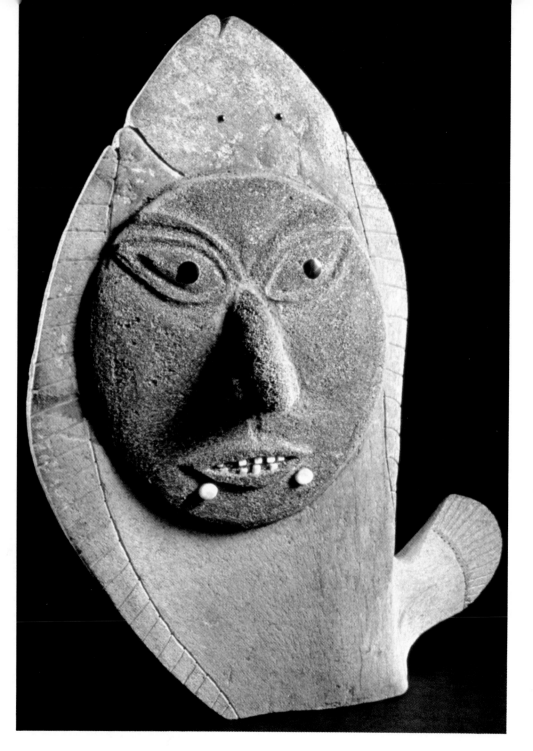

reflecting an important heritage.

Proponents of traditional native arts have initiated the formation of many programs supporting it in recent years. Several of the programs deserve mention here, and will be dealt with, along with others, in the text. The Alaska State Council on the Arts, based in Anchorage, assists in maintaining and preserving native arts through its Traditional Native Arts Program. In Fairbanks, the Institute of Alaska Native Arts is active in native arts advocacy and education. Also in Fairbanks, Ronald Senungetuk, a professional artist and chairman of the Art Department at the University of Alaska, Fairbanks, founded the Native Arts Center at the university. Senungetuk, who is Inupiat, was also a founding member of the Institute of Alaska Native Arts, and has perhaps done more to encourage upcoming native artists and make native art visible than any other individual in the state. Finally, though many organizations and hard-working individuals have been omitted, credit is due the Alaska Native Arts & Crafts Association, a major retail outlet for native artists which will soon enter its 50th year of operation.

Writing in a coherent way on a topic as broad as Alaska's native art has been a big task. There are, of necessity, omissions. Many prominent historic and contemporary native artists have not been named, and not every art form has been described in detail from raw material to finished piece. Instead, the predominant or

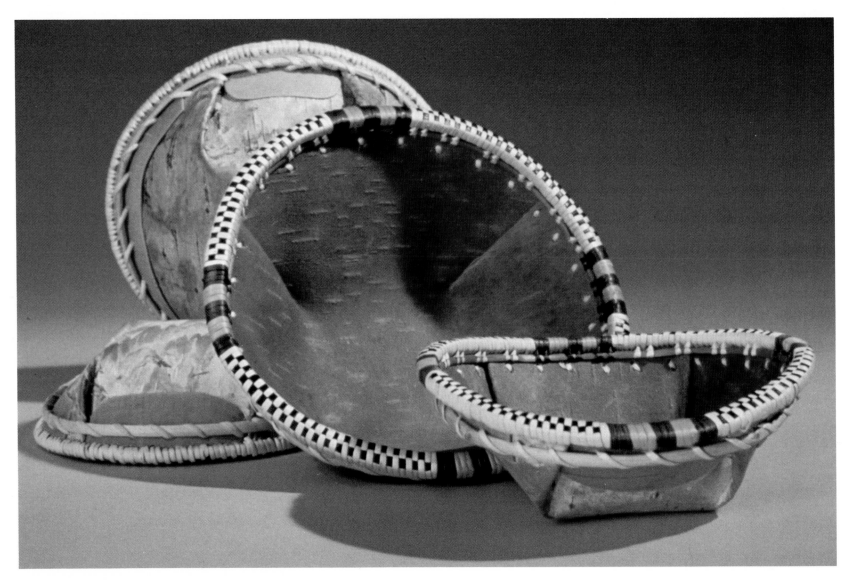

This group of birch-bark baskets, made by Belle Deacon of Grayling, was commissioned by the Alaska State Council on the Arts for the 1983 Governor's Awards for the Arts.
(Photo by Chris Arend; courtesy of Alaska State Council on the Arts)

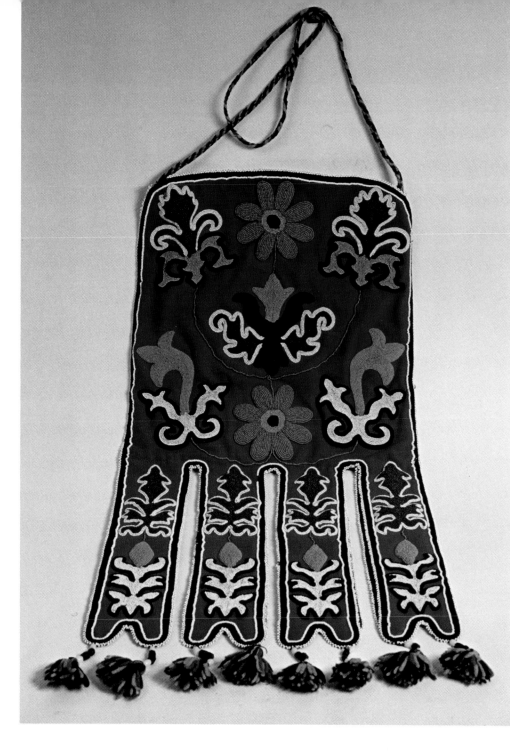

Left — *Octopus bags, so called because of their hanging "tentacles," were made by Athabascans and often traded to the Tlingits, who valued them highly. This bag is made from felt with a plaid lining, and is decorated with multicolored trade beads, yarn and thread. 42½" long.*
(Sheldon Jackson Museum, an Alaska State Museum; photo by Ernest Manewal)

Below — *Author Susan Fair (center, in glasses) listens to artists at a technical assistance workshop, sponsored by the Institute of Alaska Native Arts, in Fairbanks in 1983. Participants in the workshop include Glenda Lindley, Wendy Elsner, Kathleen Carlo, Larry McNeil and Rose Fosdick. (Institute of Alaska Native Arts; photo by Jean Flanagan Carlo)*

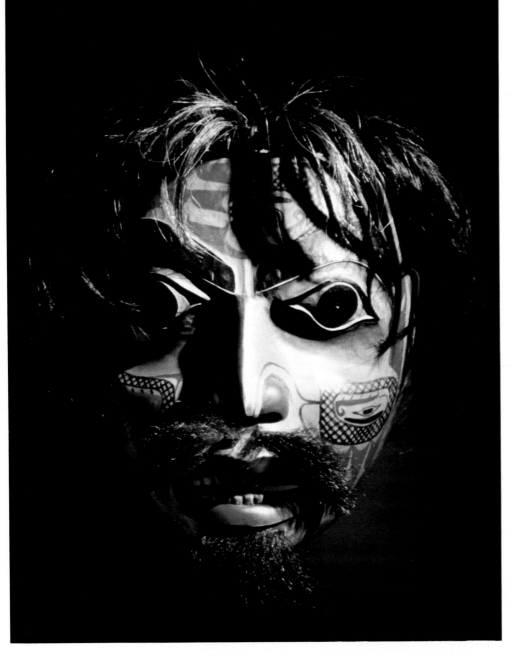

Tlingit artist Nathan Jackson carved this colorful mask in the early 1970s. The moustache and goatee are made from bear fur; human and cow hair cover the head. (Anchorage Museum)

diagnostic art forms of specific groups have been presented from a historic perspective. Ivory carving has been highlighted for the Inupiat; grass basketry and mask making for the Yupik. Fine twined basketry was an obvious choice for artists of the Aleutian Chain, and some information has been included on several outstanding contemporary Aleut artists. Beadwork and two types of basketry are dealt with in the section on the Athabascans of the Interior. Though tribes of the Northwest Coast practice many arts, I have devoted most attention to Chilkat weaving and the carving of wood, and a discussion of the symbolism used in Northwest Coast art and the important place art holds in that society. For the reader wishing more information on art forms only briefly mentioned, the bibliography at the back of the book will provide some direction.

Historic and ethnographic facts, as well as information about the prehistory of each culture group, serve as both the beginning of each section and a vantage point from which the reader may focus on the location and attributes of specific groups, discover what materials for making art are available to them through their environment or through contact with other groups and learn how the processes and products of their creative endeavors are integrated into their way of life as a whole.

Bob Shaw, professional archaeologist and chief of the Alaska archaeological survey, State of Alaska Division of Geological and Geophysical Surveys, has contributed the chapter entitled ''In Search of Ancient Man: Archaeology in Alaska.'' This section brings into focus an increasingly difficult issue: the incompatibility of archaeology, which emphasizes preservation of information and artifacts from the past, with the sale and collection of historic and prehistoric art objects.

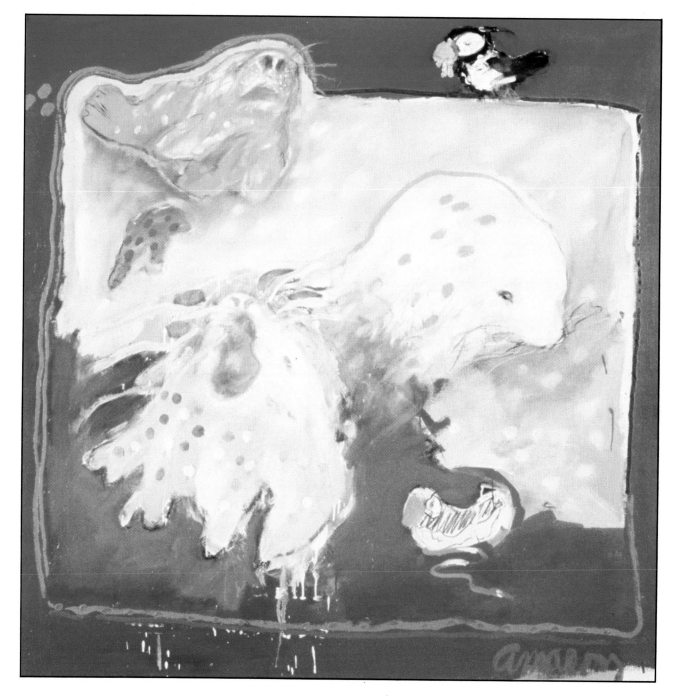

Above — *Finely twined telescoping card cases (sometimes called cigar cases) were a popular trade item in the early 1900s. This case, made on Attu Island, is decorated with rows of openwork and a design in colored silk thread. Parts, 4½" x 3" and 4¼" x 2¾".*
(Sheldon Jackson Museum, an Alaska State Museum; photo by Alice Postell)

Left — *Alvin Amason has become nationally known for colorful works depicting what he calls "Alaskan animals of the 20th century." This painting, entitled "Agripina Day from Two Rainbows," was done during the mid-1970s. 59" x 57".*
(Anchorage Museum)

13

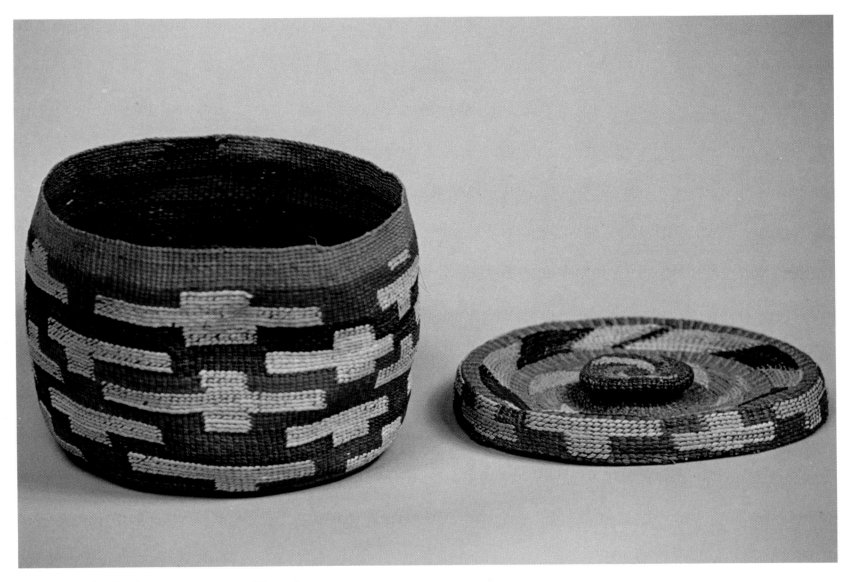

Spruce root dyed red and green was used to make this rattle-top basket, which is decorated with the "war club" design overlaid in natural color. Pebbles or shot in the knob serve as a rattle. 4¼" high; 5¾" diameter. (Sheldon Jackson Museum, an Alaska State Museum; photo by Ernest Manewal)

Acknowledgments

I first came to Alaska more than ten years ago from a job on a Navajo reservation. I was familiar with Southwest Indian arts but knew little about the native arts of Alaska. I'm still learning. Sometimes the learning process has been exhilarating — I've traveled all over Alaska, buying art, giving workshops, doing fieldwork and just visiting. At other times the process has been painful. Sometimes there were confrontations with native artists about quality, price or more philosophic matters.

My teachers and friends have, to a great degree, been native artists themselves and their families. There is room here to name only a few, and any omissions are from lack of space, not lack of gratitude. My thanks extend to Lincoln and Emily Milligrock, who have always treated me as a family member; Harry and Evelyn Koozaata, Sarah Koyuk, Frank Ellanna, Charles Kokuluk, John Penatac, Earl Mayac, Sylvester Ayek, Jerry and Eva Tungiyan, Junior and Wanda Slwooko, Annie Alowa, Christine Alowa, Judy Pelowook, Mel and Karen Olanna, Vincent and Molly Tocktoo, Elliot and Emma Olanna, Harvey and Bertha Pootoogooluk, Edna Deacon, George Ahgupuk, Riley Matthews, Alvin Amason and Myrtle Booshu. I am especially indebted to the King Islanders, only a few of whom are mentioned here. They are a tenacious and talented group, and I feel as though I grew into adulthood with many of the King Island carvers.

Many of the traditional artists whom I knew or whose work I admired when I first came to Alaska are no longer living. Josephine Ungott, Tom Iworrigan, Barbara Kokuluk, Peter Mayac, Joackim Koyuk, Ursula Ellanna, Sam Fox, Homer Hunter, Kivetoruk Moses and many others are gone. They left a legacy of knowledge about native art, technical skills and the traditional way of life to their people and to all of us. There are surely many others whom I did not know personally but who are remembered by their families and friends, and whose works are housed in museums and with collectors, no less significant because they are sometimes labeled "Anonymous."

A special thanks goes to those who took time to review portions of this manuscript. They include Bill and Karen Workman, Doug Veltre, Eleanor Klingel, Bob Shaw, Suzi Jones, Rosita Worl and Jan Steinbright. Dixie Alexander of IANA gathered materials for the Athabascan section, as did Karen Workman. My father, Robert Fair, provided office space and encouragement.

—Susan W. Fair

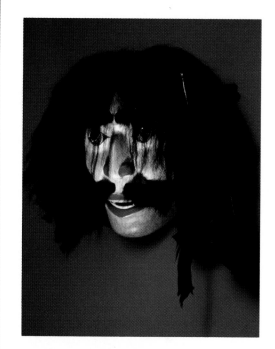

Tsimshian carver Jack Hudson is known for his distinctive traditional carving style. This male face is carved of alder and inlaid with abalone eyes; raven feathers are twined into its long black hair. 19" x 13½". (Anchorage Museum)

In Search of Ancient Man

Archaeology in Alaska

By Dr. Robert Shaw

Editor's Note: *Dr. Robert Shaw is chief of archaeological survey within the Alaska Department of Natural Resources, Division of Geological and Geophysical Surveys. His archaeological research has centered on the Yukon-Kuskokwim Delta and northern Bristol Bay areas of western Alaska. He has worked as State Historic Preservation Officer and as a research archaeologist with U.S. Fish and Wildlife Service.*

The Bering Land Bridge

Man's first entry into the New World is the subject of widespread interest and speculation. Accordingly, several theories dealing with both the time and place of man's entry into the Americas have been developed, and each has enthusiastic proponents. Discussions of an outer space connection, correlation with Biblical genealogy, evolutionary genesis of man in the New World rather than the Old, trans-Atlantic or trans-Pacific voyages, and immigration via the Bering Land Bridge all hold potential for lively and interesting interchange. Only the latter, however, directly pertains to a discussion of Alaskan art and archaeology based on scientifically validated information.

During the Pleistocene glacial epoch, or Ice Age, climatic fluctuations produced a cycle of expansion and contraction of glaciers on continental land areas. The oceans were the ultimate source of water that fed expansion of the vast glaciers. With retention of frozen water on what is today dry land, sea level lowered. The drop in ocean level exposed continental shelves, and shallow sea areas became dry land until the next cycle of climatic warming occurred and partially melted the glacial ice. Several such cycles of emergence of coastal deposits both above and below modern sea level

Sod houses were used in western Alaska until well into the 20th century. A common sod house on the Yukon-Kuskokwim Delta was rectangular and measured about 10 feet across. To construct a house, Eskimos dug a pit and built a wooden framework within the pit. They then cut sod blocks from the vegetation mat of surrounding tundra and placed them over the wooden framework. This photo shows the internal wooden framework of a partially collapsed sod house. (Robert Shaw)

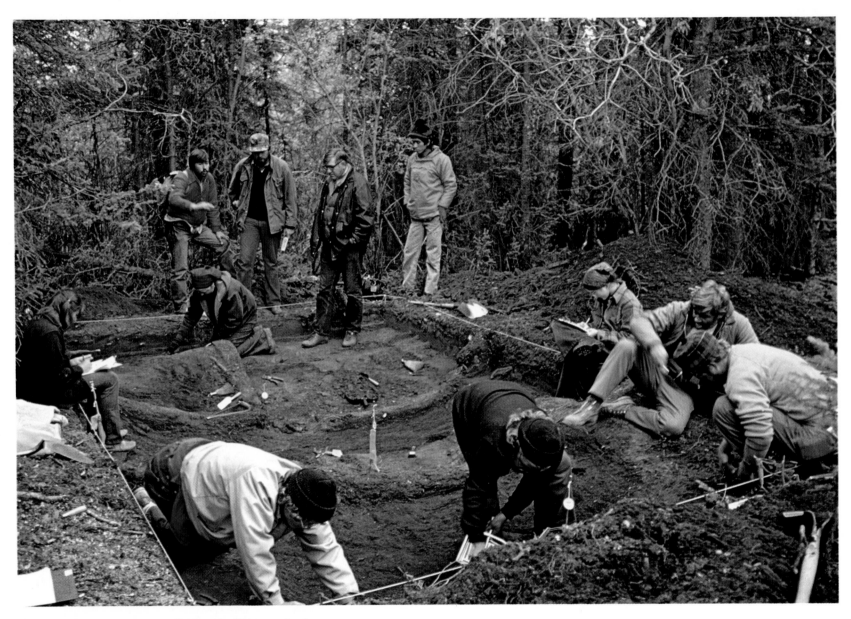

Construction of the trans-Alaska pipeline required extensive archaeological investigations along the pipeline corridor. These workers are excavating a site near Gulkana. (Steve McCutcheon)

occurred during the Pleistocene approximately 120,000 to 14,000 years ago.

The Bering Sea, which separates Siberia and Alaska, is one of the shallow sea bottoms which was repeatedly exposed and inundated. Depending on the amount of water retained in glaciers at a given time, the width of the land connection between Siberia and Alaska varied up to a maximum of about 800 miles north to south. That people entered the Americas from Asia via the Bering Land Bridge during the Pleistocene Ice Age is generally accepted by archaeologists, but the particular time of the first immigration is in question. Since the land bridge was repeatedly created and destroyed, the dry land immigration route was alternately opened and closed for thousands of years at a time.

During early glacial advances when the land bridge emerged, men apparently were not present in eastern Siberia; they were living in more moderate areas to the south and west. A likely explanation for this absence of people in Siberia is that early man was not yet adapted to living in the severe Siberian environment. Perhaps tailored clothing was not adequately developed, or some critical element in hunting strategy or toolmaking technology prevented early Pleistocene movement of men into the New World. Archaeologists have not conclusively defined the critical factors that prevented early Pleistocene people from occupying Siberia.

Unlike people, the mammal species that constitute the Pleistocene megafauna, a community of animals which shared one common characteristic — larger body size than their modern descendants — did not depend on cultural innovation and development to expand into areas surrounding the Bering Land Bridge. Mammoths, camels, bison, caribou, horses, musk-oxen and saiga antelope were present during the early Pleistocene, roaming freely across the intercontinental connection. The megafauna species were naturally adapted to the cold steppes adjacent to the glaciers, a periglacial environment. Heat conservation associated with gigantism is one aspect of natural adaptation which resulted from development of that animal community during the Ice Age. Many of the giant forms, including mammoths, horses and camels, became extinct in northern latitudes at the end of the Pleistocene. Some archaeologists claim that people played a major role in the demise of these species. Many of the earliest known archaeological sites in the New World are kill sites of extinct species.

Archaeologists hypothesize that the first men to enter the New World were big game hunters moving in pursuit of their prey. The immigration of people began thousands of years after the herds of game and their accompanying predator species, such as lions and sabertooth cats, were well-established in the vicinity of the land bridge, an area of Siberia and northern North America known as Beringia. Though this movement is momentous in our view, the earliest people were simply going about their daily business of obtaining the necessities of life, unaware of the warmer climes to the south.

Beringia was a vast area of relatively uniform glacial and periglacial climate. Glaciers covered the Brooks and Alaska ranges, but the area between was not glaciated. The mountains caused air masses to rise as they passed inland from the oceans. As air rises it cools, and the amount of moisture it can hold decreases. The moisture present at sea level was deposited as precipitation at high elevations, feeding the glaciers. The great Alaskan mountain ranges provided a rain shadow for the Beringian interior. It is through this ice-free but stark

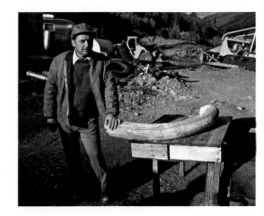

Megafauna roamed the periglacial environment of Pleistocene Alaska. This tusk, unearthed by miner Bob Cacy while working his claim on Deadwood Creek in the Circle Mining District, belonged to a mammoth, one of several species whose body size, larger than those of their modern-day descendants, enabled them to survive colder environments. (Ron Wendt; reprinted from ALASKA® magazine)

environment that people moved into the Americas.

Numerous archaeologists believe that people may have crossed into Alaska as long as 30,000 years ago, and a few suggest up to 100,000 years ago as the time of man's first New World immigration. However, data supporting the presence of people in the New World before 13,000 B.P. (before present) are tenuous. In Beringia, claims of the oldest archaeological materials are on the order of 30,000 years. These claims are based predominately on materials recovered in the Old Crow area of Yukon Territory, just east of the Alaska-Yukon border. Unfortunately, the age and cultural origin of those materials is questionable because the artifacts were found on gravel bars in the Porcupine River after eroding out of river-bank deposits. Bones of Pleistocene fauna are common on the bars, and only a small percentage of the materials are said to have been modified by Pleistocene age people. Because the items were dislodged from soils in which they originally were deposited, whether the bones were modified during the Pleistocene or long afterward is open to question.

To resolve the question of age, artifacts need to be found in the soil layers in which they were originally deposited, along with organic matter which can be directly dated by traditional radiocarbon techniques. By comparison of the carbon-14 and carbon-12 that is incorporated into living tissue in known proportions, an estimate of the specimen's age can be made because the rate of radioactive decay from one carbon isotope to another is also known: half the carbon-14 converts to carbon-12 in 5,568

Natives dug out this entrance to a prehistoric house near the village of Old Gambell on Saint Lawrence Island. (Chlaus Lotscher)

years. Though not precise in its correlation with calendar years, hence the common use of the term "radiocarbon years," radiometric dating is a valuable tool for archaeologists.

Ongoing research in the Old Crow area may resolve the current debate on the date of man's first entry into the New World by discovery of incontrovertible data. The site at Bluefish Caves, also in Yukon Territory, currently is considered to have high potential for yielding artifacts in undisturbed deposits that may push the prehistory of Beringia back once again. The cave deposits are thought to date between 10,000 and 16,000 years ago.

Taking the conservative view, not until the end of the Pleistocene glacial epoch and the last flooding of the Bering Land Bridge are archaeological sites of unquestioned validity and age known. Sites dating from 11,000 to 13,000 B.P. are numerous and widespread in North America. The Clovis culture falls within this period and is known from sites throughout the continental United States and southern Canada because of distinctive stone lance blades that have frequently been found in association with mammoths killed and butchered by people.

The earliest known occupation within Alaska was contemporaneous with the Clovis culture that flourished widely farther south. Even though a few fluted points superficially resembling Clovis points have been found in Alaska, none of the specimens are assigned to the Clovis culture.

The Dry Creek site near Healy is slightly older than 11,000 years. With the Dry Creek materials we can legitimately, though very tentatively, begin to discuss art and archaeology in Alaska. But before doing so, we need to describe briefly the conceptual framework and classification system that predominates among Alaskan archaeologists.

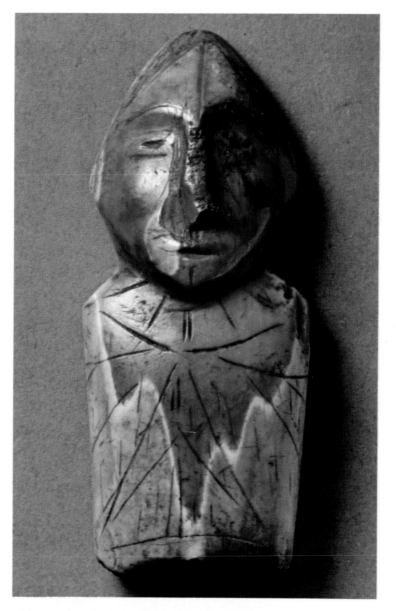

This prehistoric ivory figure found on Saint Lawrence Island dates from the Punuk period, about 900 A.D., part of the Thule Tradition.
(Chlaus Lotscher)

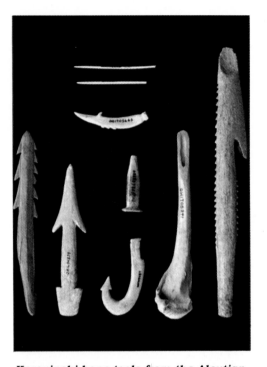

Korovinski bone tools from the Aleutian Islands include sewing needles and part of a fishhook (top); various spearheads (first, second and fifth on bottom row); a single-piece fishhook (bottom center); a labret or lip ornament (center); and an awl (fourth on bottom row).
(Douglas Veltre)

Units of Archaeological Classification
Language

Modern native peoples of Alaska are broadly identified as groups based on language, the most general linguistic designations being Eskimo and Indian. Within those two classifications, several related but mutually unintelligible languages exist. Even though the basic element used to identify the several groups is language, the identifying language names carry connotations which relate to culture, race, subsistence, geographic location and other factors. Figure 1 illustrates the correlation between linguistics and geography during the historic period.

Identifying prehistoric peoples with their modern descendants is difficult for numerous reasons. From an archaeological perspective, the degree to which linguistic terms accurately correlate with culture, race, subsistence adaptation and geographic location varies substantially, because the characteristics associated with each category of classification change through time, and the rates of change are not constant. For example, culture changes through time as people develop new technology to deal with their surroundings; note how the introduction of snow machines has affected rural hunting practices. Even racial characteristics may change, rapidly as people interbreed with adjacent foreign people or gradually through natural selection in response to changes in environment. Subsistence changes as wildlife populations are reduced by overhunting of a given species. Geographic boundaries alter as groups increase in population and expand into new territory or are conquered by surrounding groups. But even without changes in peripheral categories, the

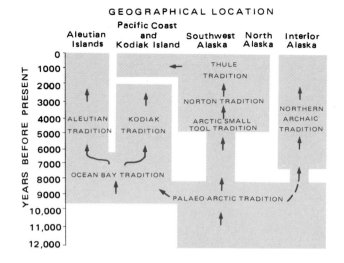

Prehistoric Alaskan cultural relationships.

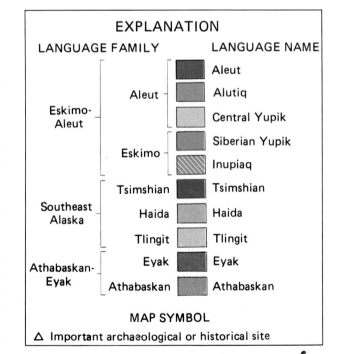

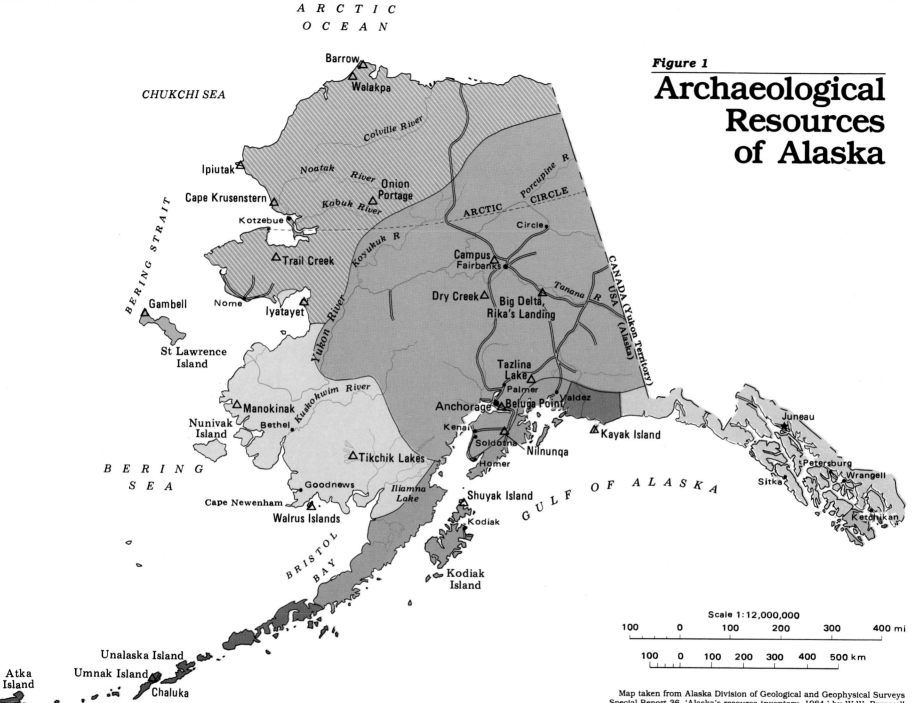

Figure 1

Archaeological Resources of Alaska

ARCTIC OCEAN

CHUKCHI SEA

Barrow

Walakpa

Colville River

Ipiutak

Noatak River

Onion Portage

Cape Krusenstern

Kobuk River

Kotzebue

ARCTIC CIRCLE

PORCUPINE R

Circle

Trail Creek

Koyukuk R

Campus Fairbanks

CANADA (Yukon Territory)
USA (Alaska)

BERING STRAIT

Gambell

Nome

Iyatayet

Yukon River

Dry Creek

Big Delta, Rika's Landing

Tanana R

St Lawrence Island

Manokinak

Kuskokwim River

Bethel

Tazlina Lake

Palmer

Nunivak Island

Anchorage

Beluga Point

Valdez

Kenai

Kayak Island

Soldotna

Nilnunqa

Tikchik Lakes

Homer

Juneau

BERING SEA

Goodnews

Iliamna Lake

Shuyak Island

GULF OF ALASKA

Petersburg

Wrangell

Cape Newenham

Kodiak

Sitka

Walrus Islands

Ketchikan

BRISTOL BAY

Kodiak Island

Scale 1:12,000,000

| 100 | 0 | 100 | 200 | 300 | 400 mi |

| 100 | 0 | 100 | 200 | 300 | 400 | 500 km |

Unalaska Island

Umnak Island

Atka Island

Chaluka

S L A N D S

Map taken from Alaska Division of Geological and Geophysical Surveys Special Report 36, 'Alaska's resource inventory, 1984,' by W.W. Barnwell and K.S. Pearson.

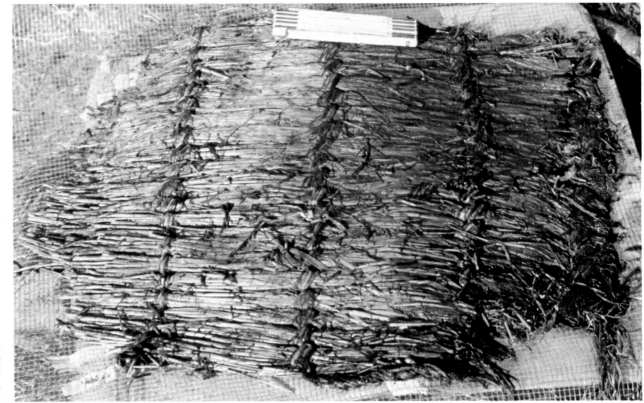

Archaeologists dug this well-preserved grass mat from the upper levels of the Manokinak site in western Alaska. (Robert Shaw)

groups defined by linguistic designations would have questionable validity through time because language also changes, though more slowly than most other aspects of culture. In the past, 3,000 to 5,000 years ago, Yup'ik, Inupiaq and Aleut diverged from a common root language that would probably not be any more intelligible to people speaking these languages today than is the speech of a modern Inupiat resident of Barrow to a citizen of Hooper Bay, where Yup'ik is spoken. Inupiaq and Yup'ik are both Eskimo languages, but differ markedly enough that native speakers have difficulty communicating. These and many other factors

form the dynamic which molded modern native peoples of Alaska and their way of life.

Artifacts

Correlations of archaeological groups with modern groups is increasingly suspect as we deal with progressively older sites. Archaeologists must depend on the physical remains, the artifacts, left at the site to interpret prehistory. But the data are imperfect. Artifacts present at a single site depend not only on the ethnic or linguistic identity of the people who lived there, but on such additional factors as the season during which the site was usually

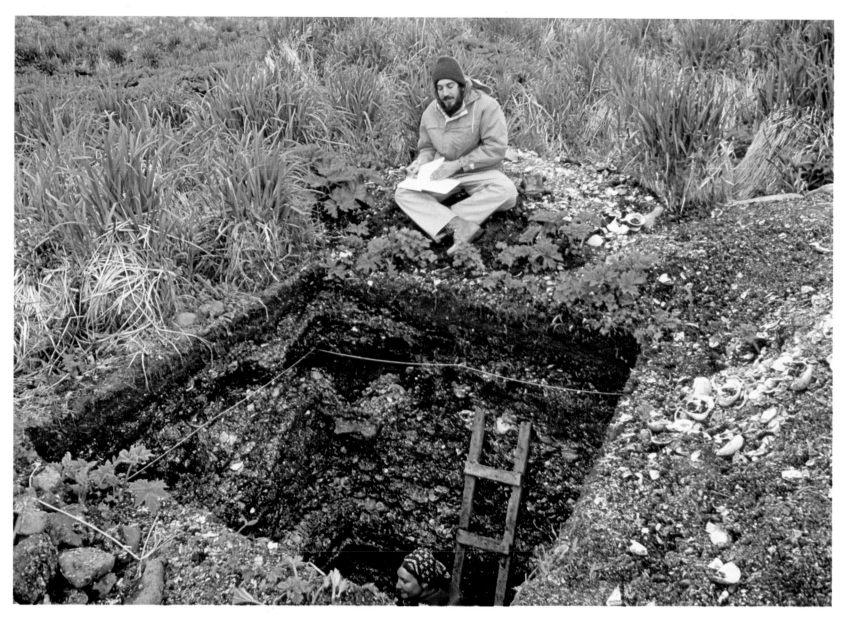

Douglas Veltre takes notes while his assistant, Pauline English, measures layers in this excavation at the prehistoric and historic site of Korovinski on Atka Island in the Aleutians. (Mary Veltre)

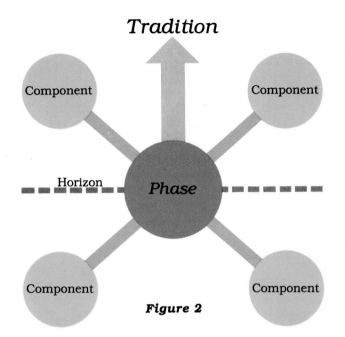

Figure 2

compared with organic materials which constituted the bulk of the artifact inventory of the original residents.

Based on the materials recovered and inferences made about the artifacts, archaeologists must describe the lifeway (cultures) of ancient people. This requires more than simple characterization of artifacts from a single site. Characterizing a culture requires statements about the relationship between numerous sites.

Gordon Willey and Philip Phillips developed in their book *Method and Theory in American Archaeology* (1958) the most common conceptual scheme used to discuss the interrelation of sites through time and space. The interrelationship between the principal terms of the schemes are illustrated in Figure 2. Archaeologists employ additional terms such as variant, stage, complex and numerous others to express subtle distinctions of classification, but the lay reader can often clarify the relationships by substituting the terms explained here.

Component

Component is the basic unit which groups together a culturally contemporaneous set of artifacts that were deposited during occupation at a *single* site by a cultural group. Several components may be present at one site, each deposited at a different time or by a culturally different group.

The several components which may occur at a single site may be defined and separated based on distinctive characteristics of the artifacts alone, but differential distribution within the deposits usually is required to adequately separate the components. Some types of artifacts change character sufficiently during short time periods to allow definition of a new component, while other artifact types remain unchanged and are present in all components

occupied and the nature of activities engaged in at the site. In interpreting a site, archaeologists have additional difficulties depending not only on the age of the site and the material (wood, bone, shell, stone, etc.) from which an artifact is made, but on environmental conditions which prevailed there through time. In one place, wood may be preserved and bone destroyed; in another, exactly the opposite. Stone most consistently is preserved, but even some types of stone disintegrate.

At many archaeological sites in Alaska, stone artifacts outnumber artifacts made of all other materials, but it is apparent from studies of technologically primitive peoples during the historic period that stone artifacts were few in number compared with artifacts made of wood, bone, antler, shell and other organic materials. Archaeologists attribute the dominance of stone in archaeological collections to its durability

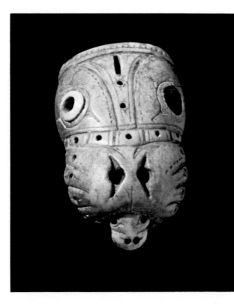

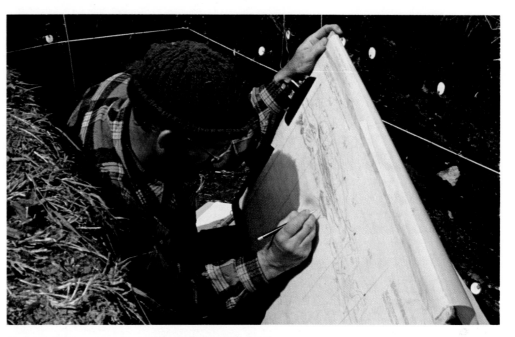

This seal-head artifact was recovered from the Ipiutak site at Point Hope, where the Ipiutak culture was first identified in the late 1930s. Elaborate carvings and highly artistic artifacts characterize this culture. (University of Alaska Museum; reprinted from The ALASKA JOURNAL®)

Robert Shaw prepares a detailed drawing of the stratigraphy exposed in the wall of a trench through a midden in western Alaska. (Courtesy of Robert Shaw)

at a site. Decorative designs on pottery commonly change quite rapidly and have often been used by archaeologists to separate components at a site. On the other hand, some scraping tools are so basic that they remain unchanged for centuries. In cases where artifacts remain unchanged or changed only slightly, the details of their location are particularly important. Stratigraphic or horizontal distribution of artifacts commonly plays a major role in defining components within a site. This is one major reason archaeologists record extremely detailed information on the location of artifacts during excavation.

Stratigraphy

When a site has been occupied during a long period of time, the debris associated with living there gradually accumulates. Modern people generally call that debris garbage, but in the strictest sense the term is inappropriate in that it suggests that the debris was purposefully disposed of after the end of its usefulness. Certainly garbage is present in some sites, but there are additional materials: remains of collapsed houses, stockpiled raw materials, perfectly functional goods that were misplaced, debris from manufacturing tools and clothing, gravel and sand used to fill wet places on the site — in short, the incidentally accumulated debris associated with living. Because it is not

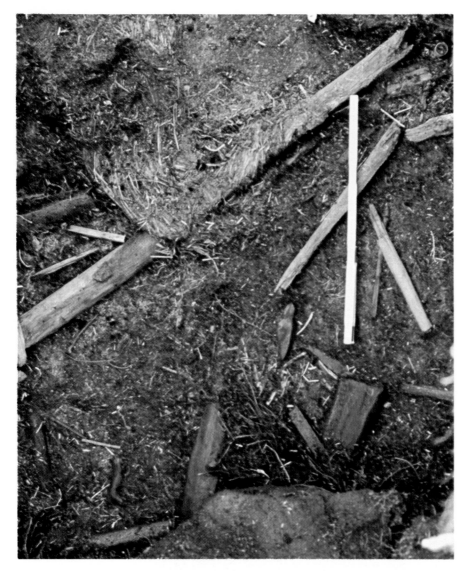

During excavation of this trench, numerous sod house floors like this one were discovered. Even near the bottom of this 1,200-year-old village deposit, assigned to the Norton Tradition, organic artifacts are preserved in like-new condition. Note the well-preserved mats of woven grass, and the wooden objects. (Robert Shaw)

all garbage, archaeologists call these deposits midden.

As midden accumulates, layers with individual, distinguishing characteristics are created. One layer may have more gravel than the one below it and fewer wood chips than the layer above; the individual layers reflect activities that occurred there. In the ideal model of midden accumulation, deposits are laid down like the layers of an onion. In the real world, the successive residents of the site dig in the older deposits, and pile their own contributions to the midden in such a way that layers vary in thickness.

Once an archaeologist has carefully excavated a trench into the midden, a detailed examination of the deposits enables the scientist to trace individual layers across the site. Depending on the similarities and differences of artifacts recovered, one or several layers (strata) may be grouped together as belonging to one cultural component. Radiocarbon dating in conjunction with stratigraphy can determine the relative age of individual strata and the artifacts each contains. All artifacts found in midden stratigraphically above the position of the radiocarbon sample are younger. A person might think that the deeper an artifact is in the ground, the older it is, but that is not necessarily true. Consider Figure 3. Even though the bottom of the house pit is deeper below the ground surface, stratum D is older than charcoal from the hearth of stratum C. Ancient residents excavated the house pit and artificially made stratum C deeper than it would otherwise have been. But they also mixed some of the artifacts of strata D and E into stratum C deposits during excavation.

Figure 3 illustrates the stratigraphy of a hypothetical site with six strata — layers of dirt and midden — one of which (stratum C) is

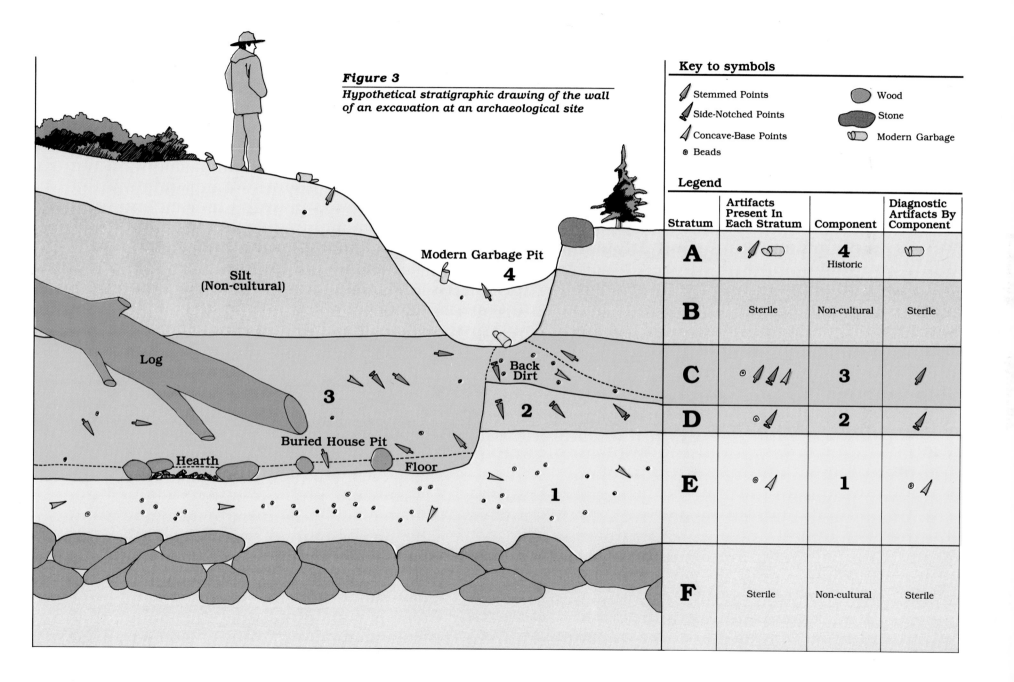

Figure 3

Hypothetical stratigraphic drawing of the wall of an excavation at an archaeological site

Key to symbols

Stemmed Points		Wood	
Side-Notched Points		Stone	
Concave-Base Points		Modern Garbage	
Beads			

Legend

Stratum	Artifacts Present In Each Stratum	Component	Diagnostic Artifacts By Component
A		**4** Historic	
B	Sterile	Non-cultural	Sterile
C		**3**	
D		**2**	
E		**1**	
F	Sterile	Non-cultural	Sterile

Modern Garbage Pit 4

Silt (Non-cultural)

Log

Back Dirt

3

2

Buried House Pit

Hearth

Floor

1

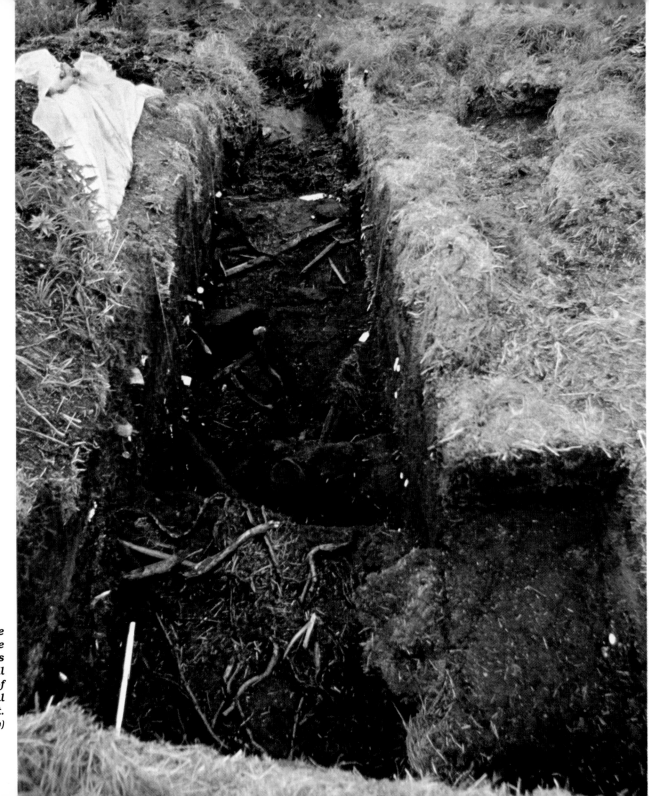

This trench into the Manokinak site on the Yukon-Kuskokwim Delta cuts across a midden, frozen until excavation, which consists of fibrous, organic material closely resembling peat.
(Robert Shaw)

subdivided into three closely related layers by dashed lines for a total of eight stratigraphic units. The silt (stratum B) was deposited by natural processes while the site was abandoned; therefore, no artifacts are enclosed within the silt. Stratum F also is of non-cultural origin; it was created by natural processes before the site was first occupied. In a case as simple as this, the archaeologist undoubtedly would have identified the non-cultural layers during excavation and would have noted the sterile separations between the historic occupation and the several prehistoric components. The radically different nature of the artifacts would have dictated definition of a historic component even if the stratigraphy did not emphasize the separation so distinctly.

Separation of the three prehistoric components is more difficult. Not only are the strata (C, D and E) of components 1, 2 and 3 in close proximity, excavation of a house pit during the time represented by component 3 caused artifacts from components 1 and 2 to be moved upward during house construction. This is depicted by the presence of side-notched points, beads and concave-base points in stratum C. Likewise, excavation of a historic garbage pit displaced beads and stemmed points to the modern ground surface. Upward stratigraphic displacement of artifacts complicates delineation of the real artifact inventory of each of the three different cultural groups that produced the midden. To define the artifact inventory of each of the components, a detailed analysis of the excavation data is required.

A graphic depiction of the artifacts present in each stratum is included in the legend for Figures 3 and 4. Comparing the large number of beads and concave-base points present in stratum E with the small number present in the overlying strata suggests upward displacement

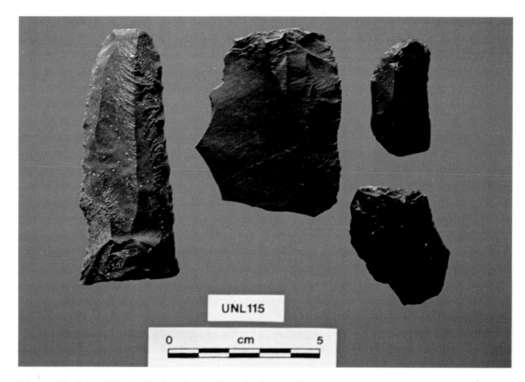

These blade artifacts, technologically similar to the ones found at Anangula Island, were found by archaeologists in 1984 at a site in Unalaska Bay. Although not yet dated, the artifacts are likely to be close in age to the 8,500-year-old Anangula remains. (Douglas Veltre)

of those artifact types. Even though negative evidence is always suspect in archaeology, the absence of beads and concave-base points in stratum D at least agrees with the hypothesis that those artifact types have been displaced upward by human disturbance. The presence of only side-notched points in stratum D defines the diagnostic artifacts of that stratum. Again using negative evidence, the absence of stemmed points from strata D and E suggests these are a younger artifact type.

Cape Krusenstern and Onion Portage

The story of ancient man in northwestern Alaska unfolds page by page in the beach ridges of Cape Krusenstern and in the stratigraphy of Onion Portage. Following the pioneering efforts of archaeologist J. Louis Giddings, scientists have uncovered artifacts from several early cultures.

At Krusenstern, northwest of Kotzebue, a series of beach ridges built up when waves of the Chukchi Sea deposited gravel on the outer shore. Each ridge contained the record of people living along the outer coast at the time the ridge was built. As scientists moved their excavations inland, their efforts disclosed cultures more and more ancient. Finally, on bluffs above the beach ridges, Giddings unearthed the oldest finds.

The work at Onion Portage along the banks of the Kobuk River east of Kotzebue, also begun by Giddings, correlated with his efforts at Krusenstern. Here, artifacts found in vertical stratigraphy, where scientists are better able to understand the relationship of one culture to another, pointed to different cultures having hunted caribou for thousands of years near the portage. Layers at Onion Portage encased artifacts from early Eskimos, early Indians, and perhaps even earlier predecessors. Scientists still strive to determine the exact nature of these cultures and their age, but the record of ancient man in northwestern Alaska was expanded considerably by the work at Krusenstern and Onion Portage.

And so the laboratory analysis goes, until the diagnostic artifacts unique to each stratum are delineated. The legend tells the story of this hypothetical case. But this grossly simplifies the process. In the real world, suites of artifact types will be involved for each component and the number of artifacts of a given type may be low. However, other evidence may be available to help sort out the problem; perhaps parts of a broken artifact were recovered in separate strata. Knowledge of culturally similar sites also helps. If components of the same cultural phase have been excavated elsewhere, the two components can be compared.

Archaeologists designate strata and components separately because they refer to different things. Also, strata designations are used in the field for orderly collection of detailed data. Components are usually designated during analysis of the data in the lab; component definition is the result of a synthesis of the information. Even though archaeology is romantically considered a field effort, the reality is that three or more days of laboratory work are required for every day in the field.

Horizontal Distribution

Horizontal distribution of artifacts, much more tentative than stratigraphic analysis because less information is available, can sometimes be employed to separate the several components at a deflation surface site in a fashion similar to that used in interpreting stratigraphic evidence. Consider a deflation surface on a windswept ridge where no soil accumulates. Rather than accumulating thick deposits of midden and causing the artifacts of each component to be enclosed within a layer of midden that constitutes a stratum, materials brought to the site gradually weather and are blown away. Only artifacts of the most durable

Jim Gallison holds large bifaces which have weathered from a deflation surface along this ridge adjacent to Kagati Lake, northwest of Goodnews in western Alaska. (Both by Robert Shaw)

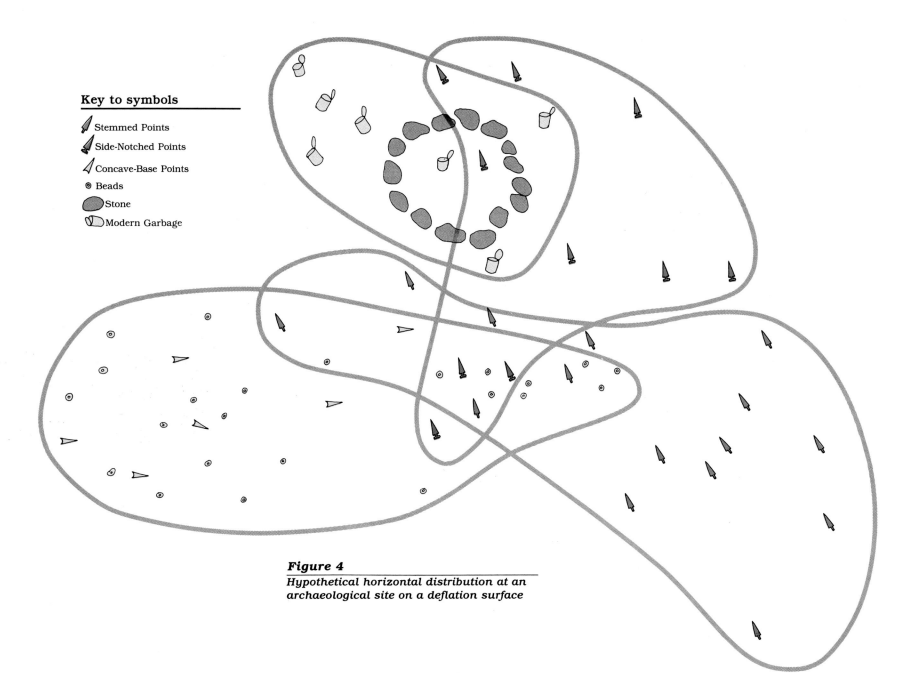

Key to symbols

⚔ Stemmed Points

⚔ Side-Notched Points

◁ Concave-Base Points

◉ Beads

⬮ Stone

▱ Modern Garbage

Figure 4

*Hypothetical horizontal distribution at an
archaeological site on a deflation surface*

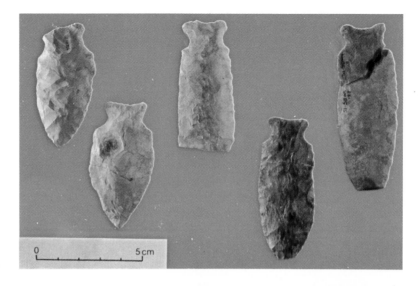

materials remain, and all are directly on the ground surface without regard to differences in age or cultural affiliation; stratigraphy never developed because of weathering. By carefully mapping the horizontal locations of artifacts on deflation surfaces, the components of the site and their inventories sometimes can be separated. The areas of overlap are confusing, until a distributional analysis reveals that only certain artifact types are found together in some areas of the site. By careful analysis of the area where artifacts do and do not occur together, the confusion of overlapping areas can be sorted out and the artifacts grouped into components.

Typology

Artifact typology also frequently plays a role in definition of components. Generally, typology means that artifacts have physical similarities and differences. These characteristics may be rooted in differences in function, in differences of technology with which the items were manufactured, in differences of raw materials, in the artistic fads of the community or even in idiosyncratic behavior of individuals.

Artifact typology frequently can be used to distinguish one stratum from another and aid in separating the components of a site. In the hypothetical site illustrated in the discussion of stratigraphy and horizontal distribution, the

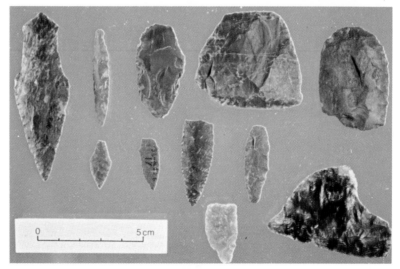

These flaked stone artifacts from the Norton Tradition component at the Chagvan Bay site near Cape Newenham are strikingly different from the side-notched points of the Northern Archaic Tradition. The two sites are less than five miles apart, but the age of the artifacts may differ by several thousand years. (Robert Shaw)

Archaeologists work with more than just ancient sites. The Bishop's House at Unalaska, built in the 1870s, was recently renovated and turned into a museum. Archaeologists work here to determine whether there are any artifacts on the site which must be taken into consideration during reconstruction. (Douglas Veltre)

shape of the arrowheads would play a role in defining the components. Introduction of an artifact type not present in adjacent stratigraphic units requires explanation, such as a change in culture. Designation of a component declares that a significant cultural difference has been recognized.

Phase

If people share language, technology, decorative style, religious ceremonies and most other ways of life, they are said to belong to the same culture. Numerous villages which share a culture may exist throughout a large geographic area. Because the artifacts they manufacture serve the needs of their culture, the artifacts produced by all individuals from a given culture have physical similarities. Individual tools may differ somewhat, but with a large number of tools being recovered from a given component, the overall similarities are apparent no matter from which village the tools came. When an archaeologist excavates several sites within a region and finds artifacts in each site that are typologically equivalent, he will define a component at each of the sites. In the regional synthesis, the archaeologist will define and name a phase which groups like components from several sites. By doing so he declares that the culturally similar components from several sites where the phase occurs represent the same culture and date to within a brief interval of time. Phase groups several typologically equivalent components on a regional basis or occurring during a relatively brief period of time, on the order of a century or two. Phase designation links several sites in a region.

Horizon and Tradition

Horizon and tradition are broader, more general units, the first emphasizing geographic

area and the latter emphasizing continuity through time. A horizon is represented by cultural traits which exist in broad geographic areas, perhaps several regions, but represent an occurrence that existed for only a short time. Though the period of time involved is relative and varies with the total time of the archaeological continuum being dealt with, for most purposes, horizon refers to a period of a few years rather than a century or more. Use of the hula hoop is a phenomenon in the recent past that illustrates the concept of a horizon marker. The hula hoop came into use suddenly, was intensely popular in several countries, and within a few years disappeared from the cultural inventory. In Alaskan archaeology, the influence of Russian culture in western and southern Alaska takes on the character of a horizon, even though the period of occurrence is unusually long for application of the term.

Tradition relates cultural phases through time. It identifies temporal cultural continuity, the passing of technology, art and other aspects of life from one generation to the next. This is not to say that there is not cultural change, for there is. But from one phase to another within a tradition there are observable similarities along with cultural differences which caused archaeologists to define the phases as distinct segments within the cultural continuum. There are even interconnections between traditions, the passing of art and technology from neighbor to neighbor.

Art and Archaeology

From the hour people cast aside the debris of their day's activities, the materials begin to deteriorate. Natural forces, from erosion along rivers and ocean beaches to the burrowing of rodents and even the action of microbes, combine to destroy the remains on which

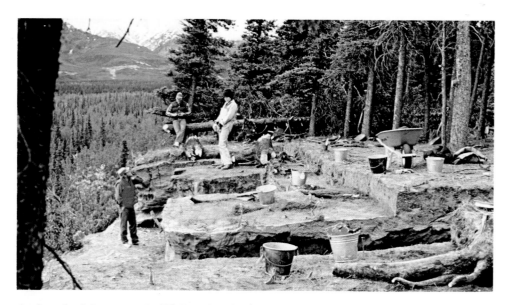

Archaeologists excavate the Dry Creek site near Denali National Park, where some of the oldest artifacts yet found in Alaska have been uncovered. (State of Alaska; reprinted from ALASKA® magazine)

knowledge of our ancestors is based. Sites like Dry Creek, the oldest archaeological discovery in Alaska, have only artifacts of the most permanent materials preserved. The inventory of such old sites is restricted to stone items and occasionally bone; wood, hide, hair and other organics disintegrated long ago.

Consequently, there is little evidence on which to base a discussion of Paleo-Arctic Tradition art. In fact, such a high percentage of the artifact inventory has been destroyed that there is little evidence on which to differentiate artifacts over extremely large areas and through thousands of years. The inventory of all sites is so impoverished that definition of phases within the Paleo-Arctic Tradition is rare in comparison with younger sites where artifacts in greater variety have survived.

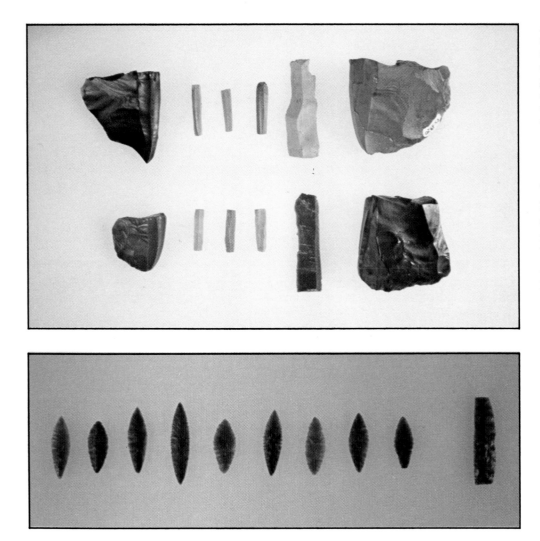

Consider, for instance, microblade cores. These small stones were flaked to produce numerous cutting blades that approximate the size of injector razor blades. These blades were inset into slots in bone tools to produce fragile but extremely sharp cutting edges. Cores, the stones from which the blades were removed, are found over most of the state and their ages span thousands of years. Phase level classification is normally based on a suite of artifact types. Archaeologists magnify the importance of typological differences based on general shape and manufacturing sequence to the point that those differences begin to take on the significance usually attached to the phase level. When archaeologists have little to work with, they commonly compensate by dealing with the data in extreme detail.

While it certainly is not valid to call microblades and cores art, these objects have aesthetic qualities. The long lineal facets produced by successive removal of blades present a pleasing appearance. Considerable skill is required to remove uniform blades one after another from a microcore. When archaeologists consider the question of art, skillful use of technology often plays as important a part as decorative elements. Skill in use of technology (craftsmanship) is a critical element in considering the degree to which an object is artistic. Aesthetic qualities can be and are imparted to rather mundane, utilitarian objects by excellent

Arctic Small Tool Tradition and early Norton Tradition stone blades frequently have parallel flaking. These Denbigh phase (Arctic Small Tool Tradition) end blades are considered typologically distinctive and characteristic of the phase. The end blades are displayed with a small blade (extreme right) like those from which the points were manufactured. These specimens are from collections at the Haffenreffer Museum, Brown University. (Robert Shaw)

craftsmen. Consider the flaked stone blades produced by prehistoric flint knappers shown in the photo on this page. One blade is flaked normally; the other has parallel flakes. Both are aesthetically pleasing, but the skill and care required to produce the parallel flaking imparts a distinctly artistic quality. Both blades are equally functional as cutting implements, but some cultural need was served by employing a high level of craftsmanship during production of these Choris phase points.

In prehistoric archaeological collections it is not unusual to find artistic expression in objects of everyday use. Ceremony overlapped into daily activities; the religious and secular realms may not have been as distinctly partitioned as in Euro-American society. Native religion sometimes required the use of stylized artistic expression. For the Eskimo this was particularly true in subsistence activities. For example, some harpoon heads are shaped like animals because the hunter believed this could aid him in harvesting the game he sought. Even though this doesn't agree with modern views of reality, prehistoric people may have viewed such efforts as functional necessities.

Even in sites half the age of Dry Creek, only stone may have survived. Consequently, our perception of Paleo-Arctic people is strongly biased. Because of a lack of data, we often assume their culture and art to have been impoverished. That is not necessarily so. Consider the beauty of the Upper Paleolithic cave paintings of France, unquestionably art of the finest quality dating to more than 10,000 years ago. The art of the Paleo-Arctic people undoubtedly was different from that of modern native Alaskans, but it was not necessarily less expressive of the human spirit.

In sites more recent than about 3,000 years ago, preservation of organic materials becomes

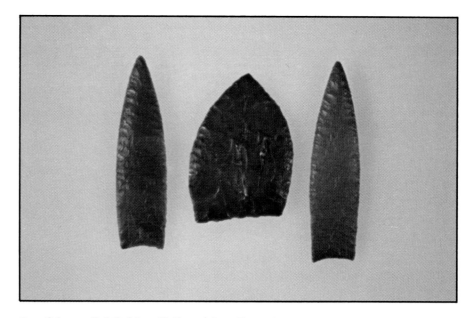

Careful parallel flaking distinguishes these two Choris phase points from the Old Whaling phase point in the center. Even though the flaking on the Old Whaling specimen is beautiful, the care and skill evidenced on the Choris points must also be considered artistic to some degree. All three blades, from Cape Krusenstern, are equally sharp despite differences in flaking style. The specimens are from the Haffenreffer Museum at Brown University. (Robert Shaw)

more common. With a more complete inventory of the material goods of prehistoric people, we arrive at a better appreciation of their accomplishments, especially in the arts. Archaeology provides a base of knowledge from which modern artists draw inspiration. Not only do the artifacts of the ancients inspire modern artists by providing examples of motifs and forms long forgotten, but they also provide perspective and pride in the cultural continuum. The arts and crafts discussed in this book are firmly rooted in the past.

The Eskimos

More than 20 discrete groups, all known as Eskimos, inhabit Alaskan regions extending from Barrow in the north; west to Saint Lawrence Island, only a short distance from Siberia; and as far south as Kodiak Island (although most Koniag today refer to themselves as Aleut), Cook Inlet and Prince William Sound.

Three linguistic groups occur within these areas. The northern Eskimos, including people of the Canadian Arctic and as far south as Unalakleet or Saint Michael, are called Inupiat, speakers of Inupiaq. The Siberian Yupik occupy only Saint Lawrence Island, west of Nome in the Bering Sea and areas of Siberia itself. Yup'ik-speaking people inhabit the remainder of Eskimo territory. Yup'ik has many complex dialects and variations, one of which is Siberian Yup'ik.

Originally, Aleuts, Eskimos and ancestors of other American Indians migrated slowly and at various times to the New World by way of a huge land mass, now submerged, called Beringia or the Bering Land Bridge. It is easy to misunderstand this movement by conceptualizing it as a process of speed and opportunism: a hunting party or tribal group ranges far afield, finds a way into exciting new territory and the migration has begun — a sort of "grass is greener" approach. Instead, resettlement of these early North Americans probably took thousands of years, coming in several different waves of occupation and for different reasons.

King Islander Earl Mayac has become known for his human-animal transformation carvings. Such transformations are said to have been performed at times by shamans, and form an important part of Eskimo mythology. 3½" x 1½".
(Anchorage Museum)

"In Eskimo thought, where spirit is regarded as separable from flesh, and each man has many helping spirits, the lines between species and classes, even between man and animal, are lines of fusion, not fission, and nothing has a single, invariable shape."

Edmund Carpenter,
The Far North

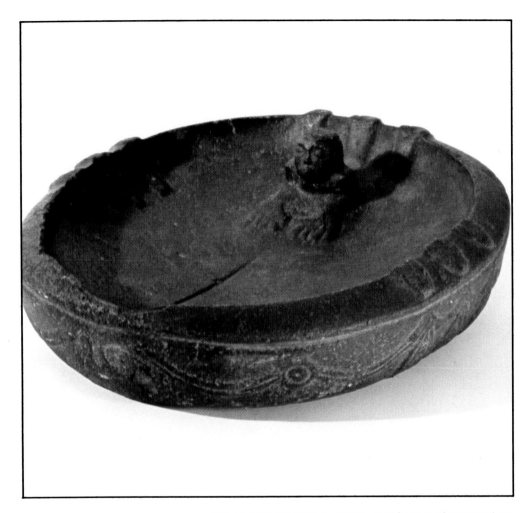

Stone seal-oil lamps, such as this one discovered on the Kenai Peninsula around 1920, were an important part of the Eskimo home, providing both light and heat. Many were quite simple, but some had decorated rims and sculpted figures, such as basking whales or this human figure with hands outstretched, inside the bowl. These carvings must have been dramatic, almost mythical, when the lamp was lit and they lay partially submerged in a flickering oval of seal oil and fire. (The University Museum, University of Pennsylvania, NA 9251; photo courtesy of Anchorage Museum)

Archaeological finds reveal that man inhabited the Seward Peninsula at least 11,000 years ago, and Aleuts are thought to have lived on parts of the Aleutian Chain for longer than 8,000 years. The Dry Creek site near Healy also shows possible occupation as long as 11,000 years ago.

The lifestyle of contemporary Eskimo villagers is somewhat like that of their early ancestors. Marine mammals, generally found in great abundance on the coast, allowed the establishment of large permanent villages, some of which have been occupied continuously for more than 4,000 years. Smaller fishing camps were established for summer use. This basic settlement pattern can still be seen today, if not always in practice, then in desire, even among the most urbanized Alaska Natives. Eskimos in a few regions either lived or ranged inland to hunt caribou, deviating from the semipermanent, sedentary lifestyle but never becoming truly nomadic.

Permanent housing for most Eskimos consisted of rectangular semisubterranean dwellings constructed of driftwood, stone and whale bone when it was available. Sleeping platforms were a common feature of these houses, as were fireplaces in areas where wood was abundant. Tunnels, sometimes very deep and of great length, allowed access to the houses without permitting inside warmth to escape.

The *kazgi* (also sometimes identified as *qasgiq, karigi* or *kashim*) occupied a prominent place in most communities. This dance house or men's communal house provided working and living space for the males of the group, as well as a place where villagers could gather for social and ceremonial functions.

Less sedentary groups such as the Nunamiut, seminomadic people of the arctic interior who

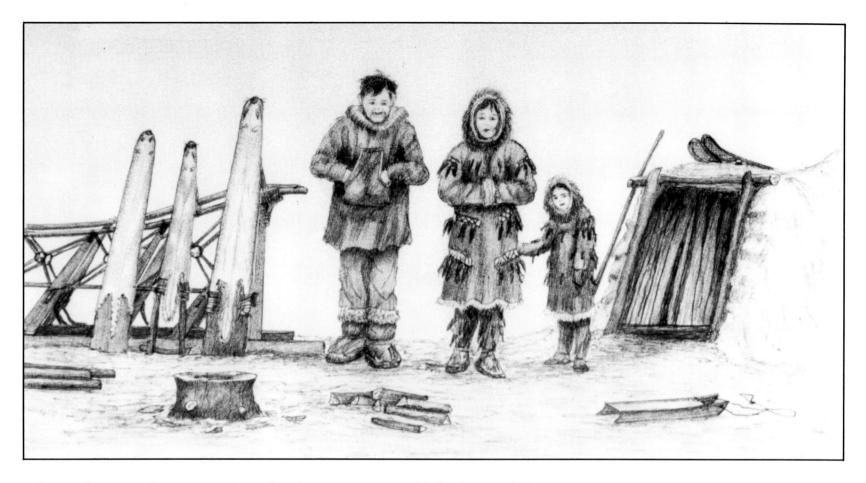

subsisted primarily on caribou, lived in movable skin tents with domed wooden frames, or moss and sod dwellings. Many residents of Anaktuvuk Pass lived this roving lifestyle, occupying caribou skin tents, until fairly recent times.

Today, as in the past, the people known as Eskimos share much in common: their languages and dialects are part of a distinct linguistic group; their cultural adaptations are unique; and all are hunters, fishermen, or both.

Large villages dependent on marine resources were established several thousand years ago and still exist in some places, particularly on the Bering Sea coast. These fairly dense population centers and the resulting camaraderie of people and ideas; an abundance of materials with which to work, such as walrus ivory and driftwood; and the genius — both individual and cultural — of the Eskimo artist combined to produce an inventory of art and cultural and artistic traditions which rank Eskimo art prominently among major primitive or tribal art forms worldwide.

The work of Milo Minock of Pilot Station, such as "Eskimo Family at Fall Camp," provides a realistic and detailed glimpse of traditional Yupik life. 8" x 5½". (Anchorage Museum)

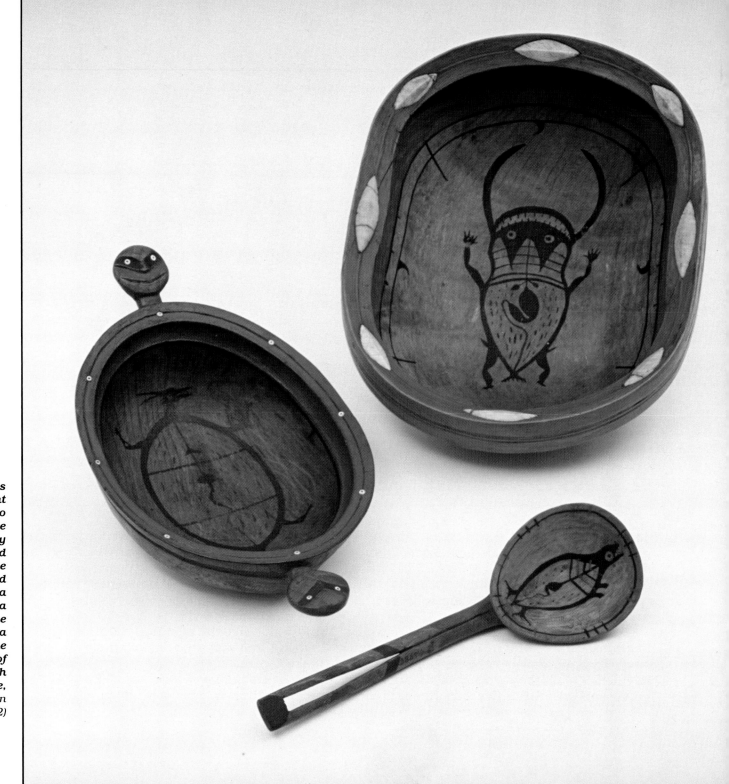

Wooden dishes, food bowls and ladles were present historically in every Eskimo household. Many of these utensils were heavily decorated with symbolic and mythological designs. The large dish, inlaid with carved stones, is painted with a mythical beast, possibly a mammothlike creature. The bowl on the right contains a bird-headed quadruped; the ladle shows an X-ray view of a supernatural creature. Both bowls, 14″ long; ladle, 11″ long. (Smithsonian Institution; 83-10712)

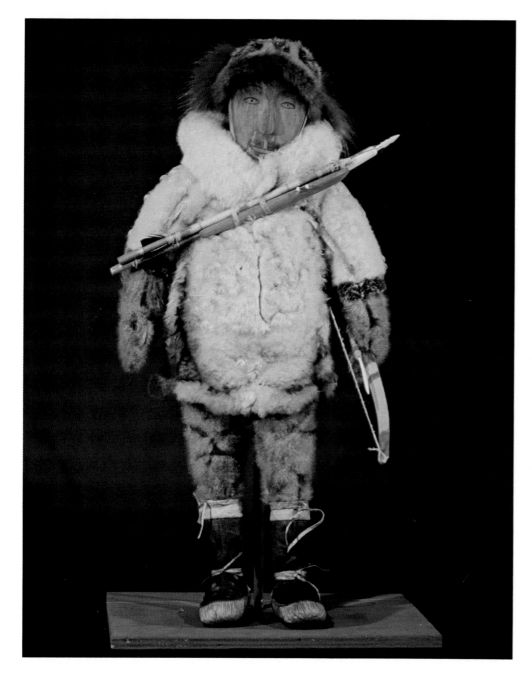

Above — *Inupiat dollmaker Dolly Spencer displays one of her dolls and its removable costume.* (Courtesy of the Pratt Museum, Homer, Alaska)

Left — *This realistic, wood-faced doll by Anna Kungurkak (Kungurak) of Toksook Bay depicts an Eskimo hunter, dressed in an eider-skin parka, carrying his weapons. Doll-making has been an Eskimo art form for at least 2,000 years, and is an activity shared by men and women.* (Steve McCutcheon)

45

Barrow's Utqiagvik Site

By John E. Lobdell, Ph.D.

Editor's note: *Dr. John Lobdell is a teacher of anthropology at Anchorage Community College. His specialty is bioarchaeology — the study of human and animal remains from archaeological sites.*

In 1982, two frozen bodies and three skeletons with some remaining soft tissues were found in a partially frozen prehistoric house at Barrow. This amazing find led to one of the most exacting scientific investigations of past northern native peoples. The frozen human bodies were found inside a house that had been crushed by *ivu*, the Inupiat term for winter sea ice pushed by strong onshore winds and tides, sometime between A.D. 1500 and 1750. Thorough examination of the well-preserved human remains revealed critical information about the prehistoric Inupiat Eskimos from the ancient village of Utqiagvik.

A Barrow resident uncovered parts of the bodies at the same time archaeologists from the State University of New York at Binghamton

Researchers excavate the Utqiagvik site, where sea ice crushed an Eskimo home nearly 500 years ago, trapping its five inhabitants. Autopsies performed on the well-preserved bodies revealed interesting information about the health of these pre-contact Eskimos.
(Dr. John E. Lobdell; reprinted from
ALASKA® magazine)

46

were excavating other parts of the old village. The bodies were carefully removed by the archaeologists and shipped while still frozen to Fairbanks Memorial Hospital for complete autopsies.

Examination of the frozen bodies provided a unique opportunity to learn more about the health of the house's inhabitants. One of the bodies was that of a woman in her mid-40s. At the time of her death she was developing atherosclerosis (normal hard deposits) of the major arteries, and some bone mass loss associated with advancing age. From breathing seal oil smoke in the tightly built house, she also had anthracosis, or black lung. She had survived pneumonia, chronic bronchitis, and a kidney failure.

The other frozen body was that of a woman in her mid-20s. She also was developing black lung, and showed advanced amounts of bone mass loss for her age, possibly from dietary deficiency such as a lack of vitamin D from the decreased sunlight of northern Alaska's long winters. Both women had died almost instantly from severe crushing injuries to the chest.

All but one of the humans showed lines of arrested growth in the leg or arm bones, caused by stress due to the seasonal malnutrition that probably occurred during the coldest months.

Levels of strontium in the bones and soft tissues suggest that the people relied heavily on sea mammals for food. Hair analysis showed high copper levels, and large amounts of mercury were absorbed periodically, probably during the fishing season. Zinc contents were far below normal, which may have resulted in chronic skin inflammations.

All tests for serious microbiologic diseases were negative except one, which showed that one of the persons suffered from trichinosis, perhaps from eating raw polar bear meat.

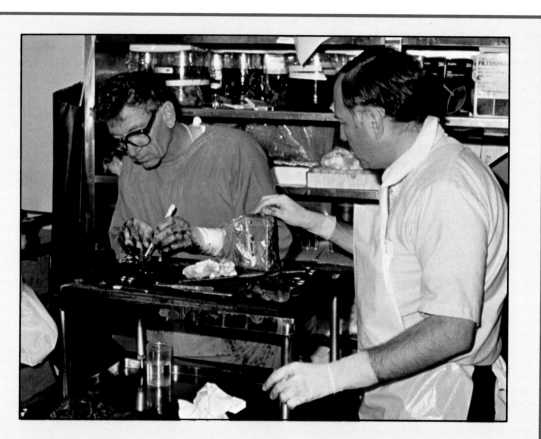

(Bears are often carriers of trichinosis and Natives today are careful to eat only well-cooked bear meat.)

This archaeological project was successful only because of the high level of concern and cooperation exhibited by the community members and elders, construction personnel, archaeologists, physicians, and others. In addition to the Fairbanks autopsy, diverse work on the tissue samples was performed by numerous specialists from across the nation. The bodies were reburied in an appropriately reverent ceremony following the study.

At Fairbanks Memorial Hospital, Dr. Arthur Aufderheide (left) and Dr. Michael Zimmerman examine organs removed from one of the bodies discovered at the Utqiagvik site. (Dr. John E. Lobdell; reprinted from ALASKA® magazine)

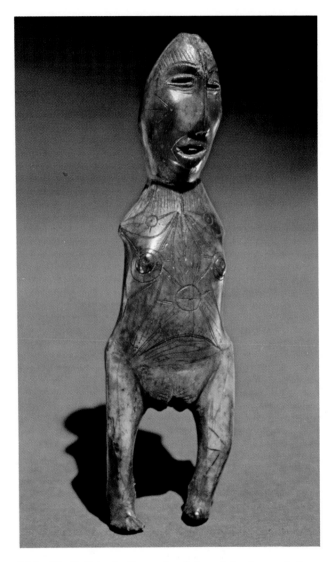

This Okvik female figure is elaborately decorated with engraved lines. The feet are actually bear paws, and the piece may represent symbolic connections or transformations between the woman and the spirit of the bear. 5" high.
(University of Alaska Museum; photo courtesy of Anchorage Museum)

Major Artistic Traditions of the Past

Important cultural and artistic traditions tie the Eskimo artist of 2,000 years ago with the artist of today. How prehistoric people lived and died, what they ate, the tools they used and the art they produced can be examined through archaeology. Artifacts of bone, wood, ivory and other materials are sometimes perfectly preserved by the frozen ground of the North. Changes in artistic style, especially in the Bering Strait region, can be documented throughout a continuous period of 2,000 years.

The oldest of these well-documented early Eskimo cultures is Okvik, dating, at least on Saint Lawrence Island, to just before the birth of Christ. Okvik designs are generally characterized by engraved ovals, circles, curved parallel lines and light, straight lines ornamented with diagonal spurs.

Okvik artists, for reasons we may never know, carved a great number of ivory human figurines, many of them female. One characteristic of these dolls is an elegant oval face and long nose with carefully engraved details such as eyebrows and tattoos. Many of the figures have only rudimentary, wedge-shaped bodies, and some are grooved around the face, indicating that they may once have worn clothing. Others have ornately carved and decorated trunks, some with exaggerated genitalia. Some female figures are depicted nursing and clasping young children. A number of figurines are headless, and many carved ivory heads have been discovered without bodies. This, and the fact that the dolls are carved in such a stylized manner, may mean that they were not playthings, but accoutrements of ceremony and ritual.

Okvik is considered the predecessor of the Old

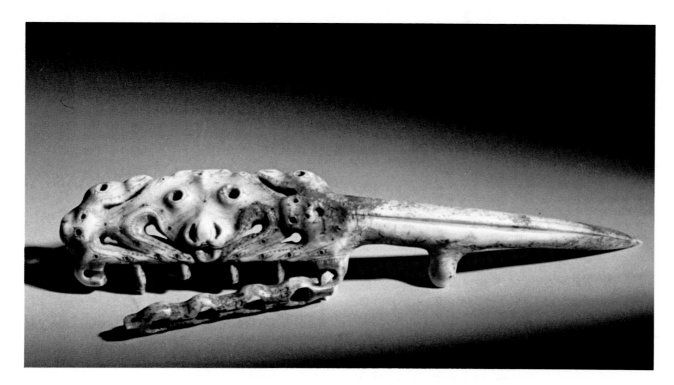

This ornately carved Ipiutak "bear comb" was collected from a site at Point Spencer on the Seward Peninsula. (University of Alaska Museum, reprinted from The ALASKA JOURNAL®)

Bering Sea cultural phase. Old Bering Sea artists lived in the same areas as earlier Okvik people, and their artistic styles share many design elements. Old Bering Sea engravers maintained a complex and skillful balance between light Okvik-style lines and spurs, heavier lines and elliptical elements, and the form of the object itself. Designs were elaborate and repetitive, often covering all available space and sometimes creating visual puns — a harpoon head, for example, might also be a bird.

Art and artifacts of the Punuk phase (around A.D. 900) show transitions in form and design as well as new types of tools. Many artifacts are indistinguishable from Old Bering Sea implements; others are new or diffused from other periods. The technology of objects such as harpoon heads appears to have become much simpler, and with the simplification, less elaborate engraving styles were used.

Engraved lines during this period became straighter, deeper and less concerned with the form of the object they ornamented. Design elements, such as the circle and dot, can be followed directly into modern Eskimo art. Finally, at least for the production of art, Punuk carvers may have been the first to use metal engraving tools, a major transition.

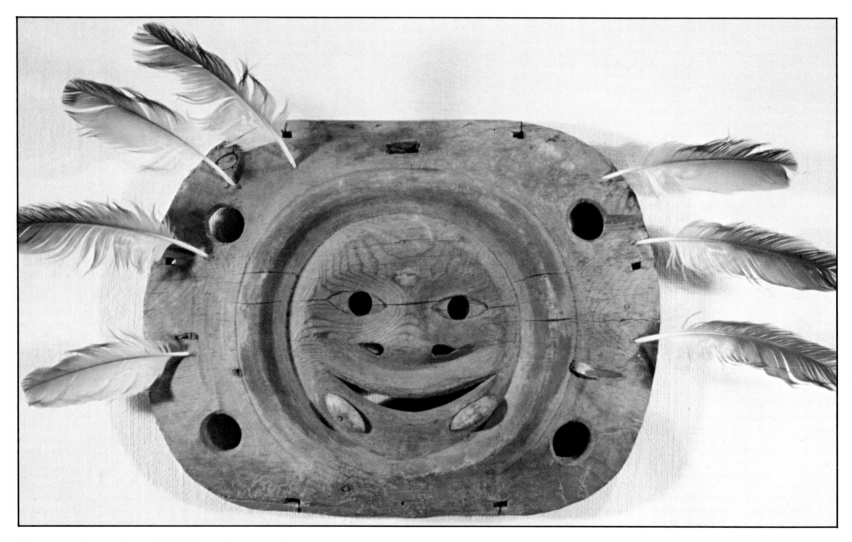

Dance masks, such as this 19th-century wood mask with feathers, from along the Kuskokwim River, were used during religious ceremonies and shamanistic performances. The mask was gripped from behind in the teeth of the performer, while feathers and attached appendages moved with the rhythm of the dance. 15½" x 11¾". (The University Museum, University of Pennsylvania, NA 1555; photo courtesy of Anchorage Museum)

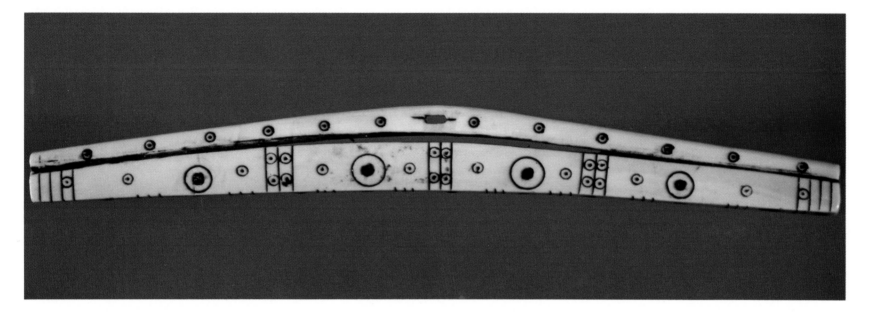

The Thule cultural tradition evolved around A.D. 1000, spreading across Canada as far as Greenland. Engraved decoration disappears almost completely during this period, and the inventory of art objects begins to show forms such as bears, ducks and other animals and realistic engraved scenes of Eskimo life in some regions. The legacy of realism left by Thule artisans can be seen in historic and modern Eskimo art.

The Ipiutak cultural phase predominated about 900 years ago at a large village site near the present-day settlement of Point Hope. Although some of the implements and design elements of Ipiutak seem related to Okvik and Old Bering Sea traditions, the art objects themselves are strikingly and mysteriously different. Ipiutak artists fashioned ivory swivels, chains, lacy abstract objects with large open areas and mythical animals. Most of these artifacts have been discovered in conjunction with burials and are considered to have been tied in some way to shamanism, ritual and ceremony presided over by a shaman, who was in direct contact with the supernatural.

Although most attention is customarily given to ancient artistic traditions of the northern Eskimos, impressive and beautiful objects were also being produced by Eskimos of Kachemak Bay and Kodiak Island. Ivory was a rare material in these regions and was only occasionally used; wood was abundant, but may not have been used to make art. Stone was best suited to creative expression by these people, and it is in their stone lamps that the use of this medium triumphs. Many of these lamps, perfect oval or teardrop shapes, are carved or decorated on the outside rims. Inside, stylized animals, basking whales or human figures with hands outstretched float in a mystic sea of seal oil and fire, perfect companions to stories told and retold throughout generations.

Design elements ranging from simple to complex were used to decorate even the most utilitarian items, such as this late 19th-century ivory fastener for a bag or pouch. The fastener is engraved and inlaid with metal. 5¼" long. (Sheldon Jackson Museum, an Alaska State Museum; photo courtesy of Anchorage Museum)

Ivory Carving

Today's boom in carved ivory springs from a 2,000-year heritage of Eskimo ivory carving. Ancient Punuk, Okvik and Thule artists left an important legacy of form and design for the contemporary carver. The successful carver today is generally someone who is aware, however subtly, of these ancient traditions, incorporating them into his or her own personal, creative way of handling the ivory.

The large islands of the Bering Sea — Saint Lawrence, Little Diomede and Nunivak — are home to the majority of Alaska's ivory carvers. Eskimos from King Island, renowned for their carving skill, now live in Nome, along with talented artists from many other villages. Large herds of walrus migrate through the area twice a year, but the critical harvest of meat, hides and ivory tusks occurs in late spring. Hunting, an uncertain and often dangerous activity, takes place from traditional skin boats, called *umiaks,* or from large aluminum boats. Crews

These walrus ivory and trade-bead labrets, ornaments made to be worn in a pierced lower lip, were collected on the Arctic Coast in the 1890s. (Collection of the University of Alaska Museum; photo by Lael Morgan)

consist of several men who are often related and who have hunted together in years past. Meat and ivory from the hunt are shared in a way governed by traditional social rules, resulting in nearly equal portions.

The availability of fresh ivory on a year-to-year basis is unpredictable. If ice conditions are wrong or the migration of walrus follows a slightly different route, little fresh meat and ivory may be obtained, and whole villages may do without.

Men who were unsuccessful in the hunt, or female carvers (who do not hunt) must buy, trade or borrow ivory from friends and relatives, dealers or residents of other villages. Additionally, walrus ivory must be seasoned to minimize cracks and breakage. A conscientious carver will not work with "green" ivory, and many carvers strive to build up a stock of seasoned material to work with in the future. Opinions differ among carvers as to how long ivory should be seasoned. Lincoln Milligrock of Nome sets his aside for a year or more, but most carvers wait only a few months before using their ivory.

The present-day trade in old walrus ivory, often mistakenly called fossil ivory, is brisk and lucrative. This ivory has been buried in the ground or has been on beaches for years, and contact with various minerals has caused it to change from white to tan or any of a multitude of colors. Some highly prized old ivory exhibits rays of deep blue or areas of brown and gold which shine like the semiprecious stone, tiger's eye.

Most old ivory comes from ancient sites or beaches on Saint Lawrence Island and is sold by the pound to non-native buyers, generally for use in some kind of artwork. Various federal prohibitions govern the collection of old walrus, mammoth and mastodon ivory. Such materials

Ivory carvings from different regions are stylistically very different and can be easily recognized. The squat walrus on the left, decorated with black and ochre pigments, is from Nunivak Island; the other walrus was made by Walter Slwooko of Gambell, Saint Lawrence Island. (Alaska Native Arts & Crafts Association)

may be gathered from private or reservation lands, but may not be traded or sold if found on public lands according to the Antiquities Act of 1906 and the Archaeological Resources Protection Act. The taking of fresh walrus ivory is prohibited to non-Natives in accordance with the Marine Mammal Protection Act of 1972.

Many carvers in Savoonga, on Saint Lawrence Island, use old ivory for their own work. They have access to literally tons of the material, but for most Eskimo carvers old ivory is prized and difficult to obtain. Carvers from Little Diomede and Shishmaref who craft delicate jewelry need old ivory for the alternating links of bracelets they make. Some of the old ivory they use is dug up or found, but much is traded for or purchased with cash from islanders at even higher prices than traders must pay because of competition between carvers and villages.

Eskimo carvers greatly prefer walrus ivory, either fresh or old. A cross section of walrus tusk ivory shows three distinct layers. Outside is a thin husk which is generally cracked and discolored on male tusks. The inner portion consists of a mottled, almost marbleized dentine core which is often used to aesthetic advantage on carved sculptures and figurines. The layer between these two is smooth, opaque ivory, sometimes a delicate rose color on female tusks. Walrus teeth, which are also ivory and are sometimes fairly large, are used for small carvings. These teeth do not have large areas of core; they are opaque and exhibit subtle rings of color.

In this 1950s photo, an unidentified Eskimo artist demonstrates a bow drill, a tool still used in carving ivory. (Steve McCutcheon)

This ivory ship, possibly modeled after the steam brigantine Jeanette, *was collected on the Seward Peninsula around 1905. It was probably made by a Diomede carver. Materials include walrus, elephant and mammoth ivory, bone, baleen, sinew, wood and thread. 22" x 19". (University of Alaska Museum; photo by Barry McWayne)*

Mastodon tusks are often unearthed in the summer by miners or found eroding from river cutbanks where they have been buried for thousands of years. Although these tusks are enormous and their colorations often beautiful, the material cannot be used as efficiently as walrus ivory. Mastodon ivory dries and separates into narrow rings. These thin, highly colored sheets of ivory are ideal for the bracelet maker from Shishmaref or Diomede, but not at all appropriate for a carver of larger pieces. Most Alaskan mastodon ivory, like much old walrus

One of a carver's most prized possessions was his tool box. Skillfully made bentwood boxes, such as this one with engraved ivory handles and decorations, are still passed down from father to son in some families. 14½" long. (Sheldon Jackson Museum, an Alaska State Museum; photo courtesy of Anchorage Museum)

the taking of sperm whales, and this type of ivory is unavailable to native scrimshanders.

Carvers work with a number of tools — heirlooms, handmade and modified commercial tools. These include hacksaws, coping saws, vises, several sizes of files, bleached sealskin thimbles for protection during filing, scrapers and assorted gravers. Two aboriginal tools still in use include the adz and the bow drill. Carving tools are generally stored in commercial toolboxes, but a few artists are fortunate enough to have worn bentwood boxes with ivory handles or inlay, which have been passed down to them through the men of their families. These wooden toolboxes, rare and often beautiful, are themselves sought after by art collectors.

Machine tools are also common among carvers today. The lathe shapes ivory beads, and motorized tools assist some artists in many stages of the carving process. The rough, etched fur on many carved bears and the geometric nicks which sometimes represent stylized feathers on birds are two examples of the work of machine tools.

Simply, the carving of most figurines progresses as follows: first, the husk is trimmed from the raw ivory tusk with an adz; then the tusk is divided into square and rectangular pieces which approximate the sizes of the objects to be made. A quick pencil sketch is made on the chunk to be carved, and a rough form is fashioned with a hacksaw. A coping saw further refines this crude form into its intended shape.

Files of increasing fineness are used to reveal the final human or animal figure. Features such as eyes, ears or mouth are cut out with a graver; eyes are often filled with a material of contrasting color such as old ivory or baleen. At this stage, file marks are smoothed out with sand-

ivory, is sold by the pound to dealers and traders, eventually reaching non-native artists outside Alaska who do etching, or scrimshaw, on the smooth, flat surface.

In the 19th century, artists who came in contact with whalers began to etch realistic scenes on sperm whale teeth. At least one contemporary carver, the renowned Peter Mayac of King Island, had a stock of these teeth which he used for etching until his death in 1976. Today, the Marine Mammal Protection Act and the Endangered Species Act prevent

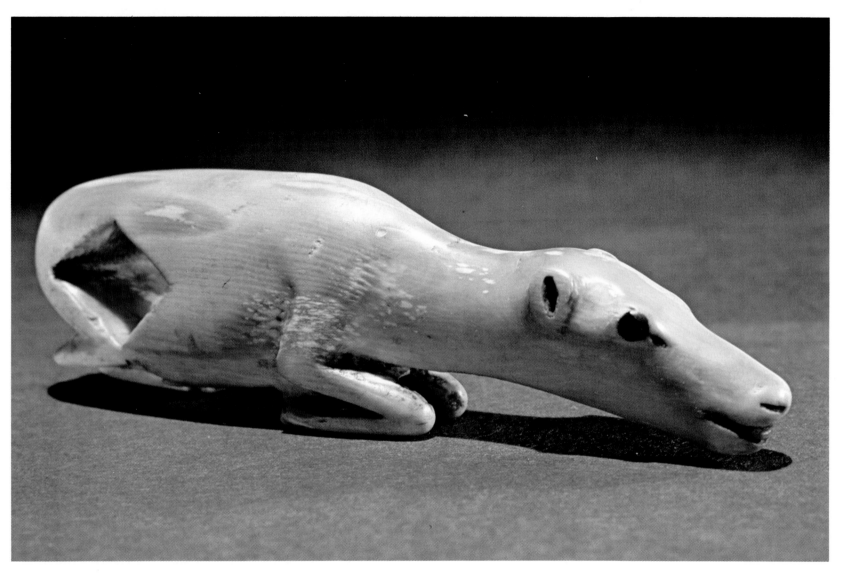

This caribou arrowshaft straightener was collected
by Edward Nelson at Cape Denbigh between 1877
and 1881. The detailed carving is thought to depict
a fetal caribou, frequently taken during hunts and
prized for its soft hide. 5¾" long.
(Department of Anthropology, Smithsonian Institution,
176 245; photo courtesy of Anchorage Museum)

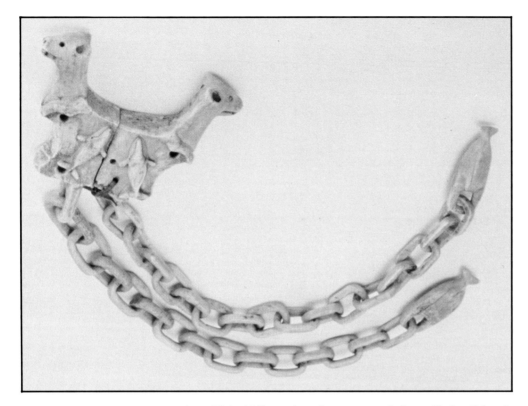

This 19th-century harpoon rack from Sledge Island, located 25 miles west of Nome in the Bering Sea, shows skillfully carved bear heads, whales and chain links made from a single piece of ivory. 8" long. (The University Museum, University of Pennsylvania, NA 4796; photo courtesy of Anchorage Museum)

other darkening agent is then applied to the entire surface, where it settles in the recessed grooves and leaves the desired pattern after the surface is wiped clean. Carver Floyd Kingeekuk of Savoonga uses a slightly different method to create the realistic seals for which he has become famous. Kingeekuk blackens the entire seal, then etches through the black surface (which makes it easier for him to see the fine pattern) with fine dental tools and finally removes the black and reapplies color only in the grooves. Using this method he is able to simulate not only the major characteristics of the animal, such as rings or ribbons, but literally to highlight each hair.

Most of the older pieces now collected as Eskimo art were originally functional or ceremonial in intent, although in some cases the original purpose is now forever obscured. Before the gold rushes of the late 19th century in the Nome area, little ivory carving was done for commercial purposes. Ivory and wooden charms were fashioned to help ensure success in the hunt or to assist a childless woman in becoming pregnant. The term "artist" would have been inappropriate and unknown to the makers of these amulets. Every man could carve, and what we now see as art objects were a necessary and integral part of everyday Eskimo life. Many functional household items, such as buckets, or hunting implements like harpoon rests and arrowshaft straighteners, incorporated sculptured animals into their design, probably to appease and attract the spirits of the animals which were hunted.

One striking art form of the historic period, the heavily engraved drill bow handle, depicted a wide array of human and animal scenes, ranging from the most mundane to the very spectacular. These engravings show all aspects of Eskimo life during this period, including

paper, and metal polish, combined with strenuous rubbing, perfects the surface. India ink, graphite, hematite or commercial coloring may be added in the final stages.

If the ivory is to be engraved, and the King Islanders are masters of this technique, gravers of assorted widths are used. The carver literally walks the tool over the polished ivory surface, creating a zig-zag pattern. India ink or some

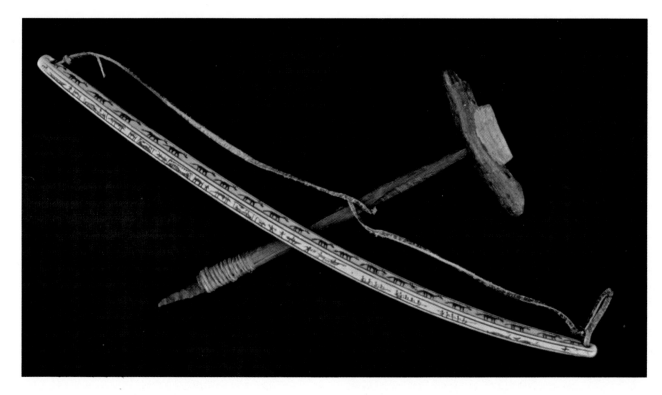

Engravings on drill bow handles depict many aspects of native life during the historic period, and may have been used to record important events in the life of the engraver. (Anchorage Museum)

ships trading with Bering Sea Eskimos, dancers shaking long, ornamented gloves and even, according to one source, a man killing his wife's lover. Some drill bows may have been records of important events in the life of the engraver.

Carved and ornately engraved ivory pipes were among the first objects made for sale. Traders encouraged the manufacture of these pipes during the late 19th century, but their appeal diminished as engraved cribbage boards gained popularity. Nome became the hub of activity for the trade in ivory souvenirs, and the list of items produced grew to include dog teams, paperweights, dice and miniature replicas of miners' tools.

One Eskimo artist, known as Happy Jack, had a particularly strong influence on ivory carving during this period. Happy Jack, whose Eskimo name was Angokwazhuk, was a young man from Diomede who had lost both feet during a disastrous hunting trip on the Bering Sea. He was an exceptional carver. Because of his talent and outgoing personality, he was asked to crew on a whaling ship bound for San Francisco, and when he returned he settled in Nome with his family. By the time the gold rush occurred, Happy Jack's engraving style had set the standard for all ivory carvings made and sold on the Seward Peninsula.

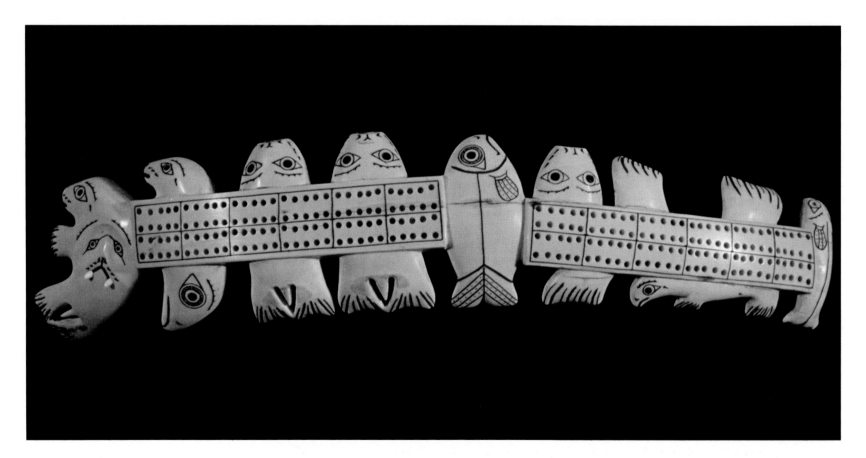

Happy Jack's talent and vision are said to have provided a real bridge between functional historic ivory carving and contemporary trends. He may have been the first to make an engraved cribbage board, a type of carving still commonly produced. Often Happy Jack's cribbage boards were ornamented with precise copies of advertisements and photographs, as well as his own designs. He is described as teacher and confidant to many early carvers in the Nome area, sharing his home and ideas freely until his death in 1918.

Anthropologist Dorothy Jean Ray remarks

Ivory cribbage boards, such as this 1930s double board from Nunivak Island, were a popular trade item. This piece shows the unmistakable, rather whimsical style of Nunivak carvers. 14" long. (University of Alaska Museum; photo by Barry McWayne)

that the carving of ivory figurines increased in popularity during the 1960s and 1970s. Today, although realistic representations and engravings of Arctic scenes and animal life are still common, a few carvers are dealing with ivory in a way reminiscent of larger sculpture. The

Diomede carver Happy Jack was well-known for his intricate etchings on ivory, many of which were as detailed as photographs. This example is an exact facsimile of a soap wrapper. (Mystic Seaport Museum Inc., Mystic, CT)

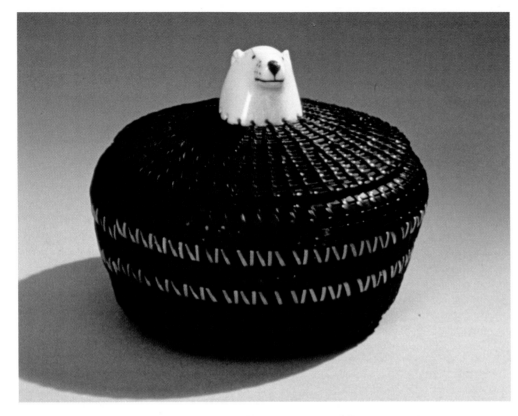

A carved ivory finial in the shape of a bear's head tops this baleen basket, made by Andrew Oenga of Barrow in 1983. The basket now belongs to the Alaska Contemporary Art Bank. 4" high; 4" diameter. (Photo by Chris Arend; courtesy of Alaska State Council on the Arts)

the Bering Sea are still the general regions where most ivory is procured and carved, although a few mainland Yupik carvers produce ivory figurines in a much different style. Inupiat carvers from northern villages such as Point Hope and Barrow create ivory finials (knobs) and bases for baleen baskets. Men from many villages carve ivory faces for the dolls that their wives and relatives make.

Because much carved ivory (as well as other native art) is left unsigned, it is often referred to as "anonymous" art. This is simply not the case. The signing of native art is a relatively recent trend which reflects Western concepts of ownership and possession. The work of many Eskimo artists is readily recognizable by anyone who knows their work or who is from the same village. Most carvers now are aware, however, of the pressure to sign their work, and the best known artists now sign all their pieces.

In the past, the Alaska Native Arts and Crafts clearinghouse in Juneau would receive large boxes and sacks chock full of carved ivory on a regular basis from native stores in Gambell, Savoonga, Little Diomede and other villages. Prices were often very low, and the work of good carvers did not seem to sell for much more than the poorer quality pieces. Now, extensive travel on the part of most villagers, bringing with it a competitive broadening of the marketplace, and the fact that many carvers have developed individual reputations, has changed this clearinghouse approach forever.

Ivory carvings bear characteristics distinctive to certain villages, such as the old ivory bases and simply formed animals of Savoonga, or the fluid, highly polished, rather naive-looking seals carved by King Islanders. Slabbed and linked ivory bracelets with etched scenes or carved motifs are usually made in Shishmaref or on

stylized work in ivory of artists like Sylvester Ayek of King Island and Melvin Olanna of Shishmaref, and the human-animal transformation pieces of Earl Mayac, John Penatac and Isaac Koyuk, all originally from King Island, exhibit a power, presence and certain mystery which places them distinctly in the realm of sculpture.

The Seward Peninsula and large islands of

Little Diomede. Gambell carvers often produce cleanly designed birds, particularly owls, which have stylized features and inlaid eyes. Skillfully carved walrus in a variety of positions are also a Gambell hallmark.

Individual artists have trademark pieces as well. For example, Lincoln Milligrock of Little Diomede has become famous for his meticulously carved bracelets made up of small, rectangular ivory links which are carved with Arctic animals, and Teddy Sockpick of Shishmaref is known for his engraved old ivory bracelets. Teddy Mayac and Charles Kokuluk of King Island, and Alvin Kayouktuk of Diomede all carve and etch several species of highly realistic birds; Mayac carves at least 35 different species. Myrtle Booshu, originally from Gambell, specializes in lifelike bears with engraved fur. All of these artists, and many others, have so many orders for carvings that they cannot keep up with the demand.

Two interesting innovations in carved ivory come from the village of Mekoryuk on Nunivak Island. The "Nunivak tusk," which is now produced only rarely if at all, first appeared in the 1920s, making use of the entire surface of a walrus tusk. Seals, walrus and other animals were sometimes carved in bas-relief, and often in full relief, intertwining over the tusk. Eyes were inlaid with baleen; details were etched and painted with hematite. Although carvings of a few animals twined together in this way or single animals with the features of these earlier pieces are still made, complete tusks are rare, possibly because it is now an uneconomical use of ivory. Judy Pelowook, from Savoonga, has perfected a complex contemporary interpretation of the Nunivak-style tusk.

Ivory spirit masks from Nunivak are a fairly recent innovation, dating from the 1950s. These etched and painted masks are usually

Lincoln Milligrock, award-winning ivory carver originally from Little Diomede, carves a piece of ivory at his workshop in Nome. Milligrock's pieces are usually traditional in style; he favors meticulous link bracelets and detailed sea mammals. (J. Schultz)

copies of larger traditional dance masks which would have been made of driftwood. King Island carvers have also borrowed from the tradition of dance, arranging miniature ivory masks with inlay and feather trim vertically on stands or gathered around a single slightly larger mask.

Above — *Paul Tiulana, King Island elder, is an artist and teacher. Here, he holds a carved ivory polar bear mounted on a jade base. (Photo by Suzi Jones; courtesy of Alaska State Council on the Arts)*

Right — *This Eskimo hunter doll was made by husband-and-wife team Floyd and Amelia Kingeekuk of Savoonga. Floyd carved the lifelike face and hands from walrus ivory; Amelia made the bleached walrus intestine shirt and sealskin pants and boots. The figure has rabbit fur hair and a seal hair moustache. 12″ tall. (Photo by Chris Arend; courtesy of Alaska State Council on the Arts)*

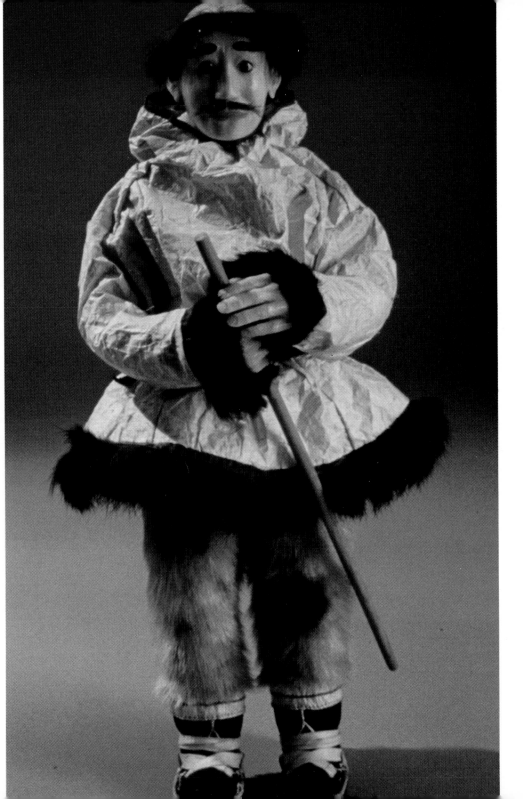

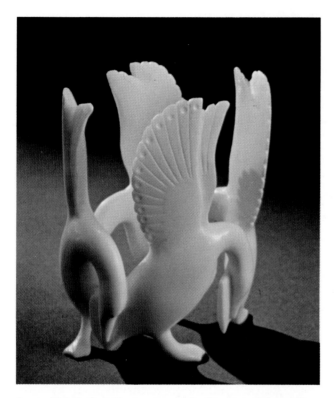

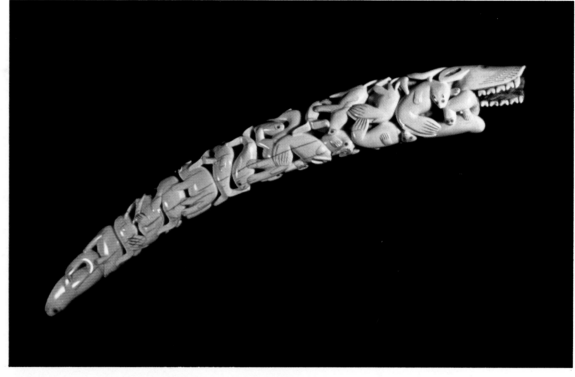

Ivory "bird rings" are carved in the round from the base of the walrus tusk. This contemporary form has a certain grace or dance to it, and is made (in quite different ways) by at least two King Island carvers. This bird ring, carved by Justin Tiulana, received an Honorable Mention at the 1977 Alaska Festival of Native Arts at the Anchorage Museum. (Photo by Sam Kimura; courtesy of Alaska State Council on the Arts)

Nunivak Island carvers developed an unusual style using entire walrus tusks in the early part of this century. This tusk, collected in the 1920s by the late Governor George Parks, is carved into a complex mass of 31 entwined seals, walrus, whales, polar bears and foxes. Mouths, flippers and ears are accented with red coloring; eyes are inset with baleen. 27½" x 3¼". (Alaska State Museum)

Skin Sewing

Just as ivory carving was once a pursuit reserved completely for men, the sewing of skin garments was and still is done primarily by women. Although men hunt or trap most of the game used to make clothing, women skin and dress the animals and cut and process the hides. Traditionally cut, skillfully sewn clothing is still essential for survival in the North. Although commercially made garments are now worn at times by many villagers, women who are exceptional sewers still not only ensure the safety of family members who must face the harsh outdoors, but are regarded as a source of pride for the entire community.

Parka style, materials used and ornamentation such as pieced calfskin or beadwork trim vary from village to village, and between Yupik, Inupiat and Siberian Yupik sewers, The cut of parkas changes from north to south; some inland Yupik parkas do not have hoods, for example.

Sewers place great importance on the use of specific materials, some of which are only available seasonally. For instance, winter-bleached sealskin can only be tanned during certain seasons. Animals like the Arctic ground squirrel must be trapped or hunted at particular times. Government regulations now restrict the use of some traditional materials such as bird skins. Blood, alder bark and red ochre are used for coloring on garments and footgear. Most sewers prefer sinew thread although in some areas sinew cannot be obtained and waxed thread or dental floss is substituted.

Braced against the wind, Savoonga doll-maker and skinsewer Annie Alowa and two of her grandchildren pose in traditional skin and fur clothing. (Photo by Rob Stapleton; courtesy of Alaska State Council on the Arts)

The cuts of men's and women's garments differed in the past, although this changed with Western contact. Women's outer parkas, as well as many of their sewing implements and other possessions, once had soft U-shaped forms, while men's garments were cut straight across. A woman's parka was also cut fuller across the back so she could pack a young child. Today, many women borrow their husbands' larger, commercially made parkas for this purpose. The lapels of men's parkas in some regions were pieced and appliqued with stylized motifs resembling walrus tusks, probably uniting the hunters spiritually and physically with the animal they sought.

Skins commonly used for making parkas and mukluks include seal, reindeer, caribou and polar bear. Wolf and wolverine are prized for ruffs. On Saint Lawrence Island, bird skins were often used for parkas. Yupik Eskimos also used bird and fish skins for making parkas. Waterproof gut parkas, parchment-thin rain garments made from the intestine and windpipe of the bearded seal, were common. Some, like those from Saint Lawrence Island, were trimmed with the mandible and beak of crested auklets or with brightly dyed tufts of unborn seal hair. Gut parkas, which crackle and rustle when dry, are said to have been worn by Eskimo shamans, who used the noise to dramatic advantage during some performances.

Eskimos from the Yukon-Kuskokwim region made clothing from sealskin, reindeer and the furs of many smaller animals such as squirrels and marten. Some fancy parkas were elaborately ornamented with pieced calfskin trim cut in geometric patterns, strips or dangles of wolverine fur, yarn tassels and beadwork. These fancy garments, which are still being made, are expressions of individual creativity — walking proof of a woman's sewing ability.

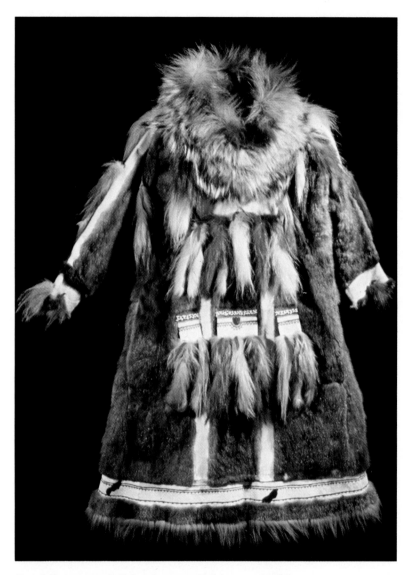

Expertly sewn clothing is essential to survival in the North. This woman's parka, made in Kwethluk in the mid-1950s, shows the skill of the woman who made it. The parka is mink with a wolf ruff, and is decorated with wolverine, pieced calfskin and beads. 46" long. (University of Alaska Museum; photo by Barry McWayne)

Good footgear is critical in ensuring the safety of a hunter or traveler in the North, and in most regions mukluk style and material vary with changes in season and weather conditions. These mukluks and boots, ranging from ankle- to hip-length, reflect the region where they were made as well as their specific use. Women of Shishmaref and Brevig Mission now make mukluks of reindeer-leg skins (silvery-white is the most sought-after color) with wide panels of multicolored beadwork at the top. These mukluks advertise the skill of their makers and the villages where they were made. Residents of Hooper Bay, Nelson Island and other areas once sewed or carved family insignias or marks of ownership on clothing, tools and household items.

Clothing is not the only avenue of creativity for an Eskimo skin sewer. Northern women once kept their sewing tools in ivory needlecases made by their husbands, while Yupik seamstresses stored their tools in elaborately decorated, pieced skin pouches known as *kakivik,* or "housewives," which they made themselves. They also made gloves and mittens, some strictly functional and others, more elaborate, for use in ceremony and dance.

The manufacture of children's toys, primarily clothed dolls and intricately sewn balls, still reflects the ingenuity of skin sewers. Making skin balls seems limited primarily to older women, most of whom live on Saint Lawrence Island. The balls are formed of pieced and appliqued scraps of bleached sealskin and other skins of contrasting colors, and are ornamented

Right — *Gut parkas, made from marine mammal intestine and windpipe, hang on a line on Nunivak Island. With properly sewn seams, these garments, which are still occasionally used, are completely waterproof. (Steve McCutcheon)*

Purses such as this one, made on Saint Lawrence Island in 1927, were produced primarily for trade or sale. The purse, designed to be worn on a belt, is decorated with reindeer-hair embroidery and beads. Today, only a few Siberian Yupik women experiment with these intricate embroidery techniques. (Collection of University of Alaska Museum; photo by Lael Morgan, staff)

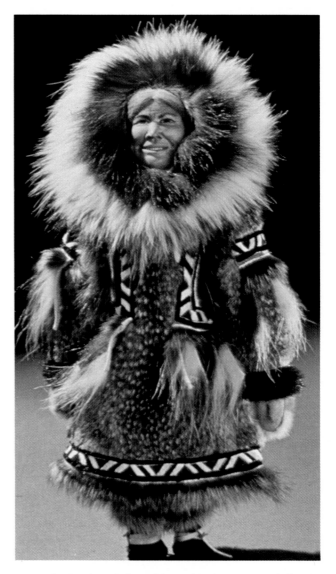

The late Alice Moore of Twin Hills poses with two wood-faced dolls she made. This style of doll, with many individual variations, is characteristic of many villages in southwest Alaska. (Lael Morgan, staff)

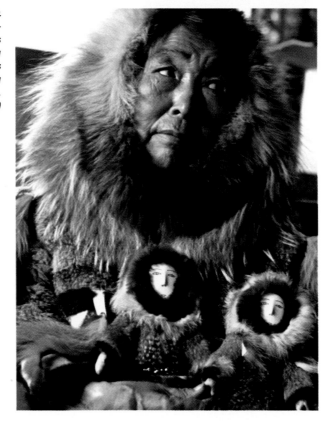

Award-winning doll-maker Dolly Spencer, originally from Kotzebue, created this lifelike figure representing a lady from above the Arctic Circle. The doll is dressed in a very detailed "fancy" parka with pieced calfskin trim and a wolverine ruff. 15¾" tall. (Photo by Chris Arend; courtesy of Alaska State Council on the Arts)

with animal-shaped appliques and strips of brightly dyed unborn seal hair. One King Islander recalls hitting these balls with a bone bat when he was young.

Dollmaking, an Eskimo art form at least 2,000 years old, is often the shared activity of women and men. Dolls were probably originally made for play, a means of allowing Eskimo girls to acquaint themselves with adult lifestyles — "playing house" is the term used in Western culture. Yupik lore today tells of past taboos on how and when young girls were allowed to play with their dolls.

Anaktuvuk-style caribou skin masks represent an unusual innovation in skin sewing. The masks began as a variation on Halloween masks, created by two trappers from Anaktuvuk Pass in the early 1950s. The earliest masks were carved from wood, but caribou skin stretched and dried over a wooden facial mold with pieced and sewn ruff and features soon became a more popular, time-saving method of production. Both women and men make the masks, and at least one woman has expanded the concept to include large dolls with masklike faces. Making masks became the primary economic activity in Anaktuvuk Pass for some time after their invention, but access to local construction jobs and a scarcity of caribou hides have slowed production of these masks.

Basketry

Basketmakers carefully pick rye grass in the fall and spring. Each stalk is individually chosen, and hung in large bundles on the sides of village dwellings and caches to dry. Traditionally, grass was used for many purposes: woven mats, bags and partitions were made for the home; grass socks and boot-sole liners provided warmth and insulation for hunters and travelers. Grass continues to be an important

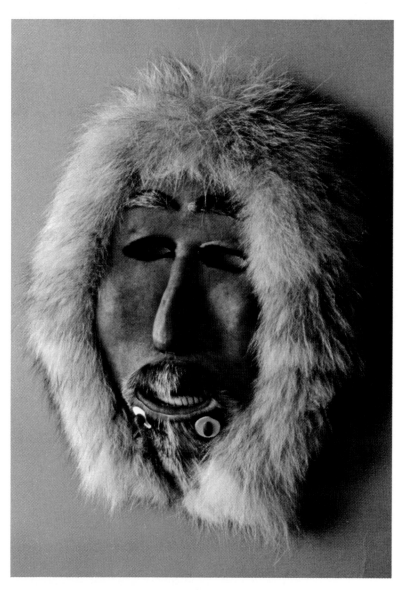

This mask created by Susie Paneak is an example of the Anaktuvuk-style caribou-skin mask, which originated in the early 1950s. The skin is stretched and dried over a wooden face mold, then fur trim and features are added. 19" x 16".
(Anchorage Museum)

Twining is an ancient basketmaking technique, still used for utilitarian containers. This issran from Quinhagak may be used as a backpack or as a container for such items as eggs or fish. (Lael Morgan, staff)

functional and symbolic material as well as the raw material for grass basketry, particularly in southwest Alaska. Native legends deal with the treatment of grass and its symbolic importance in providing both warmth and light.

Eskimo women use two basketmaking techniques common all over the world: twining and coiling. Twined baskets begin with a foundation of grass warp (vertical) strands which will eventually provide support for the bottom and sides of the piece. Two or three separate strands of grass weft at a time are then woven horizontally through the warp, twisting tightly around each vertical strand. Variations on the basic twined stitch result in interesting textures or areas of lacy open-twining. Twining, probably the oldest form of weaving practiced by Bering Sea Eskimos, is used primarily for more functional containers and mats. Twined grass bags are said to be capable of transporting loads of up to 100 pounds.

Coiled grass baskets are produced by working with a bundle of compressed parallel grass

Contemporary Eskimo basketmakers often incorporate bright colors and pictorial designs into their work. The grass basket with butterflies and chevrons was made by Jane Oscar of Tununak; the dance fans, rimmed with wolf fur, possibly came from Toksook Bay. (Alaska Native Arts & Crafts Association)

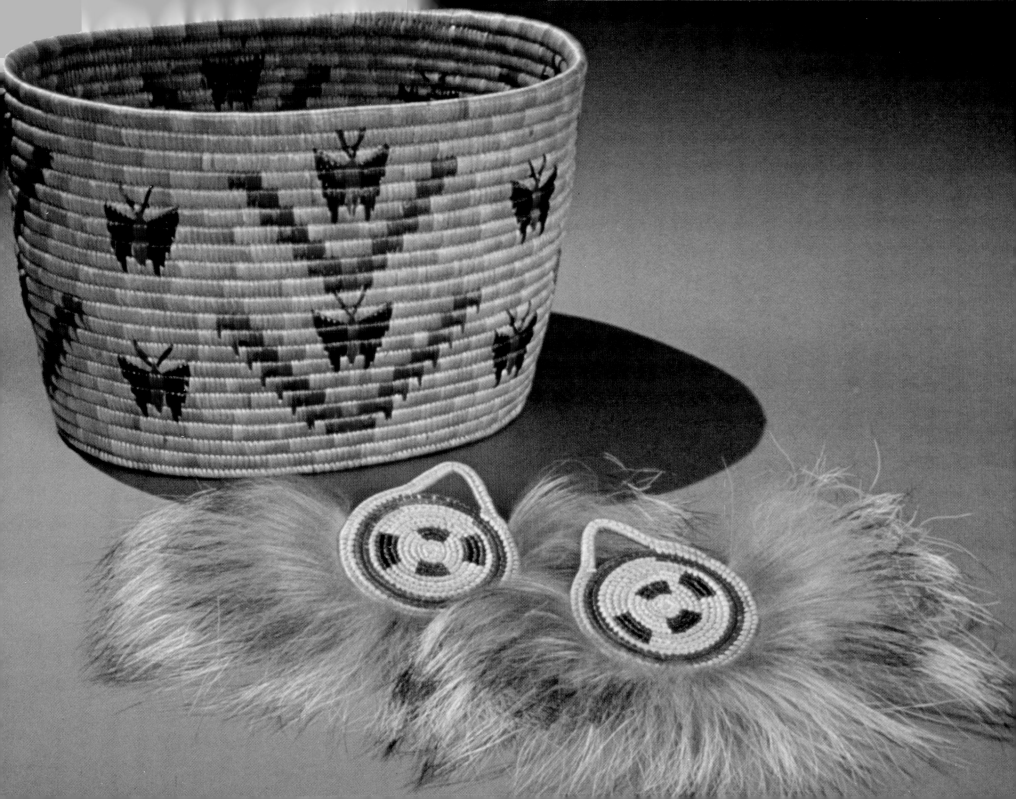

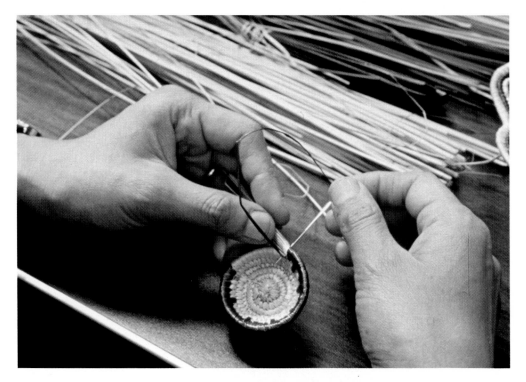

Yupik basketmaker Jeanette Trumbly wraps a strand of dyed grass around a small bundle of grass — a technique known as coiling. (Photo by Sam Kimura; courtesy of Alaska State Council on the Arts)

production of coiled basketry was confined to a fairly limited area and described the baskets as being of poor quality. Teachers and traders in the early 1900s seem to have instigated an upsurge in the manufacture of coiled grass baskets, popular with northern women for only a short time but a mainstay of Yupik artwork to this day, at least in some villages.

Pictorial designs on baskets became popular in the 1930s. These designs generally avoided mythological subjects, embracing simpler themes such as flowers, birds, insects and scenes of village life. Complex geometric patterns were, and still are, also used frequently.

Geometric motifs are sometimes symbolic, reflecting the traditional values of Yupik women and expressing a striving for harmony which is present in the culture as a whole. Basketmaking is also seen as a path to greater confidence and patience: first imparting frustration, then skill and finally accomplishment to the women who practice the art.

Many basketmakers use commercial dyes to color their grasses, but since basketry is undergoing a boom and becoming quite competitive, there seems to be a movement to return to natural dyes, which are less harsh and more varied in hue. Rita Blumenstein, a basketmaker originally from Tununak, has lectured and taught workshops in the use of natural dyes, introducing her students to the vibrant colors which can be obtained from onion skins, iris petals, blueberries and many other sources. Some basketmakers incorporate raffia and other non-traditional materials into their designs, although such elements are rarely used by the best artists.

Surface design, type of knob, overall shape and width of the coil indicate a coiled grass basket's origin. Baskets with fine coils are

stems which coils around itself, providing its own support. Vertical grass stitches join the coils and provide a smooth wrap for the bundles. Properly coiled baskets make extremely rigid containers, and the smooth, flat coils provide a perfect surface on which to work out bold and complex geometric or pictorial motifs.

Fragments of coiled baskets have been found only rarely in archaeological sites, and Edward W. Nelson, during his travels in southwest Alaska in the late 19th century, noted that

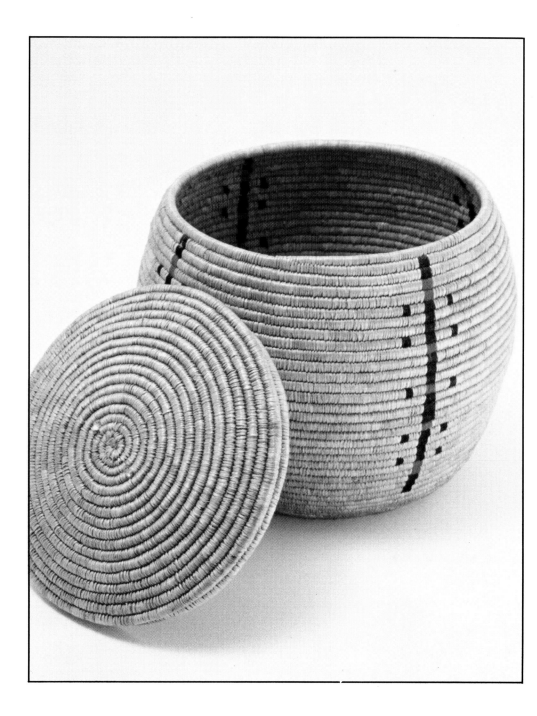

Left — *This finely coiled grass basket with lid is decorated with a simple geometric design in red and blue thread. The basket was collected at Point Barrow in the early 1900s. 7" high.* (Collection of the Newark Museum, 14.247 a, b; photo courtesy of Anchorage Museum)

Below — *Katherine Cleveland of Ambler crafted these plaited birch-bark baskets, alternating light and dark strips of bark.* (Janet Klein)

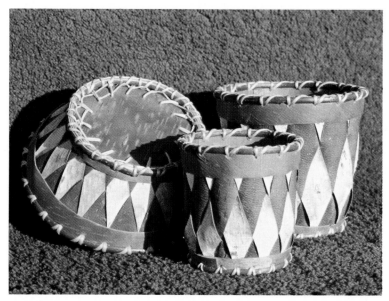

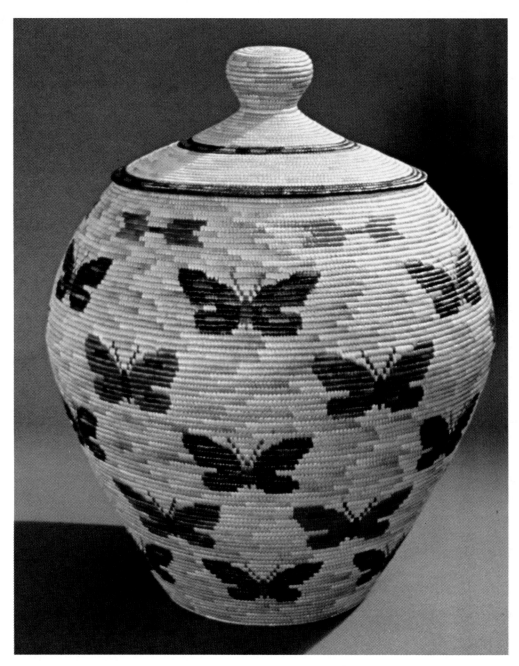

Above — *Artist Maude Weston of Mekoryuk shows off some of the dance fans and baskets she has made. (Alissa Crandall)*

Right — *This coiled grass basket decorated with butterflies and arrows was made by Cecelia Andrews of Chevak, and is in the collection of the Alaska Contemporary Art Bank. (Photo by Chris Arend; courtesy of Alaska State Council on the Arts)*

Left — *A woman in Kongiganak carries a bundle of seal intestine, inflated to allow it to dry. After being cut into strips and dyed, the intestine will be used to decorate baskets and grass dolls.* (Photo by Rob Stapleton; courtesy of Alaska State Council on the Arts)

Below — *Pieces of dyed seal intestine and dyed and natural grass will be used to make colorful baskets.* (Photo by Rob Stapleton; courtesy of Alaska State Council on the Arts)

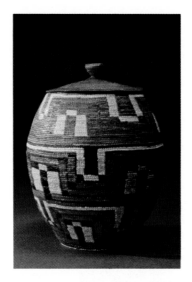

This covered grass basket made by Cecilia M. Olson of Hooper Bay was part of the 1977 Alaska Festival of Native Arts at the Anchorage Museum. (Photo by Sam Kimura; courtesy of Alaska State Council on the Arts)

generally from Hooper Bay and are extremely popular, although wide, flat, even coils with bold geometric designs are equally appealing. Basketmakers in several villages combine dyed grass with strips of dyed seal gut to form their designs. A few women also make coiled grass dolls.

Currently, Yupik Eskimo grass basketry rivals ivory carving as a popular medium for collectors and investors. Traditional grass baskets are often prizewinners at The Anchorage Museum's annual craft show, "Earth, Fire and Fiber." The Alaska Treatment Center in Anchorage sponsors an annual basket sale, selling hundreds of quality baskets. Fine examples of baskets are also for sale at the gift shop of the Alaska Native Medical Center in Anchorage.

Fragments of birch-bark baskets more than 2,000 years old have been unearthed in Kachemak Bay Eskimo sites and as far north as the Ipiutak site at Point Hope. Historically, the Kobuk River and parts of the Norton Sound region were the centers of birch-bark basketry among Alaskan Eskimos. Most baskets were made by folding and stitching bark sheets into shapes similar to baskets made by Athabascan Indians who lived nearby. Birch-bark baskets are still made in some Eskimo communities. One particularly dramatic style of basket made today by Eskimos along the Kobuk River is the plaited birch-bark basket — bowls and cylinders are woven of alternating light and dark bark strips. Traditionally, these baskets were used to hold berries, as water dippers and for other household uses.

Northern Eskimos in recent times have made an interesting type of basket from baleen. Baleen comes from the mouth of bowhead and other baleen whales, where it hangs down from either side of the animal's gums, forming a fringe which traps and sifts the whale's diet of plankton. Nineteenth-century whalers prized the strong yet malleable baleen, which they sold for manufacture into corset stays, umbrella ribs and other vanities. Aboriginal baleen artifacts include buckets and ice scoops. Baleen was also used traditionally for sleds and runners, lashing, noisemakers known as wolf scarers and many other items.

When baleen is fashioned into baskets, the single rod coiling technique is used. The baleen is secured at base and lid to a starter piece or finial, generally made of ivory. To prepare the baleen for basketry, it must be tediously soaked, split and scraped.

Baleen basketry developed early in this century in Barrow at the request of a local trader. Although it was a man's craft at the beginning, the art is now practiced by some women.

According to Molly Lee, author of a major study on baleen basketry, Kinguktuk of Barrow was the first baleen basketmaker. He apparently remained the only person pursuing the art until the early 1930s when he taught other men; innovation in baleen basketry quickly followed and spread to several other northern communities. Today, less than a dozen artists practice the craft, only a few of them young people.

Objects Made of Wood

Although no trees grow in most of the regions inhabited by Eskimos, driftwood is abundant along the coast. Consequently, driftwood has been used throughout the years to create an incredible array of objects, ranging from functional household items to elaborate ceremonial paraphernalia. Bowls, trays, ladles and toolboxes were carved from wood, painted with red coloring and decorated with mythological

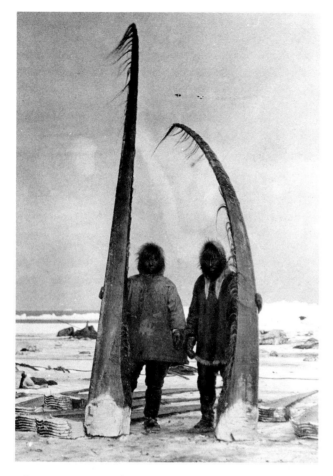

Above — *Two Eskimos at Barrow pose with enormous plates of baleen, taken from the mouth of a whale. Baleen was prized in the 19th century for use as corset stays, umbrella ribs and other items. Native uses included buckets, scoops, sled runners and lashing. Baskets coiled of thin strips of baleen were first made in the early 1900s; only a few baleen basketmakers still practice the craft.* (The ALASKA SPORTSMAN®)

Right — *This mask, created by well-known King Island artist Sylvester Ayek, is a modern interpretation, done in baleen, ivory and wood, of an older piece. 25" x 21".* (Anchorage Museum)

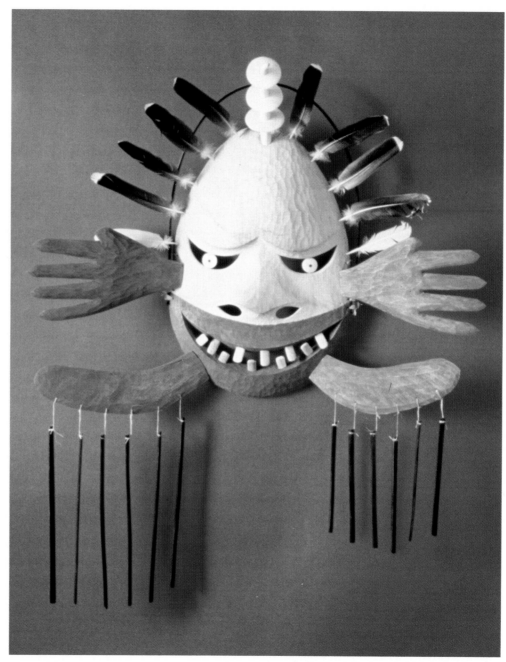

Wooden containers were an important part of traditional Eskimo art. The large red box is fitted with five compartments designed to contain many smaller objects, and resembles a western steamer trunk. The box on the right is said to represent a walrus floating on its back; the seal-shaped box in the foreground portrays a seal in the same position, complete with inua in the form of a humanlike face. The ivory-inlaid bentwood work box (left) is a superb example of the skill of Bering Sea artists. Red box, 15½" long; walrus, 13½" long; seal, 7½" long; work box, 9" long. (Smithsonian Institution; 83-10711)

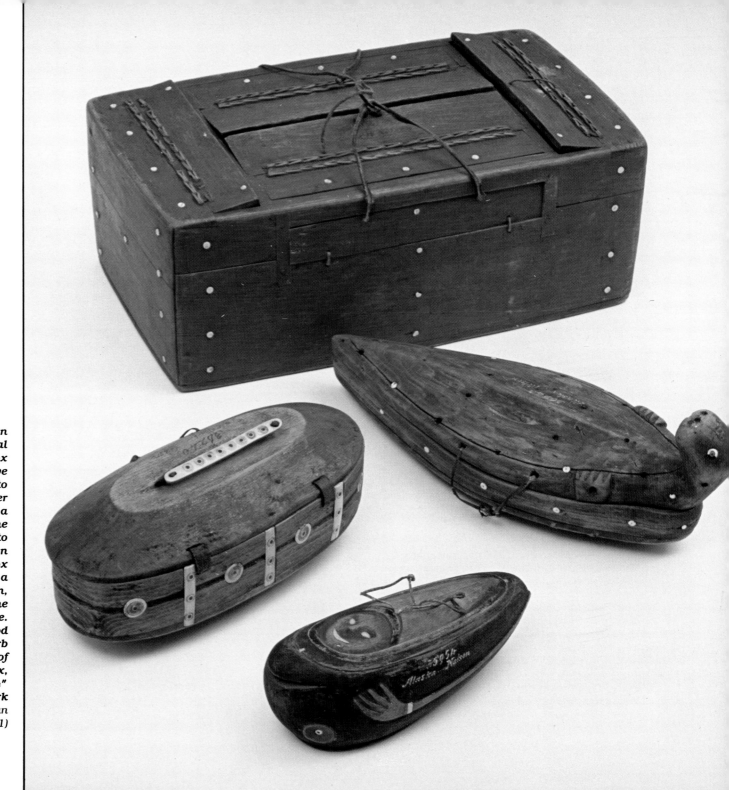

animals or marks of ownership. Complex wooden masks were made, particularly along the coast of southwest Alaska, for use in dances, ceremonies and shamanistic performances. Since wood was thought to have magical properties, wooden charms were commonly used — a miniature wooden whale kept secretly in the *umiak* might, for example, be a charm for success in whaling; or an appropriate wooden amulet might be carved for a woman to enhance her fertility or assist her in successful childbirth.

There is a tradition of monumental wooden sculpture in southwest Alaska in the form of effigy monuments, constructed in memory of the dead and placed in graveyards. Such monuments were of two types: one was a pole supporting an animal figure or revealing a carved human face; the other was a board on which hung masklike faces or entire carved human figures. Fortunately, sketches and photographs of these mortuary sculptures exist, for many were completely destroyed or taken by collectors in historic times and none are left standing today.

The complex Eskimo masks made during the 19th century rank among the finest tribal art in the world. Mask making and the ceremonialism which accompanied it were highly developed and practiced widely by the time the first Russians established trading posts in southwest Alaska, in the early 1800s.

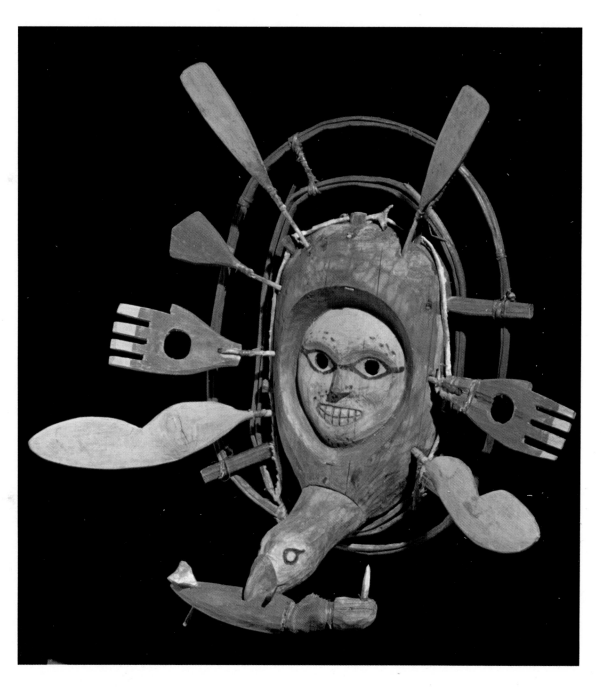

This powerful Yupik mask was collected by Edward W. Nelson somewhere south of the Lower Yukon in the late 19th century. It is said to represent a spirit-hunter acting through the body of a horned puffin. The holes in his hands, which allow some of the hunted animals to slip through, symbolize the hunter's compassion for his prey. 11" wide. (Smithsonian Institution; 83-10691)

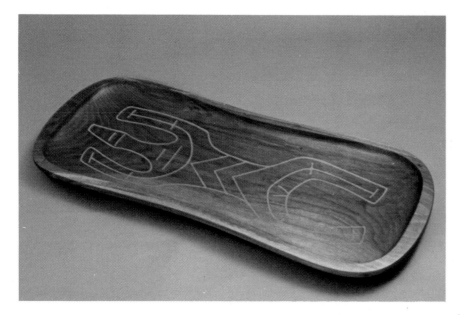

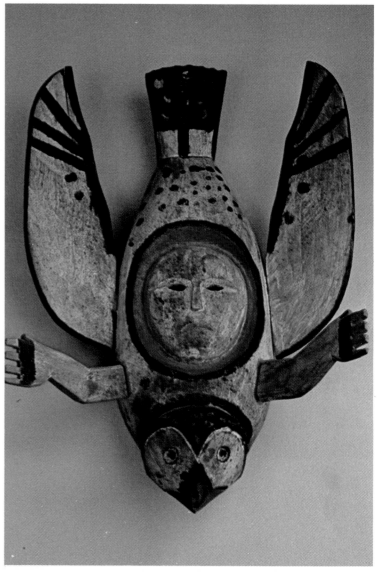

Inupiat artist Ronald Senungetuk incorporates traditional motifs into this contemporary wooden tray, "Silver Salmon Platter #2," which was part of the Anchorage Museum's "Earth, Fire and Fiber" exhibit in 1979. Senungetuk, chairman of the art department at the University of Alaska, Fairbanks, has been instrumental in encouraging upcoming native artists and promoting native art. 29" x 12". (Anchorage Museum)

This beautiful Yupik owl spirit mask was made in Kashunak around 1945. The owl's inua, or spirit, takes the form of a human face on the bird's back. 18" long. (University of Alaska Museum; photo by Barry McWayne)

This fine wooden Eskimo hunting hat is thought to have been made in the Norton Sound or Yukon-Kuskokwim Delta area in the early 20th century. The hat is made from one piece of wood, bent and held together with wooden braces and stitching. It is decorated with the painted figures of two identical animals, weasels or martens, one holding a fish in its mouth and the other carrying a rodent. (Anchorage Museum)

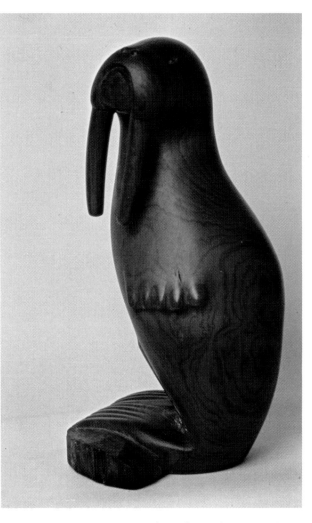

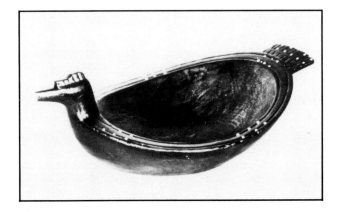

Above — *This elegant carving of a walrus was done by Rick Seeganna of Nome for a 1981 Native Art Show in Ketchikan. (Courtesy of Alaska State Council on the Arts)*

Left — *This wooden Chugach Eskimo oil dish was collected in the early 1900s at Chenega, in Prince William Sound. The merganser-shaped dish is decorated with small white beads set into the rim. 14½" x 10". (Alaska State Museum)*

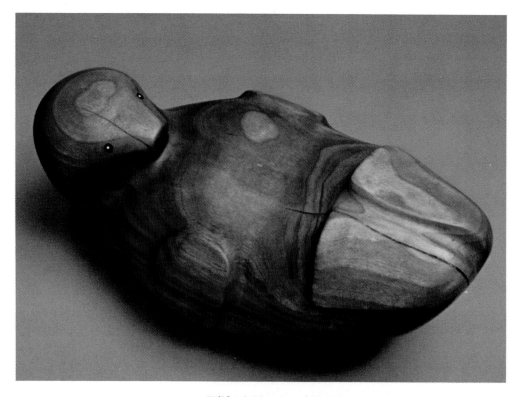

Wilfred Olanna of Shishmaref carved this stylized seal from wood, adding eyes inset in ivory. The seal is depicted lying on its back, a pose common with Bering Sea artists of the 19th century. 13" x 7½". (Anchorage Museum; photo by Sam Kimura)

Traders, missionaries and finally the gold rush had a strong impact on traditional Eskimo ways, and by the early part of this century masks were made much less frequently and were rarely made for ceremonial use.

These Eskimo masks are powerful and beautiful, even when separated from their traditional purpose. Each one has a distinct identity and meaning. Today, older carvers from several regions agree, even though they carve masks primarily for sale, that masks represent only a surface element in a sea of ceremony and traditional belief, and that they should be regarded as inseparable from their original function as part of dance and ceremony.

During certain ceremonies, the shaman used masks, sometimes in conjunction with wooden puppets, in ways that frightened and entertained participants. Dancers wore religious masks in festivals which honored the spirits of animals and birds to be hunted or who needed to be appeased. Each spirit was interpreted visually in a different mask, and each mask was thought to have a spirit, or *inua,* of its own. This *inua* tied the mask to the stream of spiritual beliefs present in Eskimo religion. Not all masks were benign; some were surrealistic pieces which represented angry or dangerous spirits.

Masks were a way of bridging the chasm between daily life and the fears and mysteries we all must confront. In some cases, whether it was comforting or not, a fear might reveal its name, spirit and visage in the form of an unforgettable mask. These masks, perhaps more than any other historic art form, illustrated the complexity of the Eskimo system of beliefs.

Mask making, although not necessarily for ceremonial purposes, has remained popular in some regions, notably among King Islanders, on Nunivak Island and in other areas of southwest Alaska. Eskimo dance is undergoing a revival today, however, and carvers are making masks for traditional purposes again. For example, a mask making workshop followed by the performance of masked dances was organized by the Bethel Native Dancers in 1982. Specific instructions as to the masks to be carved were given by a man acting on behalf of the traditional shaman. The masks, each representing an important personal vision, were carved and the dance successfully performed.

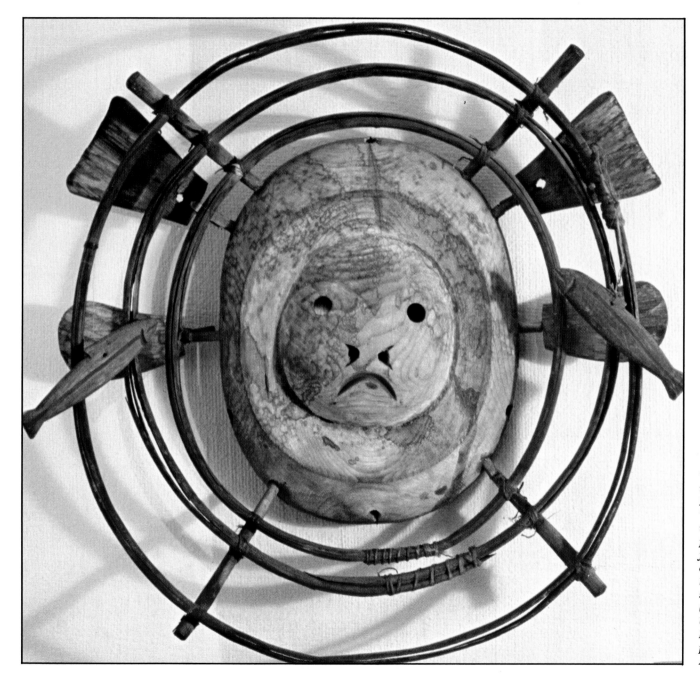

This wooden seal mask was collected on Nunivak Island in 1917. The mask is painted with faded red and blue pigments; flipper and fish appendages are attached to wooden hoops surrounding the seal's face. 15" x 13¾". (The University Museum, University of Pennsylvania, NA 6384; photo courtesy of Anchorage Museum)

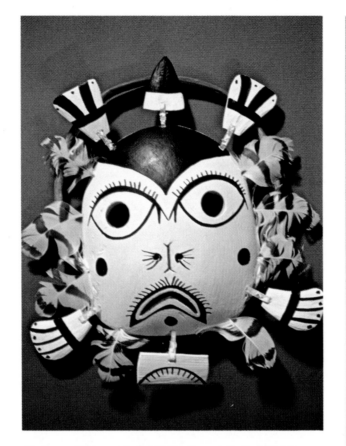

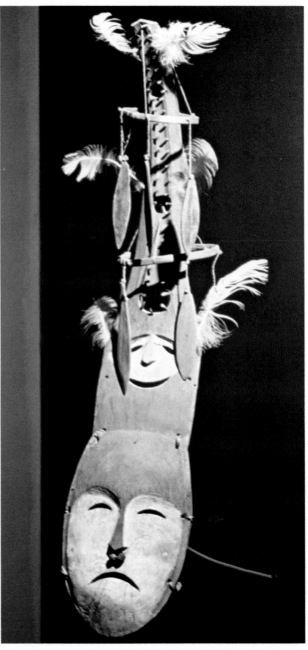

Above — *This seal spirit mask, made in 1974 by Chevak elder Joe Friday, combines traditional materials — wood and owl feathers — with one not-so-traditional — plastic. 12" long.* (University of Alaska Museum; photo by Barry McWayne)

Right — *This intricate mask, collected at Andreafsky by Sheldon Jackson in 1893, is made up of two faces topped by an elaborate headdress. The mask is decorated with white, red and green pigment, eagle down and trade beads. The form of the face closely resembles Ingalik Athabascan masks and is said to represent the dual faces of a shaman. 28" high.* (Sheldon Jackson Museum, an Alaska State Museum; photo courtesy of Anchorage Museum)

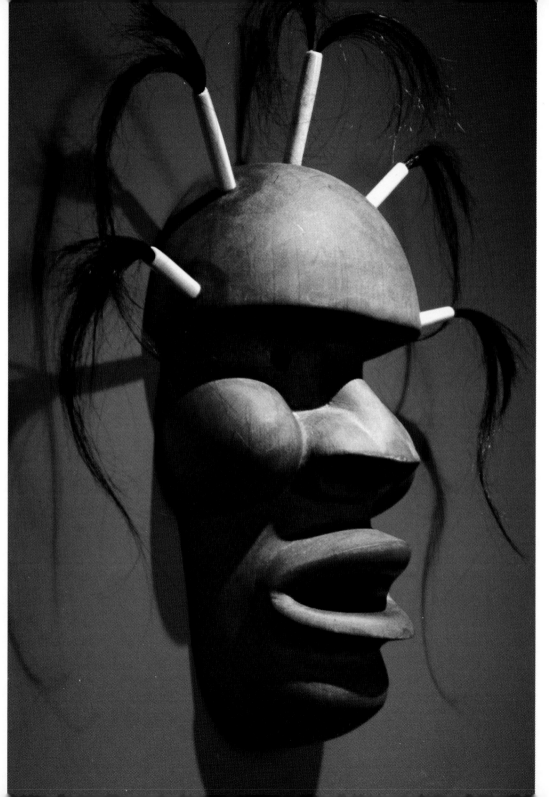

This wooden mask trimmed with human hair was carved by Joe Senungetuk, originally from Wales, at the western tip of the Seward Peninsula. Senungetuk is an accomplished Inupiat artist and writer. 15" x 14½".
(Anchorage Museum)

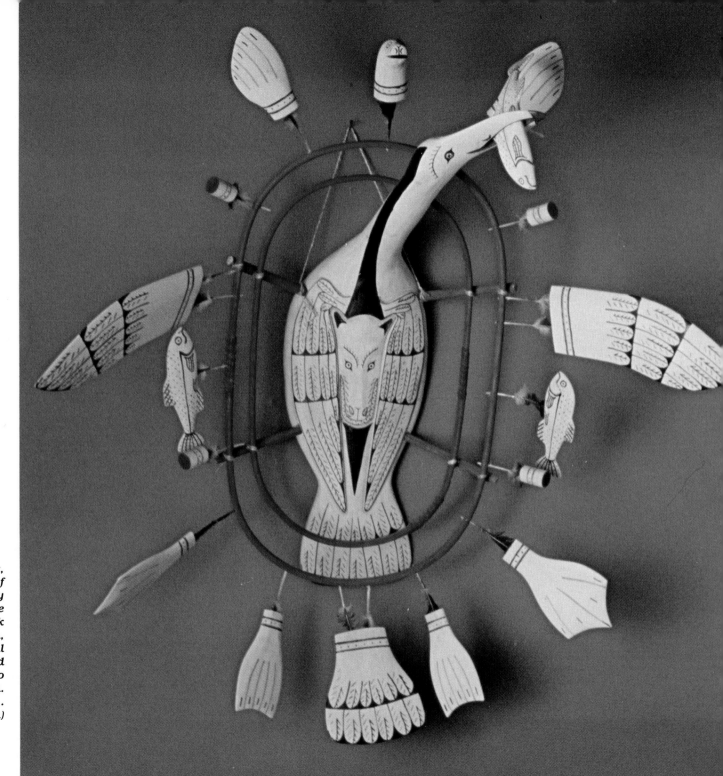

This traditional loon mask, by Peter Luke Smith of Mekoryuk, is surrounded by appendages and oval ochre rings. Although this mask was not made to be worn, appendages on traditional masks of this type would have moved up and down to a dancer's rhythm. 31" x 29½". (Anchorage Museum)

Too many fine mask makers exist to name them all here, but a few should be mentioned. Frank Ellanna and Paul Tiulana, King Island elders, and several of their contemporaries, still make walrus and raven masks, which are made to be worn. Sylvester Ayek, also of King Island, makes excellent wood and ivory masks, sometimes borrowing from Yupik motifs, and incorporates an assortment of materials into his work. Nick Charles, Yupik elder who lives in Bethel, is a fine traditonal mask maker, and John Kailukiak, also Yupik, is a painter and exceptional mask maker.

Peter Luke Smith and Edward Kiokun, both from Mekoryuk on Nunivak Island, specialize in making large masks which are carved and painted meticulously in traditional style. These masks generally feature a powerful central motif — an animal, or a bird such as a loon. Sometimes an *inua*, or spirit, in the form of a small semi-human face, is carved into some portion of the larger figure. Masks of this type are surrounded with bent and painted wooden hoops and symbolic carved appendages. Kay Hendrickson, also from Nunivak, has become famous for his carved wooden dance sticks. Sadly, one of the most imaginative contemporary mask makers, Yupik artist Sam Fox of Dillingham, was killed in an accident in 1983.

Prints, Paintings and Other Media

Pictorial engraving among Eskimos, culminating in the elaborate drill bows of the 19th century and the engravings of Happy Jack and his peers in the early 1900s, first appear in the archaeological record more than 1,000 years ago. Until recently, however, few Eskimo artists had made a transition from engraving on ivory to painting, drawing or printmaking.

A few older men are well known for painting

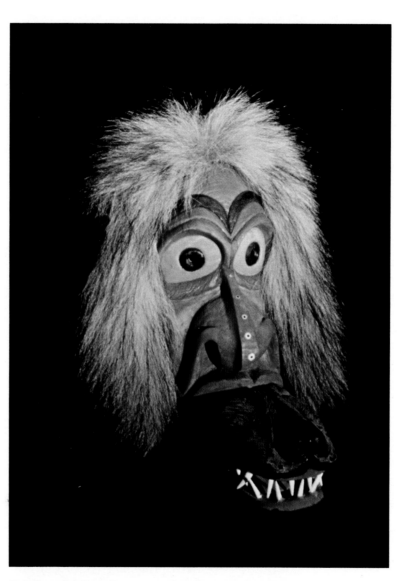

Yupik artist Sam Fox was a leading mask maker who also worked in several other media until his untimely death in 1983. Fox was not one to draw attention to his own work, but the creativity and elaboration on traditional themes inherent in his pieces now provides others with inspiration and enjoyment. (Anchorage Museum)

The late Florence Malewotkuk of Gambell did many drawings depicting life on Saint Lawrence Island for Otto Geist during his expedition of 1927-28. "Walrus on Ice Floe" is done in ink on winter-bleached sealskin. 53" x 40¾". (Anchorage Museum; photo by Sam Kimura)

or drawing on animal hides. George Ahgupuk, originally from Shishmaref, and Milo Minock of Pilot Station are two of these artists. Ahgupuk produces many small pieces for the tourist trade, and has at times executed some graphic, highly detailed depictions of Eskimo life which are becoming collector's items.

The work of the late Kivetoruk Moses of Nome has drawn considerable attention from art historians. His technique combines drawing, India ink and watercolor; his style is primitive; and his subject matter consists primarily of historic and ceremonial events. Moses's work is often so detailed that it provides an accurate visual record of a past that only an elder could know.

Most of the artists who have painted or done printmaking in the past (Joseph Senungetuk,

The late Kivetoruk Moses, well-known for his primitive style and attention to detail, based his paintings on events from his life. This scene tells of a man invoking the spirit of a dead woman who tells him that his son, who has drifted out to sea, is alive and will return soon. (Yvonne Mozee, courtesy of Father James Poole; reprinted from The ALASKA JOURNAL®)

King Island carver and printmaker Bernard Katexac of Nome created a series of four woodcuts of traditional Inupiat life. This print is "Summer," from Seasons of the Arctic. *24" x 20½".* (Anchorage Museum)

Bernard Katexac and Melvin Olanna were probably the most prolific) are not doing so regularly at this time. This may be, in part, because these activities require studios, or at least access to such space and equipment at times, whereas the carving of even large objects can be done in a smaller space. In addition, carving is more traditional and comfortable to many Eskimo artists.

Stone and whale bone are the materials most commonly used for larger sculpture. Whale bone masks similar to those used in the past in conjunction with burials are carved for sale now in the villages of Point Hope and Kivalina. Whale bone and walrus jawbone are often used for small sculpture in Gambell on Saint Lawrence Island.

In Shishmaref, the use of whale bone for sculpture has begun to evolve into a village style. Generally scavenged from the beach, whale bone has become scarce near Shishmaref because it is in such demand. It is bought, sold and traded among villagers, even those who do not carve. Several Shishmaref artists took part in a 1971 program sponsored by Community Enterprise Development Corporation in which they were exposed to the large stone sculpture and marketing techniques of Canadian Eskimos. Whatever may have been learned during this period did not immediately take hold, but at the request of traders in the late 1970s, perhaps combined with some degree of saturation in the ivory market, several men began carving large whale bone sculptures and continue to do so today. Notably, these artists include Alvin and Harvey Pootoogooluk, and Melvin Olanna. Olanna, skilled in several media, has been awarded major public commissions in Nome, Fairbanks and Anchorage. One such completed work features a life-sized whale bone figure as its central motif.

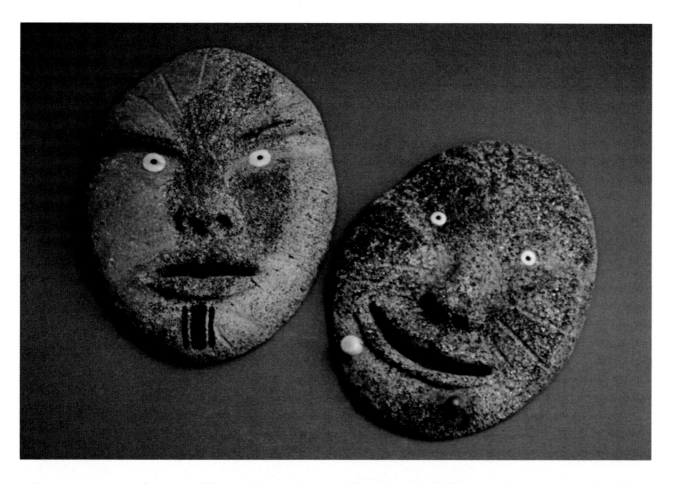

Stone was not often used for traditional art among Inupiat or Yupik Eskimos. Today, soapstone carvings, sometimes of exceptional quality, are made by a few artists, but most do not like working in the medium because of the dust and mess it creates. Artists who have had access to alabaster, including John Kailukiak, Melvin Olanna, John Penatac and Larry Ahvakana, have used it effectively. The light color of this material highlights the simple, sinuous forms often used to portray Eskimo dancers or marine mammals in sculpture.

These two whale bone masks were carved by father and son Johnny Evak and Johnny Evak, Jr., of Kotzebue. Both masks have ivory eyes; the face on the left has a tattooed chin; the other, an ivory labret. Whale bone masks are made in only a few northern villages, primarily Kivalina and Point Hope. Both, 8" x 6". (Anchorage Museum; photo by Sam Kimura)

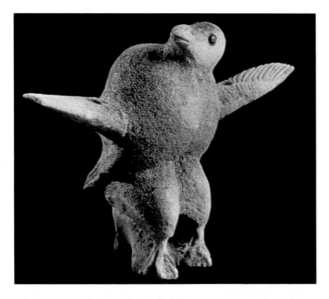

Above — *This dancing bird figure was produced from whale bone by Bert Kuzaguk of Shishmaref. Many Shishmaref residents now scavenge for beach-found whale bone, which is fast becoming scarce because of its popularity with local carvers.* (Alaska Native Arts & Crafts Association)

Right — *John Sinnok of Shishmaref carved this stylized owl from whale bone, a medium of recently renewed popularity among artists of the region.* (Alaska Native Arts & Crafts Association)

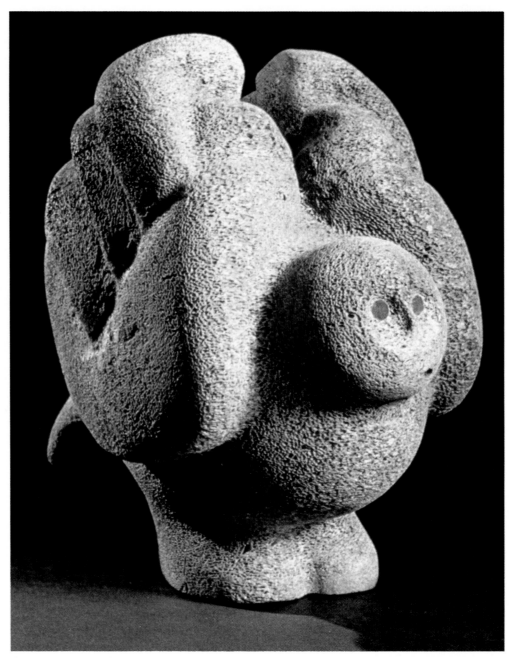

Left — *Harvey Pootoogooluk and members of his family show pieces of recent whale bone sculpture at his home in Shishmaref. Whale bone carving underwent a strong revival in 1978 and 1979 in that village. Now at least a dozen men and women pursue the art.* (Susan W. Fair)

Below — *Sculptor Larry Ahvakana of Barrow is well-known for his work in alabaster. This figure, titled "Seated Man," was part of the 1977 Alaska Festival of Native Arts at the Anchorage Museum.* (Photo by Sam Kimura; courtesy of Alaska State Council on the Arts)

The Athabascans

Alaskan Athabascans speak many distinct languages, all a part of the greater Na-Dene linguistic family. These include Kutchin, Koyukon, Holikachuk, Ingalik, Upper Kuskokwim, Tanaina, Ahtna, Tanana, Han, Tanacross and Upper Tanana; and Eyak, a distant relative. This large and widespread language family includes the Navajo and Apache of the American Southwest and 13 Northwest Coast and California tribes, in addition to the Athabascans of western Canada and Alaska.

Ancestors of present day Na-Dene speakers probably migrated across Beringia about 12,000 years ago. These early Athabascans settled in a tundra environment which slowly became forested as glaciers receded. Although precise development of Athabascan culture is uncertain, some of the people apparently migrated south, perhaps around A.D. 700, diversifying and adapting to the other cultures with which they come in contact. Others remained in the northern (boreal) forest, establishing a way of life still practiced by many modern Athabascans.

Traditionally, northern Athabascans were members of small localized groups or regional bands. These bands had no particular political cohesion, but were based instead on common language, ties of blood and marriage and the availabiltiy of food. People stayed together when they could work productively as a unit, perhaps during the summer salmon season or on a caribou hunt. In historic times, groups

Athabascan women make colorful beaded straps for carrying babies on their backs. This baby strap, made by Hannah Solomon of Fort Yukon, is beaded on home-tanned moosehide and decorated with bead and yarn tassles. (Institute of Alaska Native Arts; photo by Rose Atuk Fosdick)

"I remember Grandma always used to preach to me, like when she was teaching me how to sew, she always said: 'Now when you sew, you just do the best job you can, even if it's in a place where it's not going to be visible from the outside. If you sew something for somebody and it goes to another village, the people there are going to turn it inside-out and look to see how well it's done.' "

Eliza Jones,
The Athabaskans: People of the Boreal Forest

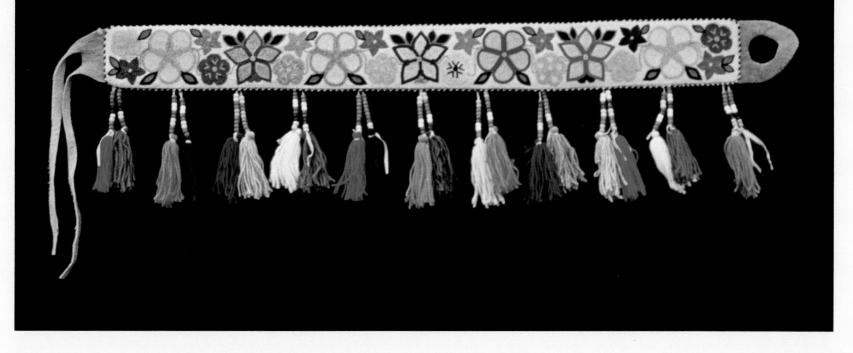

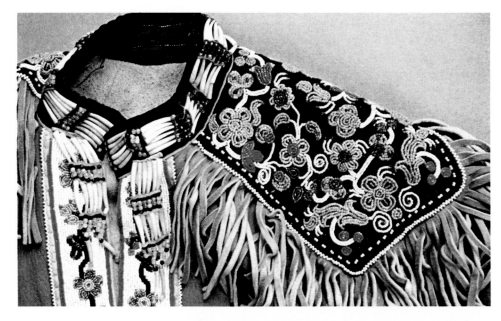

This closeup of the yoke of an Athabascan chief's jacket shows the elaborate decorations: dentalium shells ring the collar, and complex beadwork and leather fringe further ornament the jacket.
(University of Alaska Museum, photo by Barry McWayne; reprinted from The ALASKA JOURNAL®)

became great traders, bringing to their families and neighbors items of Western technology which they acquired from Eskimos to the north, and prized ornaments such as dentalium shells from the Pacific Northwest.

Today, most Alaskan Athabascans inhabit the boreal forest. This ecosystem, characterized by stands of birch, spruce and aspen interspersed with areas of muskeg and willow and alder thickets, stretches from interior Alaska across Canada and down into the northeastern United States.

Game animals such as moose, bear and snowshoe hare inhabit this forest; higher elevations support Dall sheep and caribou. Furbearing animals — beaver, muskrat, wolverine, marten, otter and mink — are trapped by the Athabascans. Several species of fish, including salmon, are also important.

Athabascan technology reflects the genius of thousands of years of adaptation to the northern environment. Snowshoe-making and the building of dogsleds reached a high degree of craftsmanship. Fish and game were taken with traps and snares, such as the fish trap (not the fish wheel, which is not an aboriginal invention) which funnels fish into a basketlike enclosure, where they remain until someone empties the trap.

Traditionally, all groups used bow and arrow to hunt land animals, though this weapon has been replaced today with rifles and shotguns. The Tanaina used Eskimo-style kayaks in addition to their birch-bark canoes, while Athabascans in other regions traveled or hunted in birch-bark canoes, rafts and skin-covered boats.

Although houses today in most Athabascan settlements are log cabins constructed of locally cut spruce, native log structures apparently were not common in most areas prior to white

often gathered near trading posts. When times were lean these bands split up into smaller groups or even into single family units to ensure success in finding game.

Bands, families and individual hunters were influenced by other cultures they encountered while they traveled and hunted. The Tanaina, who lived along the coast of Cook Inlet and in the Susitna River basin, hunted marine mammals with kayaks and harpoons, technology probably adapted from nearby Eskimos. The Ingalik and Holikachuk people of the lower Yukon and Innoko rivers shared at least one major ceremony, the Doll Dance, with their Eskimo neighbors downriver. The Kutchin

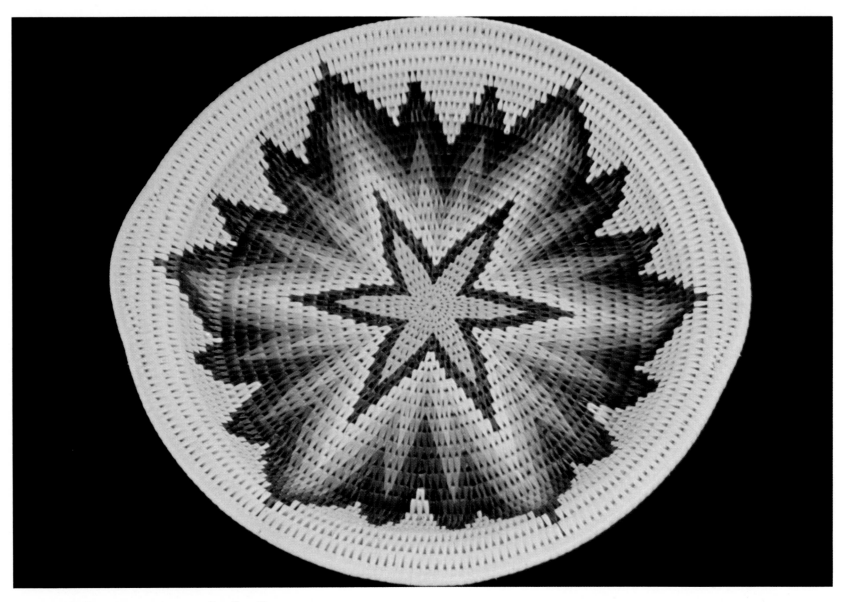

*Sturdy coiled baskets and trays of split willow root
are made today only by Ingalik Athabascan
women. Roots are dyed bright colors for use in bold
central patterns, as on this tray woven by
Edna Deacon of Grayling. (Anchorage Museum)*

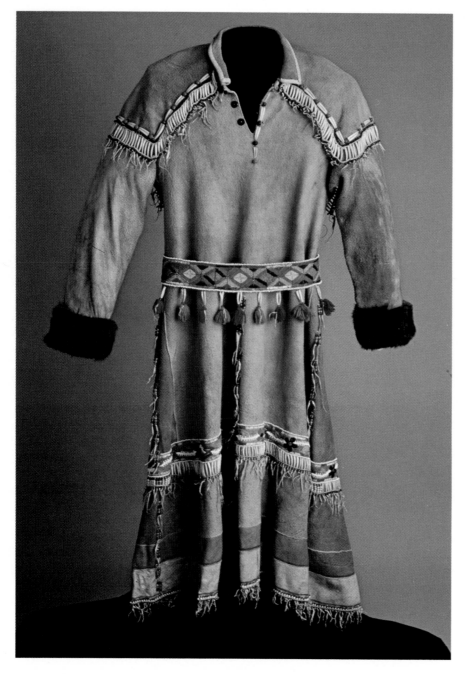

contact. Historically, the Tanaina and Ingalik lived in permanent settlements. Several families resided together in large semi-subterranean dwellings made of planked or split wood and sod. Shelves and benches lined the insides of these houses; grass mats covered the walls and doors. The Ingalik also constructed a *kazgi,* or ceremonial house, which they had probably adapted from Eskimos who lived nearby.

Most northern Athabascan homes were built on a much smaller scale than those of the Tanaina and Ingalik, generally reflecting the mobility of their lifestyle. The Kutchin, for example, used two major dwellings. The first, a domed skin shelter called a *nivaze* by Peel River Kutchin, was designed to be carried from camp to camp and was occupied between January and May. Two families generally built and lived in the tent, which consisted of a spruce pole framework covered with moose or caribou hides. Outside, the walls were partially insulated with snow; inside, a dirt fireplace raised one or two feet in the center radiated heat.

The Kutchin also built a two-family moss house, which served as a permanent dwelling through fall and into midwinter, when most activities slowed down due to heavy snows and extreme cold. This house was constructed of logs with a gable roof and was semi-subterranean among some groups. Square chunks of moss, roots turned up, were laid on the roof and sides of the house; dirt was mounded over the moss for insulation.

This Tanana moosehide dress, made around 1910, is decorated with dentalium shells, porcupine quills, beads, yarn and buttons. (University of Alaska Museum; photo by Barry McWayne)

Other Kutchin dwellings include the thin caribou lodge, much like the *nivaze* but constructed with a hairless cover so it could be more easily transported; the birch-bark house, which was covered with birch-bark strips when appropriate skins were not available; and a true tepee made from four poles and a single caribou skin. Hunters sometimes dug out temporary ice caves for overnight use, and some groups erected ceremonial houses. Most northern Athabascan groups also constructed huts where menstruating women were isolated. Construction of these small lodges varied, but most were miniature reproductions of the *nivaze*. The late Belle Herbert, in her autobiography *Shandaa: In My Lifetime* (1982), refers as well to a single-skin traveling tent painted with ochre which was used among her people.

Winter temperatures in the boreal forest may drop as low as -70°, so well-sewn, carefully tailored and insulated clothing was essential to the survival of the northern Athabascans. Typical winter clothing might have consisted of leather trousers with attached moccasins; a long, fringed coat, sometimes with a hood; and mittens. Clothing was made from many types of animal hides, although caribou and moose were preferred. Among the Ingalik, the most common type of parka was sewn of roughly three dozen muskrat skins, though ground squirrel pelts were sometimes made into decorated parkas. The Ingalik used bear intestine and the skins of lamprey eels and dog salmon for rain and wind protection, and garments were occasionally made of swan, black duck and other bird skins. Socks and undergarments in most regions were made from the skins of the snowshoe hare, and in many areas blankets or robes twined of hare-skin strips were commonly used as bedding.

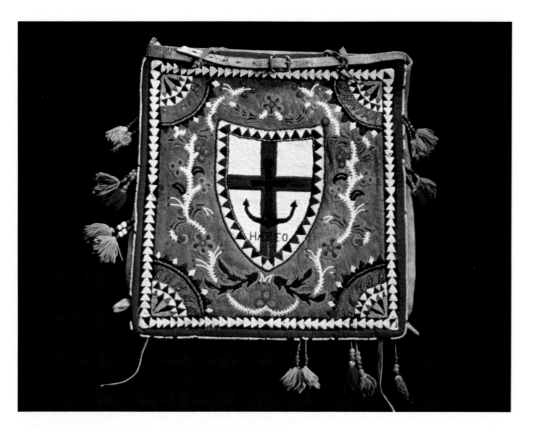

This ornate sled bag was made for Archdeacon Hudson Stuck in Arctic Village or Fort Yukon sometime before 1906. The bag is made from home-tanned moosehide, decorated with beads and yarn. It survived thousands of miles of travel with Stuck. 20¾" x 18¾". (University of Alaska Museum; photo by Barry McWayne)

Traditional clothing was beautifully tailored and decorated with leather fringes, dyed porcupine quills and dentalium shells. Cut and pieced geometric patterns of various furs decorated gores inserted into boots, at least among the Ingalik. Portions of these boots were sometimes dyed with the juice of blueberries for further ornamentation. The tiny glass beads

White and dyed porcupine quills and red pigment were used to decorate this buckskin dance apron, collected by Sheldon Jackson in the late 19th century. 50" long. (Sheldon Jackson Museum, an Alaska State Museum; photo courtesy of Anchorage Museum)

known as seed beads were not introduced until the mid-1800s, although larger trade beads had been used in some areas for several decades.

Today, according to anthropologist Richard Nelson, the extended family and the clan are still of utmost importance, and Athabascans up and downriver or from neighboring villages often refer to one another as cousins. These ties ensure cooperation in activities like the potlatch, and in the past drew people together for seasonal activities such as caribou hunting and fishing, and sometimes warfare.

The potlatch is still an important ceremony, both religious and social, to most Athabascan groups. Potlatches are sometimes held on holidays and are a time for singing and dancing, but the celebration is much more than a holiday get-together. Characterized by a large feast of traditional native foods, the potlatch is held in memory of people who have recently died, and generally involves the distribution of the belongings of the dead person as well as ritual gift giving in his honor.

The village of Nulato hosts an elaborate week-long potlatch, the Stick Dance, every two to three years. Some scholars believe the potlatch ceremony itself originated with the Tlingit Indians, but it is also possible that the tradition of the potlatch may have been shared by the two groups before they migrated to different regions, as linguistic theory and legends of Tlingit origin suggest.

Feasting and celebration occurred among most Athabascan groups when important events took place. A critical ceremony from a religious standpoint was the observance of the catching of the first king salmon every year. Traditional rituals took place at this time, ensuring that an adequate supply of salmon would reappear during the next season. The Ingalik practiced the most elaborate ceremonial

Ingalik Athabascans had an elaborate ceremonial life, similar in some ways to that of their Yupik neighbors. This mask, carved by a Holikachuk carver in the 1930s, is said to have represented "Moose-Man" in dances held during that period.
(The University Museum, University of Pennsylvania, 35.22.41)

Fairbanks sculptor Kathleen Carlo carved this contemporary fish mask from oak and spruce root. 10½" x 9½". (Barry McWayne, photo courtesy of the artist; reprinted from The ALASKA JOURNAL®)

104

life, which centered on the important ties between human beings and animals, using elaborate paraphernalia like carved wooden masks, dolls and huge wooden hoops which hung in the *kazgis.*

European goods came to most northern Athabascans through trade with other Indians and Eskimos. As soon as iron chisels, axes, knives and other items were introduced in the North, the demand for them never ceased, though the recipients might not actually have traded directly with a white man until 1772, nearly three-quarters of a century later.

Furs were the main item of trade for the Athabascans, and most contact with Alaskan Athabascans was made by Russian traders in search of furs. Russians established posts on Kodiak Island and along the shores of Cook Inlet, but relations with the Tanaina, as well as their Koniag and Chugach neighbors, were anything but peaceful. During the period from 1784 until nearly the mid-1800s, settlement patterns were disrupted as the Tanaina moved whole villages inland. The Russians also encountered the Ingalik on the lower Yukon in the early 19th century. The Ingalik had already established themselves in a trade network, exchanging their furs for trade beads, iron and copper tools and tobacco which originated in Siberia. They also traded skillfully crafted bentwood trays and bowls downriver to neighboring Eskimos in exchange for seal oil and other marine mammal products. Unfortunately, contact with the Russians brought not only coveted trade goods for most groups, but sickness, dependence on alcohol and the disruption of traditional ways. By the mid-1800's, some Athabascan groups in contact with the Russians had lost more than half their numbers, primarily to smallpox epidemics.

These Ingalik Athabascan bentwood bowls were made in Old Shageluk in the 1930s. Food bowls such as these were often traded to neighboring Eskimos, who prized them and used them for generations.
(Chuck Mobley)

From the east, English fur traders ventured north and west into Athabascan country. Hudson's Bay Company and the Northwest Company (the two merged in 1821) set up trading posts, establishing a trade network which crossed Canada. Although Athabascans in some areas, such as the Peel River Kutchin, came in contact with Hudson's Bay Company traders or members of expeditions, fur trade with the Russians continued to affect these people more than contact from the east.

Missionaries arrived on the heels of the fur traders, establishing schools and hospitals, and introducing the concept of private landownership. While some contributions of the missionaries were positive, such as improved

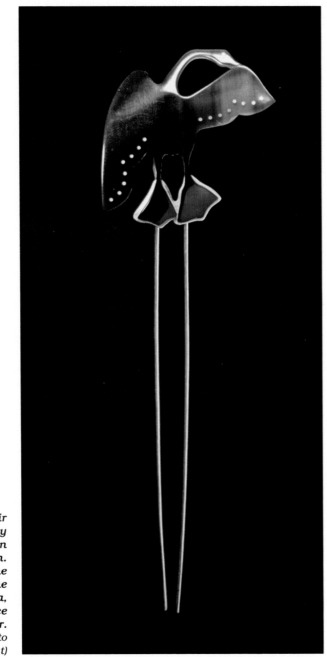

This yawning-goose hair ornament was created by Tahltan Athabascan metalsmith Glen Simpson. Simpson, an instructor in the art department at the University of Alaska, Fairbanks, made the piece from moose hoof and silver. (Barry McWayne; photo courtesy of the artist)

health care, the influence of various western religions, among them Roman Catholic, Protestant Episcopal, Anglican and Russian Orthodox, further altered the traditional Athabascan lifestyle, as did the gold rushes of the late 19th century.

Today, Alaskan Athabascans have abandoned their seminomadic lifestyle of following game, instead settling near missions and trading posts, usually on the larger rivers of the Interior. Small airplanes, access to highways in some areas and the introduction of television make villages much less isolated now than in times past, but many villages are still remote. Their inhabitants pursue a way of life which blends traditional values with influences from western culture. Chain saws and snow machines complement old-time building methods and the use of dogteams, but do not overwhelm them; village stores sell candy, soda pop and fruit, but villagers also rely heavily on succulent traditional foods like moose, caribou, duck and beaver tail. Athabascans who move into urban areas for education, employment and other pursuits find — like other Alaska Natives — that they miss the comforting aspects of rural life as well as the traditional values and support of family members.

Athabascan Prehistory

Archaeological sites in the Interior of Alaska can be divided generally into three broad categories of cultural occupation. First, many historic or late prehistoric sites (A.D. 1000 to the present) exist which are definitely Athabascan and which occur in regions where Athabascans are presently living as well as sites located to the north in areas now occupied by Eskimos. A second and older type of site characterized by certain kinds of stone tools may or may not

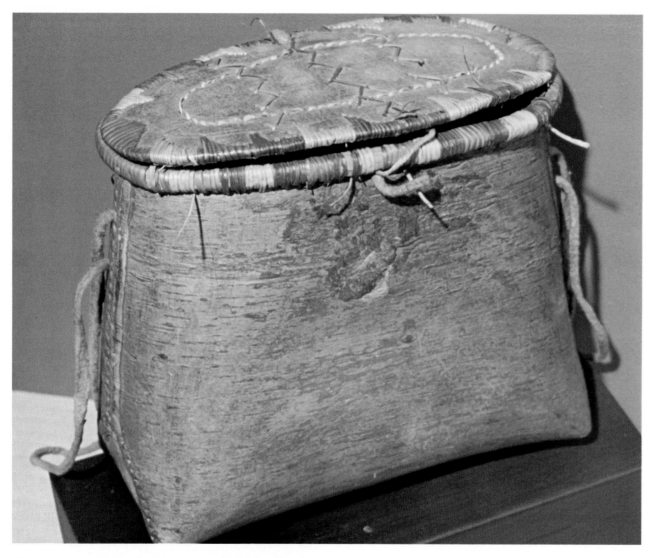

Throughout history, Athabascans of interior Alaska and Canada have fashioned containers of all kinds from birch bark. This covered box, possibly Kutchin in origin, is made from shaped and sewn birch bark, decorated with white and dyed porcupine quills. 17¾" wide. (Department of Anthropology, Smithsonian Institution, T-1075; photo courtesy of Anchorage Museum)

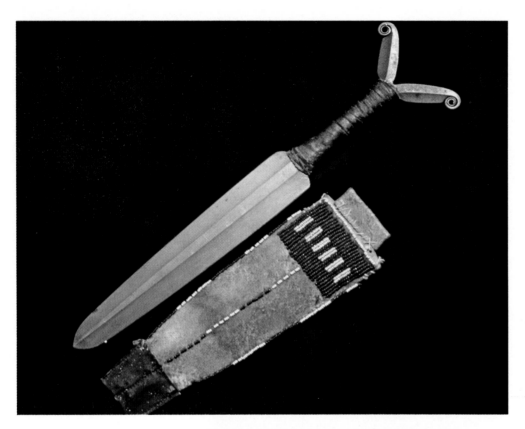

This typical Athabascan knife, made in the Gulkana-Nabesna region in the early 1900s, is made of metal with a fluted double-edged blade. The sheath is made of moosehide edged with beads and decorated with a band of beadwork; the tip of the sheath is capped with a thin piece of copper. Knife, 13″ long. (Sheldon Jackson Museum, an Alaska State Museum; photo by Alice Postell)

technologies which are distinctively different) is spotty, but it is possible that early man crossed Beringia and migrated slowly through the area more than 23,000 years ago.

Historic Athabascan sites reveal a variety of trade items such as iron files and steel saw blades, many of which have been refashioned into tools and weapons which imitate old-style Athabascan copper, bone and horn technology. Trade beads and buttons are commonly found in these sites, as are bent and folded tin containers made exactly like birch-bark baskets. Today, the perfect, seamed, cylindrical birch-bark basket which is often made in Tanacross, Northway and Eagle is referred to by some basketmakers as a "coffee can" basket; indicating that its origin may date to the introduction of metal coffee cans in the area.

Sites from this period point to a widespread historic and late prehistoric trade network. Native copper and obsidian were apparently traded widely to people located far from the source of the materials.

Flaked stone tools are nearly absent in late prehistoric sites, most of which consist of clusters of semisubterranean houses near rivers, streams, lakes or on top of bluffs. The Kavik point, a small, stemmed projectile point made of bone, stone or copper, is widely distributed, however. Another common tool of this period is the split-boulder spall, a primitive but effective stone tool used for skin-scraping. Some bone tools found in these sites are decorated with finely executed geometric motifs.

Earlier prehistoric sites are characterized by the presence of notched points, which are regarded by some as a technological adapatation to the boreal forest environment. Artifacts found in sites from this period (350 to 5000 B.C.) vary from place to place. Some sites

represent the camps and settlements of ancestral Athabascans. Many of these older sites occur in the Tanana Valley. The third type of site points to a much earlier occupation (8,000 to 11,000 years ago) in Alaska and the Yukon Territory. Evidence of these early inhabitants (several of the sites display

contain notched pebble axes or choppers; others have microblades, long, narrow stone flakes; and others, distinctive burins, tools with chisellike edges used for working bone, ivory and antler. Some of these sites lie in the Tanana Valley, and the technology generally associated with them is referred to as the Northern Archaic Tradition. Extinct animals and artifacts in other sites may push their age even farther into the past, perhaps as long ago as 20,000 B.C.

Glaciation probably blocked travel from what is now Alaska to points south during the period between 12,000 and 23,000 years ago. Some archaeological evidence suggests human occupation in Yukon Territory as long as 27,000 years ago, and investigation is now suggesting an even earlier occupation, although this is widely disputed among archaeologists. Artifacts found in this region include the cut and abraded bones of both horse and mammoth (both became extinct in Alaska at the end of the Pleistocene, about 12,000 years ago) and a flesher made of caribou bone.

No definite conclusions have been reached as to when the earliest inhabitants roamed the North, but archaeological evidence points strongly to a period of settlement long enough to allow the slow process of developing distinctive types of technology in different regions. In summary, sites occupied within the last 1,000 years are regarded tentatively as Athabascan, while earlier sites probably are not. Scientists hope that the chronological and cultural gaps in what may be Athabascan prehistory will be bridged as more sites are discovered and examined.

The Seal Beach Site

By Karen Workman

Editor's note: *Karen Workman is a research associate at the University of Alaska, Anchorage, with a special interest in the archaeology of Kachemak Bay.*

The Seal Beach archaeological site lies at the head of Kachemak Bay, near the boundary between recent speakers of Tanaina (Athabascan Indian) and Eskimo languages. The site represents a late 19th century hunters' camp where men traveling by *bidarka* could rest, protected from the elements, before going into the Fox River and the high country beyond.

Picture four or five men lounging inside the drip line of the overhanging rock, with a large copper kettle on a roaring fire. One of the men takes from his travel kit some tea, a little sugar, and a china cup and saucer. Another has just finished butchering a seal, while a third examines the difference between an inch-long bone point he has just completed and the one he brought with him, purchased from the Alaska Commercial Company trader. Perhaps a man tends a pot of molten lead, pouring it into a mold to make musket balls. They share a comfortable silence; after spending many hours in the *bidarka* it is good to sit on one's haunches, leaning back against the wall and basking in the heat of the fire.

What evidence is there that this scene or some variation of it actually occurred? Excavations by the University of Alaska, Anchorage, in 1980 and 1981 documented intensive use of this site between about 1880 and 1900. Scattered around the old hearths, indicated by charcoal and layers of burned earth, were hundreds of fragments of china, all from a mere six cups and nine saucers. Also found were a few kitchen items, musket balls, a gunflint, numerous percussion caps and cartridges. Wooden pegs and toothed bone fleshers bear testimony to the defleshing of skins. A single sea-otter tooth represents an entire animal, while four small bone sea-otter darts are evidence of the technology used in the capture of this valuable creature. Bone refuse completes the inventory and documents a wide-ranging variety in the diet of these hunters of land and sea mammals.

Fragments of china and bone sea-otter darts were unearthed at the Seal Beach site. (Both by Karen Workman)

110

This view shows the systematic archaeological excavation at the Seal Beach site, at the head of Kachemak Bay, used as a hunting camp in the late 19th century. (Robert Shaw)

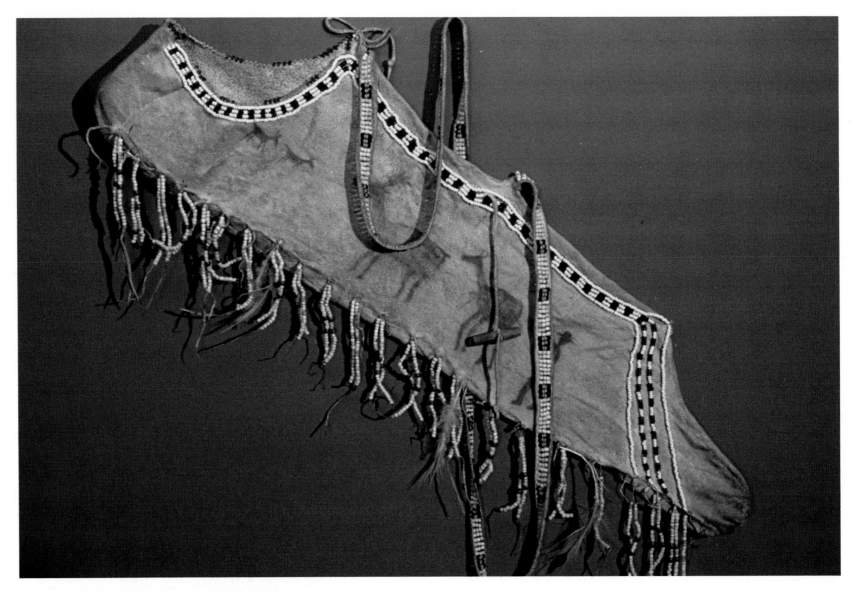

Beadwork and feathers decorate this buckskin quiver, collected in 1888. The scene, painted in red pigment, depicts a man in a broad-brimmed hat shooting at four animals, thought to be moose or caribou. 44½" long. (Alaska State Museum; photo courtesy of Anchorage Museum)

Beadwork and Skin Sewing

Personal ingenuity and skillful adaptation to the northern boreal environment are manifested in most examples of Athabascan technology. Most objects are simply made and adorned only slightly, if at all, but each is perfectly suited to its function, which can only reflect many years of refinement. The semi-nomadic lifestyle of traditional Athabascan groups limited the amount of material goods they could possess, but did not always limit the time spent in designing and ornamenting the objects they made. Moosehide and caribou-skin clothing and footgear, carefully tailored and designed for survival in the North, was one area in which Athabascan women could combine pure function with elegant, artistic designs of porcupine quill and beadwork.

Historically, porcupine quill embroidery decorated portions of skin garments and boots, although quills were quickly and almost totally supplanted by glass beads when they became widely available in the 19th century. Occasionally, caribou and moose hair were incorporated into quilled designs or tufted in alone, and plaited grass was sometimes used for decoration.

When embroidering with quills, a sewer dampens and flattens each quill between her teeth, attaching it with sinew to the leather backing. Because of the even, flattened surface, a number of plaited and folded patterns can be expressed in quillwork. Quilled designs result from the combinations of these weaving techniques and variations in color obtained from analine dyes, vegetal dyes and from the natural brown and white of the quills. Quills are occasionally used to wrap leather fringes as well. Flattened, folded quills are generally worked into geometric patterns, particularly among Alaskan Athabascans.

Hannah Solomon, originally from Fort Yukon, is well-known for her beadwork, such as this moosehide scissors case. Floral motifs are typical of Fort Yukon and nearby villages. (Institute of Alaska Native Arts; photo by Rose Atuk Fosdick)

In addition to quillwork and embroidery with animal hair, a variety of other ornaments decorated and personalized Athabascan garments. Beads were sometimes carved of willow wood, or made from seeds of certain shrubs and trees. Animal claws and bird beaks became dangles. When metal coins and cartridges became available through trade, they too were ornaments for Athabascan clothing.

Pre-contact Athabascans favored dentalium shells for ornamentation. These fragile white tube-shaped shells, obtained in trade with the Tlingit Indians, were used as beads or sewn directly onto leather clothing. Among a few Athabascan groups, dentalia also served as currency, and although their appeal as money

eventually waned, they still appear along with trade beads in necklaces worn by Athabascans for prestige and ceremony.

Glass seed beads became available to Alaskan Athabascans in the mid-19th century, although some types of larger trade beads were in use earlier. Beads quickly became a most coveted trade item, sometimes the only goods for which an Athabascan might be willing to trade his furs. The *Cornaline d'aleppo,* an opaque red bead with a white center, and the faceted "Russian blue" beads were among the most popular types.

The introduction of small glass beads also sparked changes in beadwork style and design. More colors were now available than could be expressed in dyed quillwork, and these smaller, more easily maneuvered beads made it possible to work out delicate floral patterns impossible with larger trade beads.

Eskimo and Indian women create a variety of beaded items from seed beads, which are still widely available. These beads are generally sold in hanks containing about 12 strands each and come in several sizes and a dazzling array of colors. The average glass bead is approximately one-sixteenth of an inch in diameter and most are gently rounded. The Alaska Native Arts and Crafts Association (ANAC) in Anchorage sells seed beads in 30 translucent, opaque and clear colors. Mary Lou Lindahl, manager at ANAC, says Eskimo skin sewers generally buy the same size beads as Athabascan women. Tlingit

Altona Brown of Ruby made this doll, a rare example of Athabascan dollmaking, in 1969, dressing it in the traditional style of clothing worn by her father around 1910. The moosehide doll is wearing a mink parka. All of the clothing is removable and can be buttoned or tied. 15" tall. (University of Alaska Museum; photo by Barry McWayne)

women are reported to prefer slightly smaller beads.

Historically, beads were sewn directly onto leather garments or other items with a stitch known as the overlay stitch. Contemporary beadwork is often done on a separate piece of felt which is not visible once the beads are stitched in place. When sewing with the overlay stitch, a woman lays a segment of beads, usually strung on thread now instead of sinew, in the shape to be portrayed on leather or cloth backing. With a second needle and thread the sewer then makes a tiny stitch between every other bead to secure the pattern in place. The

An essential tool for skin sewing is an awl or leather punch. These Athabascan awls have been decorated with beadwork. (Collection of the Alaska State Museum; photo by Lael Morgan, staff)

overlay stitch allows almost unlimited flexibility of form and design, and permits deviation from the geometric patterns often seen in quillwork in the past.

Alaskan Athabascan beadworkers sometimes use paper patterns, often combining several motifs and tracing their outline on the surface to be worked. The most common designs include flowers, leaves and berries, some in

115

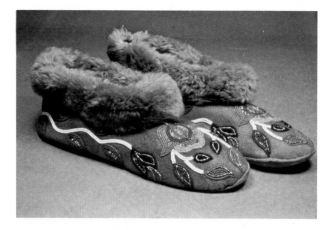

Above — *These moosehide moccasins, trimmed with beaver and decorated with bright floral beadwork, were made by a Nenana woman in 1910. (Alaska State Museum)*

Below — *A complex beaded floral pattern adorns these moosehide mittens trimmed with beaver fur, which were made on the upper Yukon around 1915. 14" long. (University of Alaska Museum; photo by Barry McWayne)*

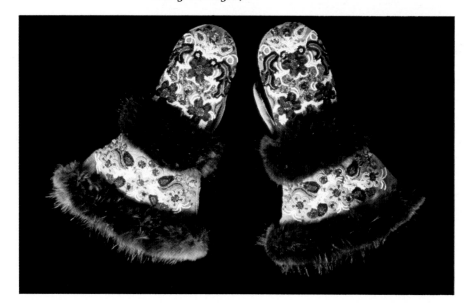

very stylized form. Some of these designs probably reached Alaska in the 19th century, brought in by traders or voyagers of the Hudson's Bay or the Northwest Company, although many patterns are drawn simply from the sewer's environment. More recently, magazines, commercial advertisements and patriotic motifs such as the American bald eagle have inspired Athabascan beadworkers, although stylized floral designs are still the most popular.

Designs vary regionally, as does the way in which they are applied to garments or footgear. Women from some areas do beadwork so fine and distinctive it can be recognized at a glance. Kate Duncan, from the University of Washington Department of Art History, has done extensive research on Athabascan beadwork. She notes that sharply pointed leaves and petals which are rather realistic are common to villages such as Rampart, Tanana and Fort Yukon, and that these designs become more stylized as they extend toward Canada, growing softer and somewhat less recognizable toward the south. Examinations by Duncan of examples of Athabascan beadwork in various museum collections pinpoint specific designs, combinations of designs and use of color to individual villages and makers.

Historic Athabascan clothing was carefully tailored, designed for survival in the bitter cold of the northern forest. Many different kinds of animal skins, including moose, caribou and hare, were made into garments. Caribou hide was a preferred material because it is extremely pliant and provides great warmth. Snowshoe hare skins were made into blanket strips, socks and undergarments and served as swaddling for infants.

Cold weather clothing consisted of a long-sleeved pullover shirt with an attached hood, or

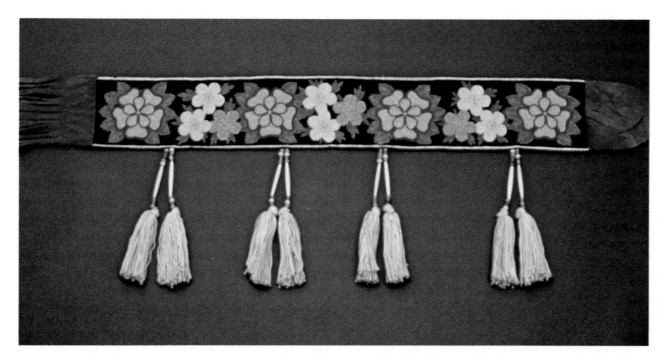

This beaded baby strap was made by Delores Sloan, originally from Fort Yukon and now living in Fairbanks. The strap is part of the collection of the Alaska Contemporary Art Bank, Alaska State Council on the Arts. (Photo by Chris Arend; courtesy of Alaska State Council on the Arts)

a long, belted coat with a separate hood. Trousers usually had a drawstring waist and attached moccasins. Mittens were separate, usually secured to their wearer by a harness so they could be slipped on and off easily. Hair or fur was generally removed from summer clothing, while winter garments had the fur intact and turned to the inside. The cut of men's and women's garments was somewhat different among most groups.

Traditional garments were decorated amply with skin fringes, dyed porcupine quills, dentalium shells, trade beads, ochre paint, bits of fur and beaded floral motifs. Although winter clothing was similar in many groups, differences in the materials, cut and surface ornamentation point to the region and tribe of the garment's origin, and underline the care taken with both practicality and beauty.

Clothing manufacture was and still is the work of Athabascan women. The tools most common in tanning and sewing are the *ulu*, a semi-circular knife; various scrapers; a sewing awl; skin thimbles; and, in some areas, boot crimpers. Historically, Athabascan men made the tools from stone, bone or wood, although some of these traditional tools have now been replaced by modern ones. Sinew thread from various animals was commonly used and is still preferred for sewing.

The tanning of skins, particularly caribou and moose, was a lengthy process. Hides were first cleaned of excess fat and tissue, and the hair was removed with a scraper. The hides were then stretched, scraped again on both sides, and left outside to freeze or dry for several months in the late winter. Next, the skins were lightly smoked, oiled and deposited in a large

117

Hannah Solomon, Athabascan Beadworker

By Jan Steinbright

Editor's note: *Jan Steinbright is Program Director for the Institute of Alaska Native Arts in Fairbanks, an organization which provides assistance and support to native artists.*

Right — Hannah Solomon creates a wide variety of beadwork items. This moosehide picture frame is decorated with a floral design typical of Fort Yukon beadworkers. (Institute of Alaska Native Arts; photo by Rose Atuk Fosdick)

Below — In this photo taken July 4, 1952, Hannah Solomon holds her youngest child in a butterfly baby belt. The belt is now in the collection of the University of Alaska Museum in Fairbanks. (Photo courtesy of Hannah Solomon)

"Anything that's made out of beads is always pretty." This is the way Hannah Solomon, an Athabascan born at Old Rampart on the Porcupine River, northeast of Fort Yukon, feels about her lifelong occupation, beadwork. Hannah's mother was a bead and skin sewer, and as soon as Hannah could manage a needle and thread, she took up the art. Soon they began to work on projects together, Hannah doing the beadwork and her mother sewing the moose skin into slippers, gloves, mittens and boots.

"In those days, we did beadwork mostly for our own use, for our family's use and for special occasions. In the early days, we didn't have electric lights. When I was young, it was candlelight and kerosene lamp and then later, gasoline lamp came in. We used to sit to the lamps until two, three o'clock in the morning and do the sewing. We used to make all new boots for the kids and all. We made beaded moccasins for Christmas coming. And during New Year dancing, everyone had beadwork on them."

At a recent dance in Fairbanks during the Athabascan Old Time Fiddling Festival, Hannah joined many other Athabascans sporting ornately beaded dancing boots. Due to

a knee problem, she was unable to actually get up and dance, but she says, "I was right there in the middle with my body dancing, but not my feet."

Hannah continued her bead sewing for her own family's use and to provide an income after she was married. Her work is included in private and museum collections and she has been featured in various exhibits around the state. She is very proud to have her work in these collections and exhibits. She only wishes she knew more about where her other work is.

"A few years ago they asked me to come up to the University. They were checking to see where different sewings were from. It was easy! We could just say, 'This was made here.' When I got there I was so surprised to see my first son's baby strap was out there. In the early days, we did things for ourselves; we just kept it so long and then we would trade our bead-work for clothes and food through the mission. And then also, so many people buy from me, I don't know where my pieces are. I would really like to know."

Like many Athabascan beadworkers, Hannah is finding it difficult to get the velvet-soft, native-tanned smoked moose skins for her work. As the tanning process takes many days and requires a lot of hard physical work, not many women are willing to do it today. But skin tanned the native way is prized for its softness and durability; it outwears the commercially tanned skins, which are often too thin and soft, and its texture is suitable for attaching the beads.

"I used to tan my own skins when we lived out in camp and in the village, but in the city, you can't. Also, in those days, the men knew the skin was going to be used so they handled it right. Now they just cut it all up. Back then when they were fleshing it, they made sure they

Despite an aching knee, Hannah Solomon was able to dance at the Second Annual Athabascan Old Time Fiddling Festival held in Fairbanks in November 1984. (Rob Stapleton)

didn't cut holes in it. Then they'd bring it home and the ladies would work on it. Nobody brings skins home now."

Fort Yukon-style beadwork, at which Hannah is one of the acknowledged masters, is some of the finest in the world, consisting of vibrant floral patterns on a background of white beads. Hannah's work glistens with carefree designs in brightly colored beads; light is captured and played with in fanciful ways, moving in and throughout leaf, stem and petal. The energy in the colors keeps the eye dancing, just like Hannah's spirit.

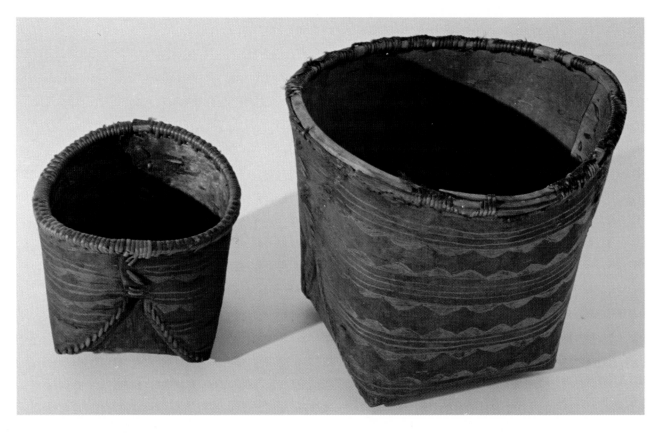

These folded and sewn birch-bark baskets were probably made for utilitarian purposes. They are decorated with horizontal patterned bands.
(Anchorage Museum)

container with a mixture of rotten moose brains and water for a short soaking. They were then removed, scraped again and returned to the solution for several more days. After the skin had soaked it was wrung, twisted and scraped many times until it was soft when dry. Further smoking gave the softened hide a beautiful golden-brown color and made it extremely durable. Today, commercial tanning methods simulate smoke-tanning almost perfectly, but a few Athabascan women still prefer the traditional process.

Basketry

The boreal forest consists of dense spruce, birch and aspen, interspersed with areas of muskeg and tangled thickets. Athabascan Indians use each plant and animal in their environment in a special way. Plants provide wood, bark, pitch and roots for a variety of tasks. Perhaps no plant is more important than the white spruce: products from this tree are used in more than 60 specific ways, ranging

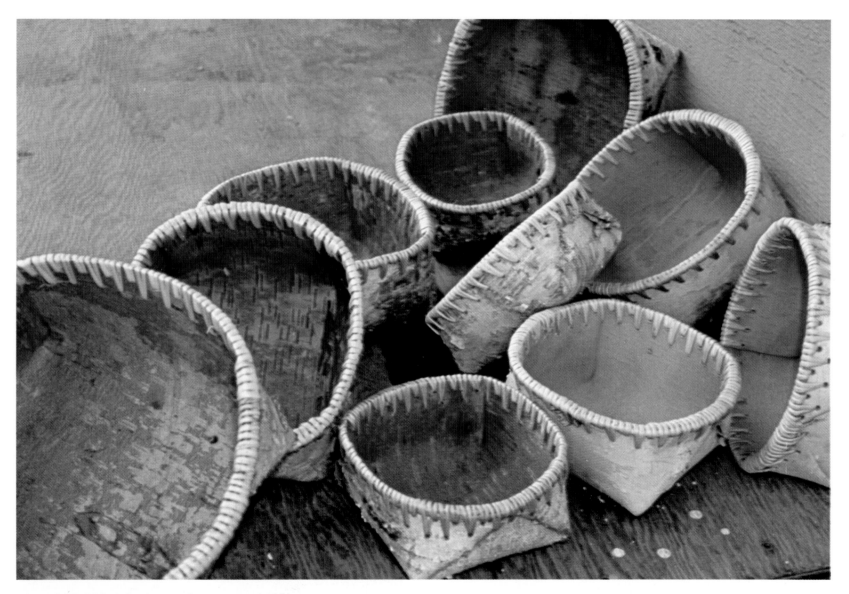

These folded birch-bark containers were made in Northway. Historically, baskets of several shapes were watertight, made to be used for cooking by dropping hot rocks into a basket containing food and broth. (Staff)

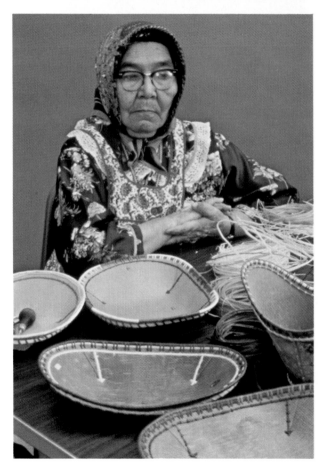

Award-winning split willow and birch-bark basketmaker Belle Deacon of Grayling (right) exhibits some examples of her work. In the photo above, Mrs. Deacon sews spruce-root lacing onto the rim of one of her baskets. (Both by Sam Kimura; courtesy of Alaska State Council on the Arts)

from medicinal teas for treating colds, ulcers and other ailments, to the expulsion of bad spirits by the shaman. Snares, fish traps and the lashing on baskets are fashioned from white spruce roots. Birch wood and bark are also important. The lightweight wood is made into snowshoes and household utensils; the bark is transformed into practical birch-bark containers. Strips of birch bark covered summer dwellings of some groups.

Birch-bark containers are made widely in interior Alaska. Aboriginal containers included baby carriers, cups, spoons and many other household utensils, as well as waterproof baskets. True birch-bark baskets adhere to two basic styles. The first, and older, consists of a single sheet of bark folded into the desired shape and stitched in such a way that it remains watertight. Containers made for storage were often covered. Historically, cooking was done in birch-bark baskets: food was placed in the basket, hot rocks were dropped in and the broth or meat was stirred while it boiled. Some elders say that broth cooked with rocks is much more delicious than that made in a metal pot. Other birch containers, at least among the Ingalik, served as water containers and dippers, berry baskets, large baskets for transporting fish and as containers for urine.

The second major style involves baskets cut and stitched in separate sections, some of which are cylinder-shaped. These are not waterproof and are probably a later invention, mimicking the shape of tin cans and other metal containers obtained in trade.

Birch bark for basketry is gathered in the spring from trees that are full of sap, and with a minimum of knots or limbs. A sample piece of bark is removed from the tree, folded and tested for cracking and if it is strong, a larger

piece is torn off. Bark must be peeled off the tree slowly and carefully so it is not damaged. Light-colored bark is generally preferred. After being removed, the rectangular pieces of birch bark are rolled carefully together, tied with strips of willow and stored in a cool, damp place.

When the bark strip is ready to be used, it is dampened and cleaned, then cut along penciled marks. One form of functional birch-bark container is made by folding, then basting and sewing the corners with sharpened willow roots. Basketmakers generally use two layers of bark to increase the basket's durability. Separate pieces of bark are cut and slipped between the folds of the original form, then secured with a hoop of sturdy willow which has been whittled down (among the Ingalik this strip is made of cranberry wood). A slimmer strip of willow encircles the basket rim. It is sewn in place with spruce roots which have been painstakingly dug, rolled up and stored in a damp place. These roots are torn open and split, usually in quarters, and the bark is skinned off with a knife. They are then plaited into geometric patterns, sometimes multi-colored, around the rim of the basket.

Coiled split-willow basketry is now made only by Ingalik Athabascan women. About 20 weavers still practice this dramatic type of weaving in the villages of Anvik, Shageluk, Grayling, Holy Cross and in some urban areas.

The technique used in split-willow basketry is called single-rod coiling. Willow roots are dug, split and stored in much the same way as spruce roots. Some are dyed, often with bright analine dyes, for the bold central pattern; the background and rim almost always remain the natural color of the stripped roots, which mellow and darken with age. Split willow is usually fashioned into large circular trays with handles, although occasionally an oval tray can

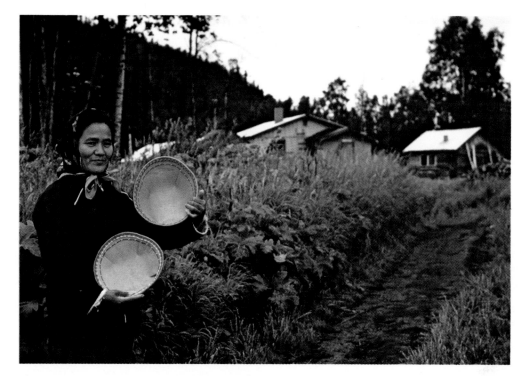

Edna Deacon of Grayling, herself a skilled basketmaker, poses near her home with a neighbor's birch-bark baskets. (Susan W. Fair)

be found. A few women make round and oval covered baskets, which are relatively rare. Some older examples of these covered baskets are fairly large.

Cornelius Osgood, in his extensive work among the Ingalik in the 1930s, does not mention split-willow basketry, but goes into detail about birch-bark basket construction and use, and notes the manufacture of several types of grass articles, both braided and twined. This suggests that split-willow basketry became popular in this area sometime after 1940, and it is possible that the concept was diffused or borrowed, as were many aspects of Ingalik

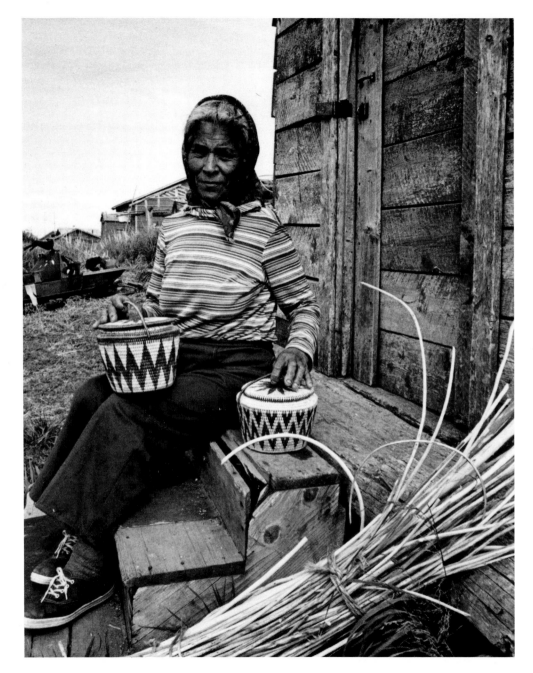

technology and ceremonial life, from their downriver Eskimo neighbors. It is interesting to note, however, that split-willow baskets were made in villages far upriver, such as Eagle, as early as the turn of the century, and may have been practiced by Eskimos of some regions as well.

Most split-willow trays depict a single centralized motif, often a large, splayed star in several bright colors, which resembles the pattern of a Lone Star quilt. Although Yupik women sometimes incorporate a similar motif, the sharp delineation of each willow root and the neutral background provide Athabascan trays with a more graphic presentation than the softer, subtler medium of coiled grass. Older split-willow trays often display floral motifs similar to those found in beadwork. These designs are also repeated on circular, lidded baskets, becoming more stylized as they conform to the curvilinear shape.

Ingalik women today tend to color their baskets with bright analine dyes: older baskets are usually mellower in hue. Much of this can probably be attributed to fading, but a few earlier baskets may have been dyed with vegetal dyes, which are less harsh, or wih a combination of analine and vegetal coloring. Primary colors are popular now, as are bright, startling combinations such as burgundy and dark green or purple and gold. Striking colors almost always complement the bold designs and graphic characteristics of the baskets. Willow-root baskets are rigid, and more durable than almost any other type of Alaskan native basketry.

Anna Matthews of Old Shageluk holds split willow baskets made during the summer of 1982. Stripped willow roots lie bundled in the foreground.
(Chuck Mobley)

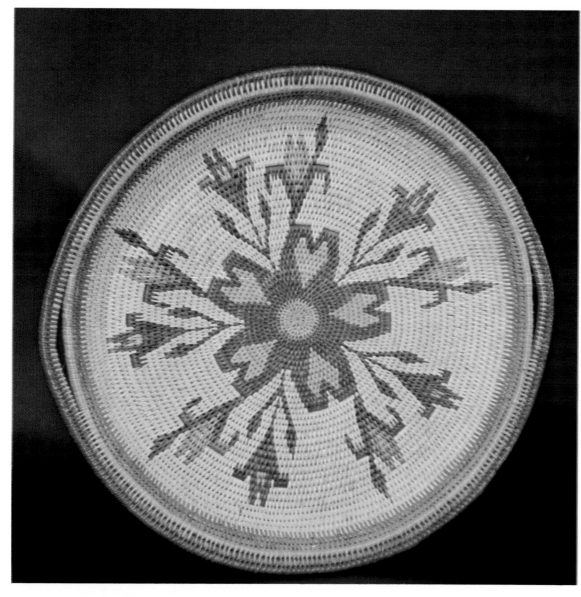

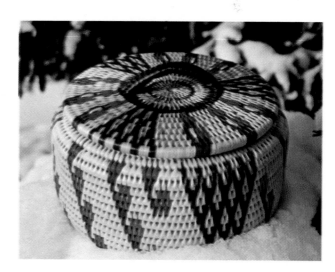

Edna Deacon of Grayling, skilled at split willow basketry, made this covered basket decorated with a brightly colored geometric pattern. Covered split willow baskets are less common than trays. About 20 women still practice this art. (Susan W. Fair)

Split willow trays often display large splayed stars or floral patterns similar to those used in beadwork. This tray was probably made by Lina Demoski of Anvik several years ago. (Steve McCutcheon)

The Aleuts

The ancestral home of the Aleuts consists of the western portion of the Alaska Peninsula, the Shumagin Islands and the many islands of the Aleutian Chain, which arcs gently for 1,000 miles into the Bering Sea. Local legends maintain that the Pribilof Islands were known to Aleuts before contact, but were probably not inhabited prior to the Russian period.

The Aleutian coastline is rugged and strewn with rocks, leaving few locations suitable for establishing settlements. Although both historic and present-day inhabitants use the islands' interiors for gathering berries and greens, most necessities come from the coast or the ocean.

Temperatures in the Aleutians are mild, but the weather is not. Winds and storms often batter the islands, which remain shrouded in fog and mist much of the time. Coastal areas are covered with thick bright green vegetation though fewer plants grow at higher elevations.

Aleutian waters are dominated by the Pacific maritime climate and do not freeze. Historically, sea mammal hunting here was done on the open ocean by means of two-holed kayaks, occupied by a striker, who aimed and threw a harpoon at the hunted animal, and a man who guided the boat. Sea otters, sea lions and various species of seal were commonly hunted. Hunters in kayaks darted whales with a poisonous substance, then salvaged the animals after they died and drifted to shore.

Historically, a typical Aleut household was made up of a man, his wife or wives, his children and his older married sons and their

This tightly woven covered grass basket is decorated with multicolored embroidery.
(Sheldon Jackson Museum, an Alaska State Museum; photo by Ernest Manewal)

"Yet, since the message and not the object . . . was of primary importance, the objects, as far as we know, were not marked. Probably because Aleuts considered boasting reprehensible and fulsome praise by others in bad taste, no name of a famous carver or a master basket-weaver has come down to us in any known story or song."

Lydia T. Black,
Aleut Art

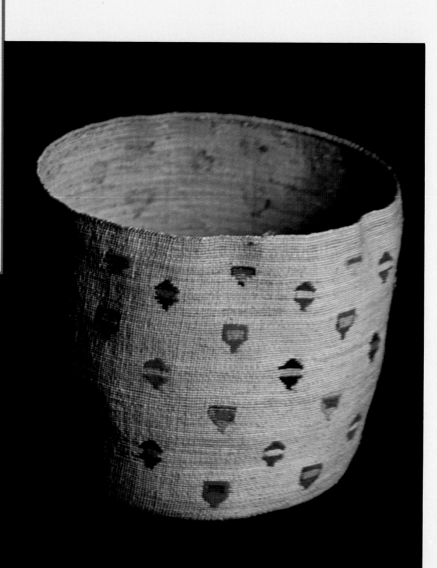

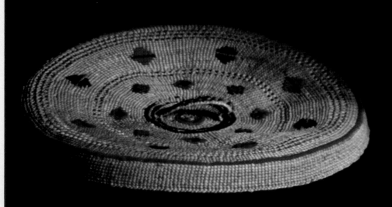

Aleut hunters are realistically depicted in this model of a three-man bidarka. The frame of the bidarka is covered with seal intestine and painted red. The men are dressed in gut parkas; the front man wears a hunting visor and holds a gun. All three men have moustaches and tattoo lines on their chins. 19" long. (Sheldon Jackson Museum, an Alaska State Museum; photo by Ernest Manewal)

families. Ten or more families apparently occupied each communal semisubterranean dwelling. Dimensions given by early explorers for these houses, called *barabaras,* varied, but some were reported to have been quite large, perhaps up to 200 feet long by 60 feet wide. Archaeological excavations of these houses reveal human burials beneath the floor, as well as hidden pits or compartments whose specific use remains a mystery. Traditionally, these secret rooms are said to have been covered meticulously with grass mats. They may have protected sleeping children against surprise attacks from neighboring raiders, or may have

been used by menstruating women, who were isolated from the group by taboo.

Traditional Aleut social structure consisted of three classes, chiefs or honorables, commoners and slaves. The chief, his immediate family and Aleuts descended from notable leaders were included in the first category. Commoners were those members of the tribe who had not distinguished themselves in any way, though this category was apparently rather flexible. Higher status could be achieved by bravery in war or through social service. Conversely, a chief could lose his rank if his leadership in battle proved ineffective. Slaves were primarily

Aleut Archaeology

By Dr. Douglas Veltre

Editor's note: *Dr. Douglas Veltre teaches anthropology at Anchorage Community College, and has been conducting archaeological research in the Aleutian and Pribilof islands since 1971.*

The prehistoric cultural record of the Aleutians begins with tiny Anangula Island, a few miles off the coast of Umnak Island, where the oldest archaeological remains on the entire coast of northern and western Alaska have been found. With an occupation dating to approximately 8,500 years ago, the Anangula site is thought by many to be the earliest evidence of Aleut culture. Others, however, point out that the site's distinctive stone technology, which differs from later Aleut materials, and the gap of several thousand years between Anangula and more recent sites in the Aleutians, make it difficult to be certain that the ancient occupants of the site were, in fact, ancestral Aleuts. In any case, Anangula's early date and interesting technology rank it as one of the most important archaeological sites in the circumpolar region.

A void of some 3,000 years separates Anangula and later Aleutian sites. By about

Archaeological sites in the Aleutian Islands often stand out from the surrounding country because of their relatively lush vegetation. The greener grasses and irregular ground surface in the foreground identify this Umnak Island site as a former Aleut village. Mount Vsevidof towers in the distance.
(Douglas Veltre)

Remains of the Russian period are often easily distinguishable from earlier remains. While prehistoric Aleut houses generally leave oval-shaped depressions in the ground, these rectangular, raised ridges on Amlia Island are identifiable as the remains of Aleut houses of the early 1800s. (Douglas Veltre)

5,500 years ago, however, it is clear that a continuity of archaeological cultures begins which culminates in the Aleuts of today.

Perhaps the best known of these later sites is Chaluka, today part of the village of Nikolski. The Chaluka site is remarkable in that it represents a virtually uninterrupted Aleut settlement from 4,000 years ago to the present — a historical continuity of which few other communities in the state can boast.

Like most Aleutian sites of the last 4,000 years, Chaluka is a midden site — a mound composed of the building materials, food refuse,

tools and other elements of day-to-day life which accumulate when people live in one place for a long period of time. Building up at a rate of less than one inch per year, midden sites in these islands are often more than 20 feet deep. Of great interest to archaeologists is the excellent preservation of certain organic remains, notably shell and bone, in Aleutian middens. Unlike Anangula, where only stone tools survived, these later sites contain the tools, weapons and art objects Aleuts carved from bone and ivory. It has been possible, through analysis of sea mammal, fish and bird

bones, and of the shells of marine invertebrates, to reconstruct the ancient Aleut diet. Likewise, examination of prehistoric human skeletal remains gives clues concerning ancient health and disease as well as Aleut burial customs and knowledge of human anatomy.

From analysis of food remains and artifacts, most archaeological sites in the Aleutians may be classified as either village locations, places inhabited for most or all of the year; or camp locations, inhabited for short periods for specific subsistence purposes. Burial caves of the prehistoric Aleuts, however, are much different.

Coastal rock crevices and overhangs, most often situated in relatively inaccessible locations, were sometimes utilized as burial tombs for the mummified remains of important men, women and children. The mummies were prepared by eviscerating the deceased individuals and filling the body cavities with dried grass. They were then placed in the caves along with their boats, clothes and tools. Famous among these caves are those on Kagamil Island, a small volcanic island west of Nikolski, and Ship Rock, an islet in the dangerous pass between Unalaska and Umnak islands. From these two places, Ales Hrdlicka of the Smithsonian Institution recovered dozens of Aleut mummies in the late 1930s. Because such materials are not normally well preserved in most archaeological sites, Aleut mummies and the artifacts buried with them provide a rare and valuable glimpse into the past.

Although archaeological research has been carried on in the Aleutian Islands for more than a century, much remains to be learned. It is clear that Aleuts throughout the archipelago shared generally similar cultural traits. Relatively free from outside influences, changes in prehistoric Aleut culture throughout time are perhaps best understood in terms of the chang-

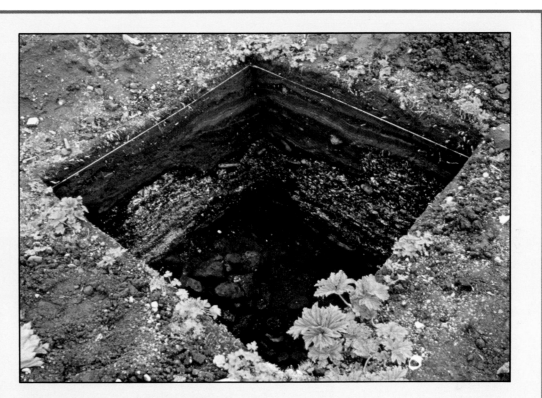

A six-foot-square excavation at the site of Korovinski on Atka Island reveals materials common to many Aleutian sites. The lighter-colored deposits are composed largely of the broken shells of marine invertebrates. Above them are several bands of gray ashes from nearby volcanoes. Because of their chemical composition and good drainage, such shell deposits preserve bone and ivory artifacts exceptionally well. (Douglas Veltre)

ing demands of life in the island chain. However, archaeology has yet to explain such things as regional variation within the Aleutians, and archaeologists today are continuing to pursue answers to these and other questions.

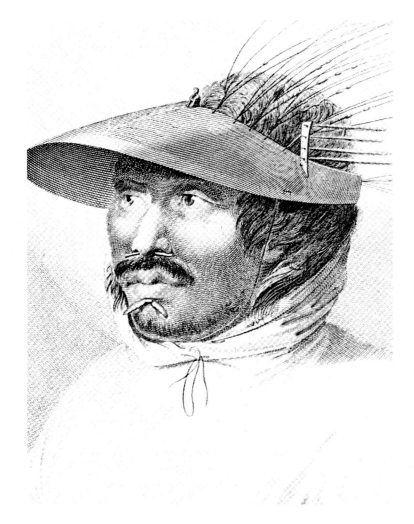

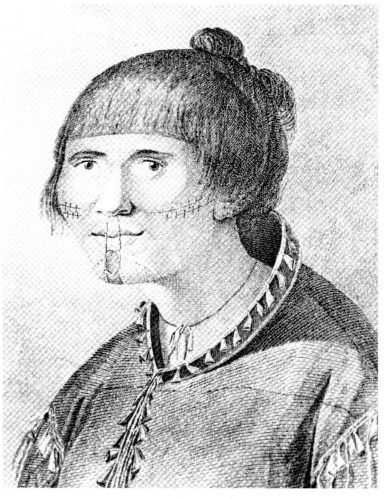

The illustrations of John Webber, official artist for Captain Cook's third voyage (1776-1780), provide valuable information on native ways of life more than 200 years ago. The two portraits, an Aleut man and woman, show facial ornaments and clothing typical of the period. The interior of a barabara (right) in Unalaska shows the arrangement of the semisubterranean communal dwelling, with sleeping areas, partitioned off with mats, around the perimeter. (From engravings by John Webber, reprinted from ALASKA GEOGRAPHIC®)

prisoners from other islands or orphaned children, and ownership of slaves was an important sign of status and wealth.

The Aleuts were divided historically into a number of distinct political units. These were not all of equal population or strength, and represented culturally diverse groups who spoke several different dialects. The word Aleut may, in fact, be the term one localized group called itself, meaning crew or kinship unit.

These political units were based on kinship, with authority and social status transmitted through male lineage. High chiefs, probably chosen from the ranks of those men who had already inherited chieftanship, governed village clusters or entire islands, but their power did not extend from island to island. Raiding was common between islands, generally initiated because of real or imagined insults committed against the family of the chief, or in revenge for blood shed by his forefathers. The protection of his own honor and a heroic responsibility for the good name of his kin were the paramount concerns of an Aleut chief.

Russian domination of the Aleutians began after Chirikov and Bering traveled along the south coast of Alaska in 1741. Russian voyagers of this period traded with Aleuts and returned to their homeland with samples of a few furs, including sea otter pelts. The Russian response to the furs was immediate. Succeeding voyages became frequent and were quite routine by the 1760s. The traditional Aleut lifestyle was forever changed as the fur trade intensified. Approximately 80 percent of the aboriginal population died during the first 75 years of

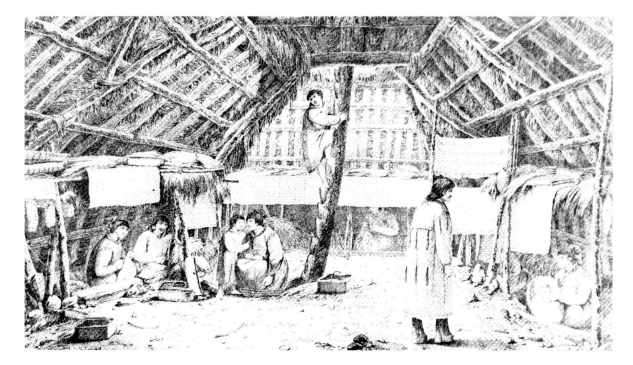

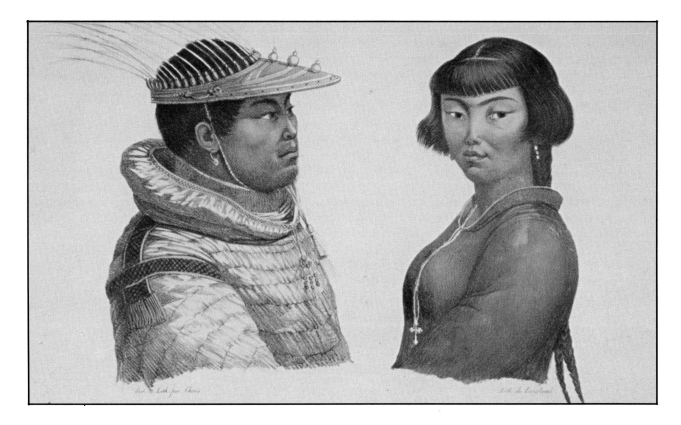

Russian-Aleut contact. Families were broken up as Aleut men were taken from their homes to all-male settlements in areas where sea otters were more accessible. Women became servants and mistresses of the Russians. Conflict, change and stress ate at the fabric of Aleut society. Many Aleut women began to accept polyandrous relationships, taking a Russian lover or housemate who provided for her family when her husband was away on long, sometimes permanent, absences. In some areas, Aleut blood may not have been shed entirely at the hands of Russians; rival Aleut hunters also attacked other hunting parties and seized their furs.

M. Louis Choris, artist for Otto Von Kotzebue's 1816 expedition, made a detailed record of traditional native clothing and lifestyles. The man in Choris's "Inhabitants of the Aleutian Islands" wears a decorated kamleika and hunting visor. The woman's clothing is less traditional, and she wears a Russian Orthodox cross around her neck.
(Anchorage Museum)

The Russians subdued the Aleuts island by island until much of their traditional culture had vanished or changed dramatically. Aleut men, though themselves the critical link in the procurement of furs, lost morale during this process. The traditional religion, which required the strong leadership of Aleut men and

the formation of secret societies which precluded female participation, gave way to the establishment of the Russian Orthodox Church. Today, no Aleut knows the traditional ceremonies used before the coming of the Russians.

Ultimately, Russian domination lessened and a new Russian-Aleut culture stabilized and survives to the present day. Russian rule ended formally with United States acquisition of Alaska in 1867. More social and cultural disruption was in store for the Aleuts, however, with the onset of World War II. Japanese planes bombed the military base at Dutch Harbor in June 1942, then Japanese forces seized the islands of Kiska and Attu. Attuans were incarcerated in Japan for the remainder of the war and many died there. Aleuts west of Unimak Island and residents of the Pribilofs were evacuated to various southeastern Alaska locations for the duration of the war, where many died and some resettled permanently. Aleuts who returned to their islands at the war's end faced further devastating cultural change when they found their homes had been looted and vandalized. They began the long process of renewing and revitalizing their ravaged way of life, a process which they continue today.

The Arts

Prehistoric art and artifacts from most of the Aleutian Chain show links to several other widespread cultural traditions, including what appear to be subtle influences from mainland

This carefully carved bone dart may have been used for seal hunting. The barbed dart was collected on Amaknak Island, off the coast of Unalaska, in 1937. 7¼" long. (Department of Anthropology, Smithsonian Institution, 389 967; photo courtesy of Anchorage Museum)

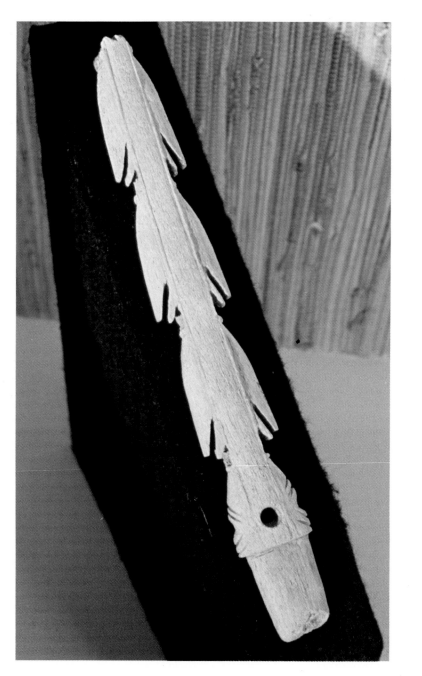

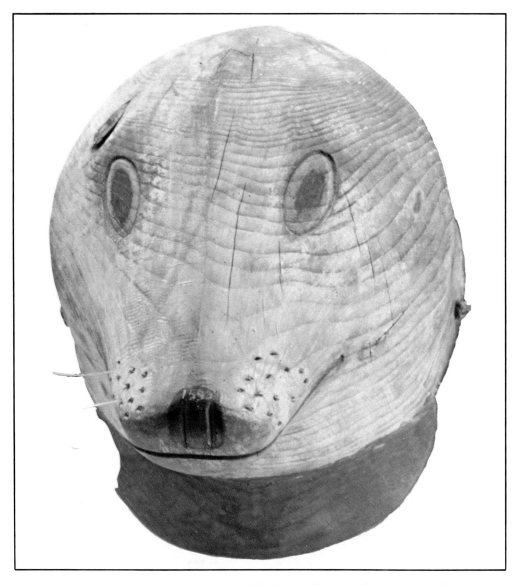

Edward G. Fast collected this seal decoy helmet on Kodiak Island in the late 1860s. The helmet is wood, painted red, white and black, and has a rawhide chin strap. 10" long. (Peabody Museum, Harvard University, 69-30-10/64700; photo courtesy of Anchorage Museum)

Asiatic cultures. Historically, Aleut artists worked as their predecessors had, making functional and ceremonial items from local materials such as grass, sea mammal intestine and driftwood, or from imported materials such as dentalium. Men worked with wood, ivory, stone and bone, manufacturing tools and weapons and most ceremonial and ritual objects. Women made baskets and sewed spectacular garments for dance and other important social functions. Shamans generally carved their own ceremonial paraphernalia, which included masks, special amulets and other objects.

Aleuts of the Shumagin Islands were the first Alaska Natives to trade their art and artifacts to non-native visitors. Members of Bering's 1741 expedition procured hunting hats, ochre paint, carved ivory figurines and other items from residents of Bird Island.

Many of the finest examples of Aleut art from this period are housed in Finnish and Russian museums. During the early contact period, several artists and illustrators, including John Webber of Capt. James Cook's voyage, made detailed paintings and drawings of Aleut artifacts and portraits of the people themselves. This visual record and the journals kept by early explorers of the region make up much of the body of our present knowledge about the life of pre-contact Aleuts. With the onset of the fur trade, the traditional Aleut lifestyle and the material culture which accompanied it changed forever. By the turn of the 19th century, Aleut and Pacific Eskimo traditional men's arts had nearly vanished, though Aleut women continued to make fine baskets, as they do today. Aleut craftsmen of this period began manufacturing and carving, with great proficiency, non-native style furniture and tools for their own use.

Basketry

Aleut baskets, particularly those from Attu, are among the finest in the world, exhibiting up to 2,500 fibers per square inch. Fine grass mats, among the prized possessions of Aleuts in early times, were useful in trade with other groups. Aleut mats, for example, have been collected as far away from the Aleutian Chain as Nootka Sound, on Vancouver Island. A variety of materials and a specific, identifiable local style found in archaeological sites on the Islands of the Four Mountains establish basketmaking as an essential, regionally distinctive and certainly highly developed craft before western contact. Out of the concept of twined fiber as an outstanding, but purely functional craft, grew the development of Aleut basketry as a widely recognized art form. By the end of the 19th century, Aleut basketry was finer and more beautiful than ever before. Baskets made during this period were sold or traded, and at times even served as currency.

Some scholars believe that Aleut basketry began on Attu and diffused slowly to the rest of the Aleutian Chain. There is no clear evidence of this, but it is certainly true that on Attu the art reached its most refined and delicate forms, often leading the general public to believe erroneously that all Aleut baskets are Attu baskets. The late Anfesia Shapsnikoff, researcher and a basketmaker herself, identified three major traditions in Aleut basketry: the fine Attuan weave; the Atkan style; and the Unalaskan style, which has a coarser texture and was used primarily for utilitarian purposes.

The exact origin of an Aleut basket is often difficult to pinpoint, but basketmakers of certain regions seem to have differentiated themselves from their island neighbors by fineness of weave, and by the form of the basket itself, the shape of its knob and the shape of its

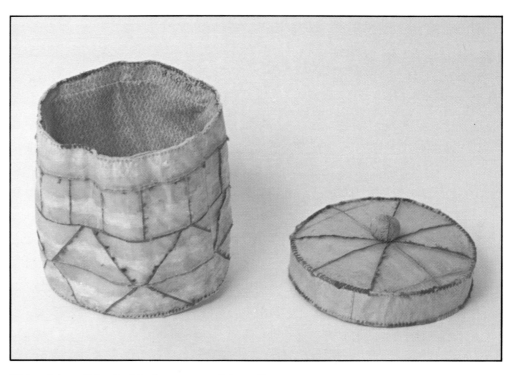

Thin strips of dyed skin form geometric patterns on this seal intestine canister, which is lined with red cotton cloth. The canister was made on Attu Island and may have been used for holding a woman's sewing implements, scraps and beads. It was collected by Sheldon Jackson in 1892. 6" high. (Sheldon Jackson Museum, an Alaska State Museum; photo by Ernest Manewal)

corners and rim. Attu knobs have short, thick stems and an unusual corner stitch; knobs on Atkan baskets are wider in circumference and nearly paper-thin, often sagging on their stems. Knobs on Unalaskan baskets are as heavy as those from Attu but have rounded edges and are seated on longer, slimmer stems, according to Shapsnikoff.

Ornamentation on baskets varied as well. Threads of silk and wool were used as

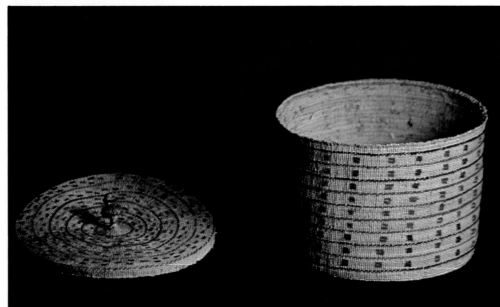

Left — May baskets — ornate open baskets with fluted rims — were popular trade items in the early 1900s. This basket shows European influence in its Greek key border and predominant design of roses, which do not grow in the Aleutians. (Alaska State Museum; reprinted from The ALASKA JOURNAL®)

Below — This sturdy covered basket is a good example of the Unalaskan style, generally coarser in texture than baskets made in other parts of the Aleutians. Decorations in red, blue and black yarn cover the surface of this basket. 6½" high (with cover); 6½" diameter. (Sheldon Jackson Museum, an Alaska State Museum; photo by Ernest Manewal)

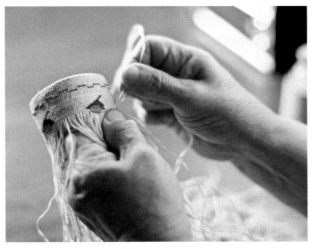

Atka basketmaker Vasha Golidorff expertly fashions a small, tightly woven basket. These fine baskets require a great deal of work, sometimes up to 15 hours per inch. (Lael Morgan, staff; reprinted from ALASKA GEOGRAPHIC®)

Aleut basketmaker and sculptor Gertrude Svarny, originally from Unalaska, occasionally combines the two crafts into a single piece, such as this soapstone carving. (Lael Morgan, staff)

Wild rye grass, also called beach grass, grows in profusion on the islands of the Aleutian Chain. Grass for basketmaking is gathered twice a year, then left in the open to dry or bundled and stored in a cool, dark place where it dries and loses color. (Both by Douglas Veltre)

decoration during historic times in all villages, but women in particular areas supplemented these commercial goods with more traditional decorations, such as eagle down and pieces of the parchment-like throat of the sculpin.

Wild rye grass, or beach grass, is still the predominant material used in Aleut basketry, although analysis of fibers found in archaeological sites on the Islands of the Four Mountains, particularly in the Kagamil Caves, shows early use of a variety of materials, including spruce roots and birch bark (both imports or trade items) and beach pea. The type of grass used and its method of preparation may have varied from region to region along with differences in style and technique.

Grass used for Aleut basketry is generally collected from hillsides during July and November. The stalks are sometimes left to cure in the open, but more often are bundled, placed in bags, and left in a dark, cool place where they dry and lose color. Grass is sometimes soaked in salt water during the curing process, which helps to bleach the stalks a light yellow. If fresh grass is to be used for baskets, it must be taken from the lower portion of the blade, which is lighter in color from lack of sunlight.

Blades of cured wild rye are split with long, adept fingernails to make the finest baskets. The baskets are made upside down, usually placed on a post or mold, with fine fibers of the warp hanging down from the base, which is rimmed by a decorative stitch called a turning stitch. Fine baskets take a great deal of time to make. Small lidded containers made by skilled basketmakers may take up to two weeks of full-time work, or approximately 15 hours per inch.

Two types of false embroidery or overlay work have been used to decorate Aleut baskets. Early basketmakers interspersed baleen, spruce roots, feathers and caribou hair with strands of

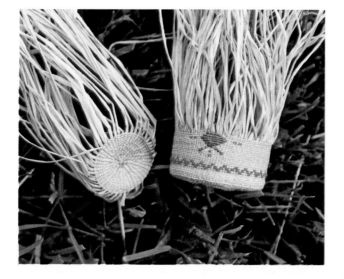

Rye grass continues to be skillfully twined into fine baskets. Aleut baskets are among the finest in the world, exhibiting up to 2,500 fibers per square inch. (Douglas Veltre)

colored grass, while silk threads and worsted wool predominated after contact. Early mats from Kagamil Island show outlined stripes and bands, sometimes forming a checkerboard pattern. Other mats combine variations of twined weaving techniques, creating interesting textural effects. Later baskets, made primarily for sale or trade, are decorated with intricate geometric and floral designs, often borrowed from Russian and American motifs popular during the period.

Card cases, also called cigar cases, made of two flattened and decorated cylinders which slip together to form a packet, were a popular trade item with sailors early in the century, who reputedly paid up to $12 for each one. May baskets (ornate open baskets with fluted, frilly rims) and covered bottles were also collected widely during this period. Today, the most

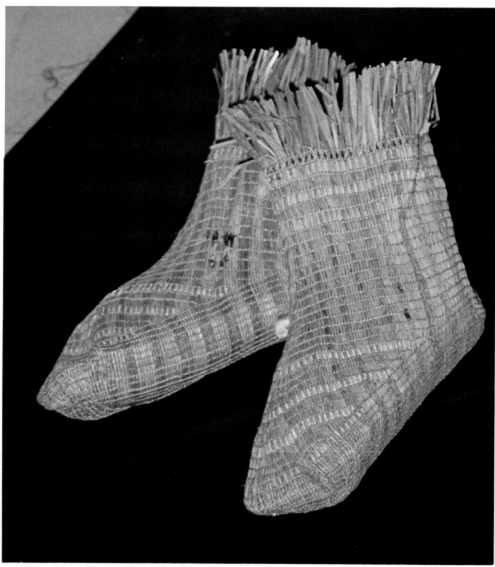

Aleut women, long known for their basketmaking skills, used grass to make many other useful items. These woven grass socks were made to serve as insoles in sea-lion and sealskin boots. (Collection of Sheldon Jackson Museum, an Alaska State Museum; photo by Lael Morgan, staff)

141

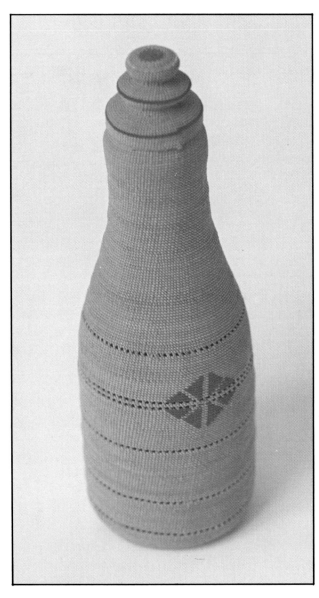

Twined grass covers this bottle, collected on Atka Island in 1922. The simple decorations are applied in red silk thread. 6½" high; 2" diameter.
(Sheldon Jackson Museum, an Alaska State Museum; photo by Ernest Manewal)

common Aleut basket is a small, finely woven cylinder with a lid and knob.

The pre-contact predecessors of these woven pieces were made primarily to be used. Early forms included hats, socks, mittens, various containers, purses and mats. Mats were used as blankets, capes, window shades and room dividers, and were probably a popular trade item. The dead of Kagamil Island and a few other regions were wrapped in finely woven mats, found by archaeologists and explorers in later years. The mats were usually rectangular (a few were oval) and sometimes reached a length of six feet. Most were decorated with simple bands of color, though later mats were more complex and focused on a central design. Mats required a tremendous amount of time to make, and as a result, most women ceased making them when western garments and bedding were introduced late in the 19th century.

Aleut women also made woven goods in many other forms. Cords, cables and fish line were woven of plant fibers and animal tissue. Some cables were apparently strong enough to haul a killed whale to shore. Baskets provided storage for personal items and food; some were used for carrying eggs and fish. Pouch- or sack-shaped baskets of various sizes, some with drawstring closures, were favored by many people. Some pieces were heavily and artistically decorated with tufts of animal hair and feathers, serving possibly as an influence on later Aleut twining and decorating techniques. Lidded baskets appear to be a fairly recent innovation, as none have apparently been discovered at archaeological sites.

Dr. Lydia Black believes birch bark was prized by Kagamil Island weavers. Of the two known examples of finished Aleut birch-bark baskets, one is decorated with designs similar

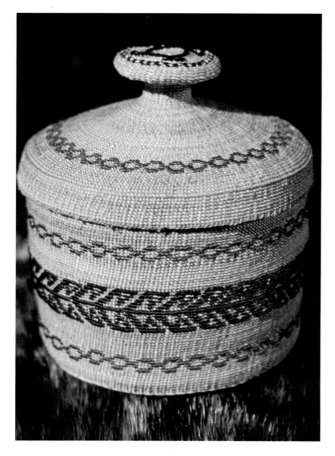

This finely woven grass basket was made by Agnes Thompson, an Aleut from the village of Atka who now lives in Anchorage. (Douglas Veltre)

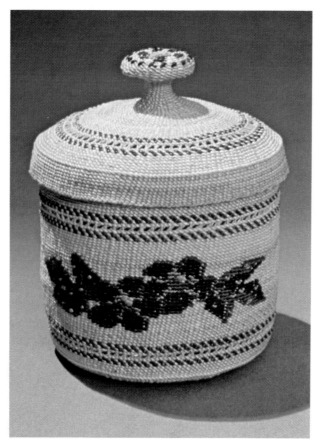

Simple openwork and floral designs decorate this small, lidded basket made by Agnes Thompson of Atka. (Alaska Native Arts & Crafts Association)

to the motifs used on Aleut hunting hats; the other is undecorated. Goods found in the graves of women of Kagamil and other areas include needle cases, other sewing devices and many rolls of birch bark, underlining the importance of this material to weavers. Birch-bark strips were also used in the geometric designs of false embroidery on other items.

Today, approximately 45 Aleut women make baskets much like those of their forebears. A workshop on Aleut basketry, sponsored by the Baranof Museum in Kodiak and the Institute of Alaska Native Arts in Fairbanks, was held at Kodiak in October 1981. The workshop was attended by 14 basketmakers as well as student participants and many onlookers. Although some members at the gathering expressed concern about the lack of interest in traditional

basketry by many young Aleuts, it was generally acknowledged that contemporary Aleut basketry is a growing, still innovative art.

Sewing and Embroidery

Kamleikas, waterproof gut parkas, represent the finest achievement of Aleut sewers and present a model for waterproof garments which can hardly be surpassed today. Sailors who visited the Aleutians quickly adopted native gear. Explorer Otto von Kotzebue is said to have outfitted the entire crew of his 1816-17 voyage with two *kamleikas* apiece. Since making a single gut garment took a seamstress nearly two months, such a request would certainly have taxed village women or literally stripped the garments from the backs of local Aleut hunters. Decorated *kamleikas* were already an important item of trade for aboriginal Aleuts, paid for by mainland groups with metal, shells and beads. After contact, the waterproof parka became a status symbol for visitors to the Aleutians. Shirts, capes and jackets of gut cut in the Russian style were popular among the Koniag and residents of the Pribilofs.

Kamleikas were made from sea lion, walrus, bear and whale intestine. The original Aleut style was easily distinguishable from the gut garments of Eskimo neighbors. The body of each parka was composed of horizontal gut strips approximately two inches wide. Seams were doubled and folded, sewn first with a fine running stitch and then with an overcast stitch of sinew thread, creating a waterproof seal. Most *kamleikas,* except those used for ceremonial purposes, had hoods. Colored strips of sea lion esophagus were often sewn or glued onto the *kamleika* as decoration, along with delicate loops and geometric patterns of tufted and embroidered hair. The garment was not only practical, but dazzling.

Koniag ceremonial garments were similar to Aleut *kamleikas.* Koniag women were often taken by the Aleuts in warfare and forced to sew *kamleikas* for the brisk trade; Aleut women were taken and enslaved by the Koniags in retaliation. Certainly sewing secrets and design preferences must have been exchanged in the process. Koniag and Aleut contact grew as time passed, and the Russians referred to the Koniag as Aleuts. Today, many Koniag consider themselves members of the Aleut cultural tradition, though their linguistic roots are actually *Alutiiq* Eskimo.

Carefully sewn kamleika *seams ensure a waterproof garment. This closeup shows how the seams are folded and tightly stitched. (Douglas Veltre)*

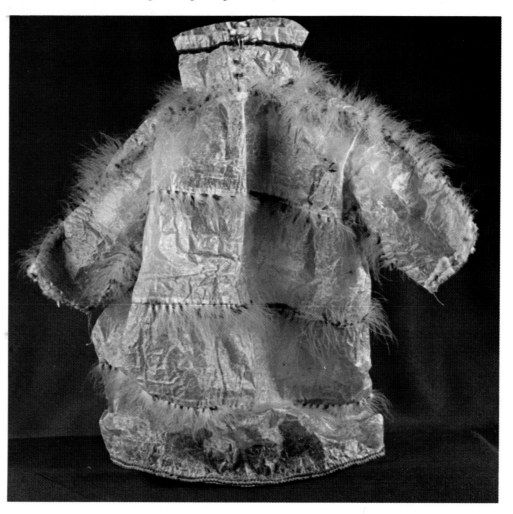

Left — *This drawstring pouch, collected by Sheldon Jackson in the late 19th century, is made from walrus intestine and decorated with dyed skin strips, colored yarn and eagle down. 7½" high. (Sheldon Jackson Museum, an Alaska State Museum; photo courtesy of Anchorage Museum)*

Below — *This child's kamleika, decorated with yarn and eagle down, was worn by Herman Von Scheele of Afognak Island about 100 years ago. (Baranof Museum, Erskine House; photo by Jerry Martini)*

Carving and Sculpture

The carving of bone and walrus ivory, most of it done for purely functional reasons, was the realm of Aleut men. (Walrus were accessible occasionally to the easternmost Aleuts, but were absent throughout the rest of the Chain. Most walrus ivory must have been traded between groups.) Spear-throwers, painted and often decorated with miniature ivory carvings or inlaid beads, represent prime examples of the skill of these early carvers, who made all of the weapons used in hunting and warfare, as well

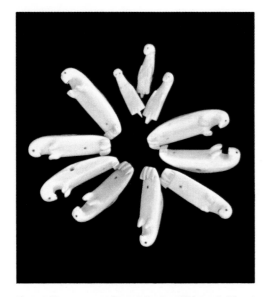

Sea otters, prominent in traditional Aleut mythology, occur frequently in historic Aleut carvings, such as these ivory charms. The charms are drilled at the back for sewing on as decoration at the tops of hunting hats and visors. (Kodiak Historical Society; photo by Nancy Kemp)

as ornaments for personal adornment and the sewing implements of village women.

The complexity of a particular carving and the decorations which adorned it apparently stemmed from the symbolic significance surrounding the object's intended use. Most Aleut ivory carvings collected around the time of contact are miniatures which represent male or female figures. Seated male figurines were often positioned on the front center of hunting hats and visors; female figurines are thought to have been used as fertility charms or as aids to women during childbirth.

Prominent in traditional Aleut mythology, sea otters are the figures which occur most commonly in Aleut ivory carving of this period. Otter figurines are elaborately crafted and painted. Each of them shows the sex of the otter, and many of the females are depicted in various poses with their offspring. Some examples are clothed in what appear to be festive parkas; others are carved with skeletal motifs and painted.

Carving and sculpture was transformed from a utilitarian and symbolic pursuit to a commercial art during the 19th century. Carvings from some regions began to take on humorous overtones, while others, either wood or ivory, took the form of complex calendars and board games. Some of these carvings were used in native households; others were traded or sold.

Shades of red from various minerals had magical connotations for both Aleuts and neighboring Eskimos. Grays came from copper ore, and various colors, obtained from minerals, vegetal dyes and human blood (from self-induced nosebleeds) were an important decorative and symbolic addition to all Aleut art, including sculpture. Scenes involving various animals, in specific colors, occurred occasionally on Aleut bows, and hunting hats

blended brightly painted geometric designs with representational and curvilinear motifs. Some scholars attribute the predominance of both curved shapes and multicolored painting in Aleut art to a link with cultures of the Northwest Coast. Widespread trading networks and the Aleut mastery of difficult seas would have made such influence possible, but whether or not actual contact took place remains a subject for further research.

Masks

Examples of masks used on various islands of the Aleutian Chain for shamanistic and ceremonial purposes are reported as early as the mid-18th century. Some of these early masks were described as bizarre representations of various animals, but many were apparently destroyed after use and none survive today. Aleut legends maintain that some masks were associated with ancient inhabitants of the region, a people apparently considered unrelated. Mariners collected at least two such legendary masks in the 1800s, calling them shaman's masks. One is a complex mask with a frame which may represent a helmet, and both show signs of having been worn.

On the Shumagin Islands, a group of cavelike chambers yielded important examples of Aleut masks late in the 19th century. Alphonse Louis Pinart visited one of these caves in 1871, recovering and documenting various artifacts associated with human burials, including masks. Pinart was convinced by local legends and the presence of artifacts related to sea hunting and war that the burials were the remains of Aleut whalers. Present day scholars generally agree with his theory.

Two years later, William H. Dall explored the same caves and found a number of well-

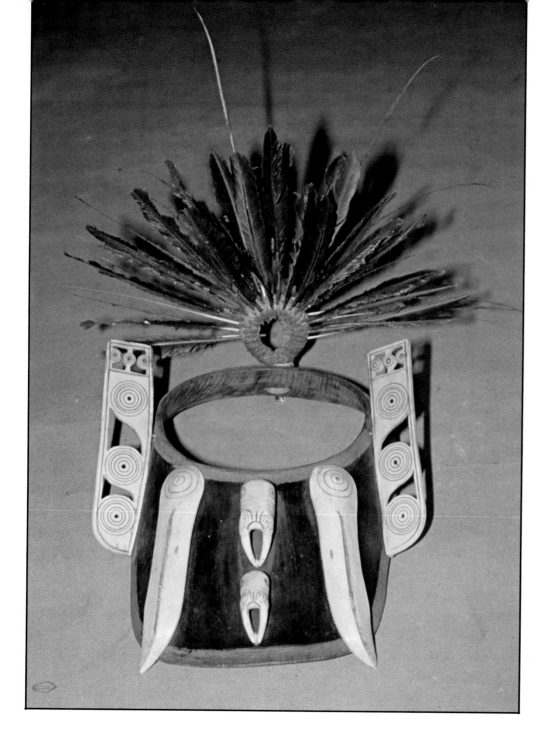

Left — This Eskimo hunting visor, made in the late 1800s, is similar to those worn by Aleut hunters. The visor is made from bent wood and decorated with cormorant and duck feathers and carved, engraved ivory pieces. (Collection of the Smithsonian Institution; photo by Lael Morgan, staff)

Below — Aleut artist John Hoover has become well-known for carved and painted wooden sculptures which open to reveal other forms inside. This piece is titled ''Cormorant Spirit.'' 48" x 12". (Anchorage Museum)

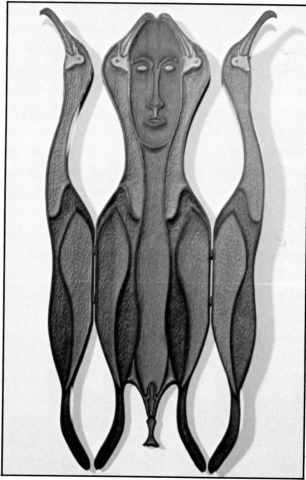

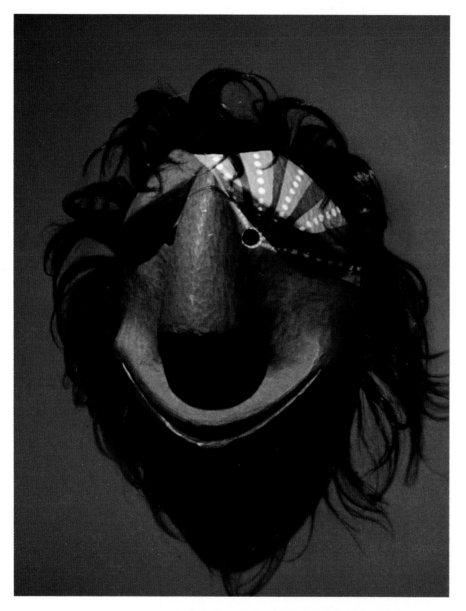

Aleut sculptor Fred Anderson, former sculpture studio manager at the Visual Arts Center in Anchorage, is known for his carved wood masks and large sculpture. 9" x 5". (Anchorage Museum)

preserved masks, all of which had once been painted. Some of these masks, many of them now in the Smithsonian Institution, have attached ears, and pegs where tooth grips for wearing the masks would have been placed. Other pegs and holes were used for inserting feathers or carved wooden appendages similar to those of Eskimo masks of southern Alaska today. Fragments of composite masks, those decorated with feathers, appendages or movable parts, have been found on Kagamil Island in association with burials at levels much lower and more ancient than the renowned mummy burials at the surface.

Early accounts of masked Aleut dances say that performers of both sexes participated in the ceremonies, and that each dance was accompanied by special songs. Composite masks are said to have been the products of the imaginations of individual carvers. Most masks were apparently hidden in caves or secret places when the ceremony ended, possibly for good luck. Bone masks worn by members of burial parties in some regions were broken and discarded at the gravesite when funeral rites were completed.

Today, no Aleut mask makers in the old tradition survive, so further explanation of the use and significance of masks already collected depends on future archaeological investigation.

Bentwood Headgear

Visors made from wood or skin were used by oceangoing Eskimo hunters from Norton Sound to Kotzebue Sound, while conical bentwood hats were worn by the Eskimos of southern Alaska, and later, by hunters and warriors of most islands of the Aleutian Chain.

A bentwood hat was an Aleut man's finest possession. Many examples now housed in museum collections show that their owners

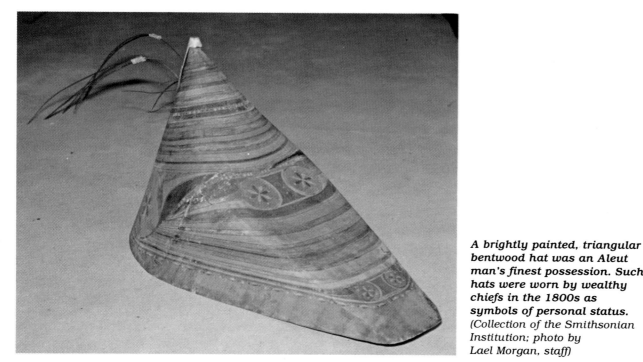

A brightly painted, triangular bentwood hat was an Aleut man's finest possession. Such hats were worn by wealthy chiefs in the 1800s as symbols of personal status. (Collection of the Smithsonian Institution; photo by Lael Morgan, staff)

made extensive, careful repairs. They were also expensive: a single hat might have cost from one to three slaves, a substantial portion of even a wealthy man's possessions.

Ornate painted and decorated triangular hats with a closed crown were worn by wealthy chiefs, particularly in the eastern Aleutians, as a symbol of personal status, privilege and local alliance with other groups. These hats became fashionable around 1800 when Russian fur-traders began to court the favor of high-ranking Aleuts, identifiable because of their hats, in hopes of influencing the rest of the group. These long-visored hats became common after contact, perhaps because more men could afford them with the income earned from the Russian American Company during fur trade.

Functionally, these hats probably underlined the skills of an Aleut warrior in battle, as well as his rank. Sea-lion bristles were placed on hats as a testimonial to the skill of a hunter. Some hats spoke of the capture of nearly 40 sea lions. Hunting hats, which were never worn on land, were also designed to ward off glare and spray, and to secure the hood of a hunter's *kamleika* against the wind. Aleut hunters were apparently trained never to turn their heads, but instead to scan the horizon with only their eyes, a motion the hat would effectively have hidden. This motionless position may have had practical overtones as well, as the long visor could have been prone to catching gusts of wind, tipping *bidarka* and hunter into the sea.

Symbolically, the pointed visor and its ornate decorations resemble a bird in flight or the head of a predatory animal. This might have been to

The two hunters in this model bidarka, collected at Unalaska, are dressed in kamleikas. The front man wears a bentwood hat; the other, a wooden visor. Both hats are painted and decorated with beads. (Collection of the Smithsonian Institution; photo by Lael Morgan, staff)

attract good luck to the hunt or even to distract the hunted animal.

Hats were made of driftwood, including spruce, birch, oak and cedar, by male artisans assisted by young apprentices, who sometimes worked several weeks on a single hat. The wood was steamed, then bent into a circular form and stitched at the back with sinew. Wooden braces were applied to the inside of the rear seams. On long-visored hats, the rear seams were often covered on the outside by slim plates of painted bone or ivory.

Bentwood hats were brightly painted: some exhibited simple multicolored horizontal bands; others combined geometric motifs with curvilinear designs somewhat reminiscent of

Fishing in Kodiak

By John Blaine

Editor's note: *John Blaine, former executive director of the Alaska State Council on the Arts, is currently director of the Visual Arts Center in Anchorage. He became acquainted with Aleut artist Alvin Amason in 1980, when Amason was a member of the arts council. The following is an account of a fishing trip the two men took on Kodiak Island, Amason's home.*

We got into Alvin Amason's motorboat on a cool September afternoon and bounced out into the bay, soon coming to a pretty half-moon beach. I helped him throw out the gill net and the floats and we left them in the water while we went up the beach to have lunch. As we ate, Alvin told me about going to pick up some tourists just a little farther along the coast one time years before. He was with an Aleut friend, and when they got to the pick-up place, they saw the tourists cooking salmon over a campfire. They also saw a big old Kodiak bear coming toward the salmon . . . and the tourists. Alvin shouted, "You gotta gun?"

"Yes," one of them answered.

"You better use it. There's a bear coming toward you, back there . . ."

The tourist raised his rifle and shot over the bear's head. The bear stopped for a moment, and then just kept on coming. He shot again, and this time the bear didn't even pause.

About that time, Alvin's friend jumped out of the boat and trotted up the beach. He had a little .22 pistol and he shouted at the bear and shot his little pea-shooter. The bear stopped, stood

up on his haunches and sniffed a little, then dropped down and ran off the other way.

Alvin said to his friend, "That bear must have smelled an Aleut."

"Naw," his friend said, pulling a Russian Orthodox cross out of his shirt front. "He knew I had this."

Alvin said he got three or four good pictures out of that experience, big oil paintings of bears with titles such as "I'll Be Watching You," and "Papa Would Like You."

We finished up lunch, and went out to see if we'd caught anything. The net was heavy when we pulled on it. But the first fish that came out was nothing more than a bloody head. Alvin and I both saw a very large gray seal a little way off just then, and Alvin said seals were terrible thieves and would take a whole catch if they could get away with it. We pulled the net in some more, and wound up with a king, 12 or 13 big pinks, a steelhead, and another bodyless head.

The sky was crystal blue with a few puffs of cloud in it. A few birds flew up high. One might have been an eagle. I'd never been fishing in Alaska before, and this was magic. Alvin said it was not a bad catch, but not really a good one either. We started the engine and headed back for Kodiak, looking out for the big gray seal.

"The Eagle Gave Me Fish Today" is one of several paintings Alvin Amason completed following a fishing trip to Kodiak.
(John Blaine)

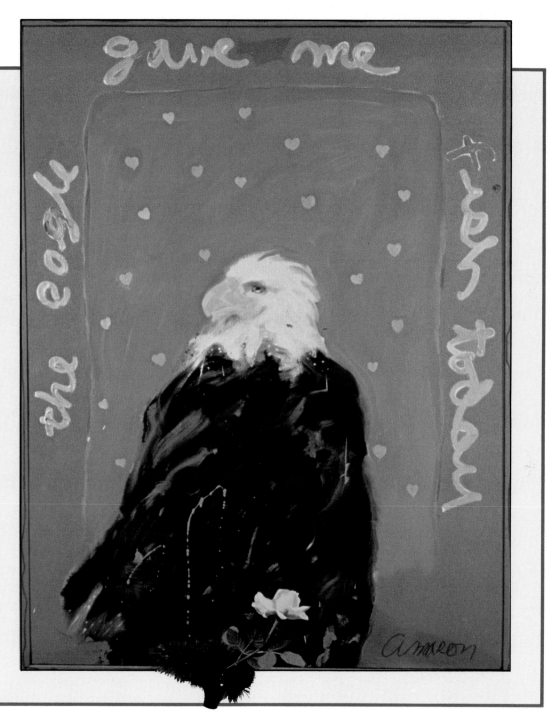

Tlingit symbols. Scenes involving confrontations between hunters and sea mammals are found on some hats. The application of paint and the colors chosen may have been purely decorative, but it is likely that both had symbolic meaning, as the use of color did for most other aboriginal Alaskans.

Ivory carvings and other ornaments adorned the hats. In addition to the ivory strip covering the rear seam, an ivory figurine perched on the center front of most hats, into which the whiskers of captured sea lions were inserted. Among the Aleut, this tiny sculpture was almost always a human figure, while Yupik hunters generally wore stylized bird and sea mammal decorations. Elaborately carved ivory side pieces, called volutes, decorated each Aleut hat. These rectangular or wedge-shaped decorations were carved with ornate geometric and spiral motifs. Some clearly represent the head and long beak of a bird. Carved birds and animals, trade beads or miniature hunting scenes were often attached to the upper edge of the volute.

Sea-lion whiskers and strands of trade beads festooned Aleut hats. Originally, amber obtained from local sources and beads traded from the mainland were used; large, opaque Russian beads became popular after contact. A small teardrop-shaped loop of glass beads was secured to the top of the hat, and tiny seed beads were sometimes inlaid into the wood.

Chugach Eskimo and Koniag hunters wore hats woven of roots which resembled headgear of the Northwest Coast, and carved wooden hats shaped like the head of a seal. Koniag men are also said to have worn eyeshades or visors elaborately set with beads, and probably with amber. Visors of stiff leather and wood were used by hunters of the Bering Strait region, while farther north, wooden goggles were used instead. Finely embroidered hats were made by Aleut women for ceremonial purposes. Simple visors were probably the earliest form of Aleut headgear, transformed after Russian contact into the artistic conical hats referred to here.

Contemporary Aleut Art

In addition to basket-making contemporary Aleut artists work in various media including sculpture, mask making and painting.

Gertrude Svarny of Unalaska, for example, carves realistic whale bone figures, some of which are involved in traditional activities such as making baskets.

John Hoover, an Aleut sculptor now living in Washington state, has developed a style which draws upon traditional motifs, yet minimizes them through the use of nontraditional forms. Hoover works primarily in wood: many of his wall pieces are hinged triptychs which open to reveal painted animals and human faces.

Another well-known Aleut artist, Fred Anderson, works chiefly in stone and wood. Anderson, former sculpture studio manager at the Visual Arts Center in Anchorage, is known for large sculptures and carved wooden masks which reflect his Aleut heritage.

Alvin Amason, originally from Kodiak, has become nationally known for his large whimsical paintings of Alaskan animals and scenery.

"Volcano Woman," carved in red cedar by Aleut sculptor John Hoover, was commissioned by the Municipality of Anchorage for the new William A. Egan Civic and Convention Center. The grouping depicts the Aleut creation legend in which cormorants watch as the first woman emerges from the crater of a volcano. The cormorants then fly over the land, distributing the woman's offspring and thus populating the Aleutian Islands. (Jimmie Froehlich; courtesy of the Municipality of Anchorage)

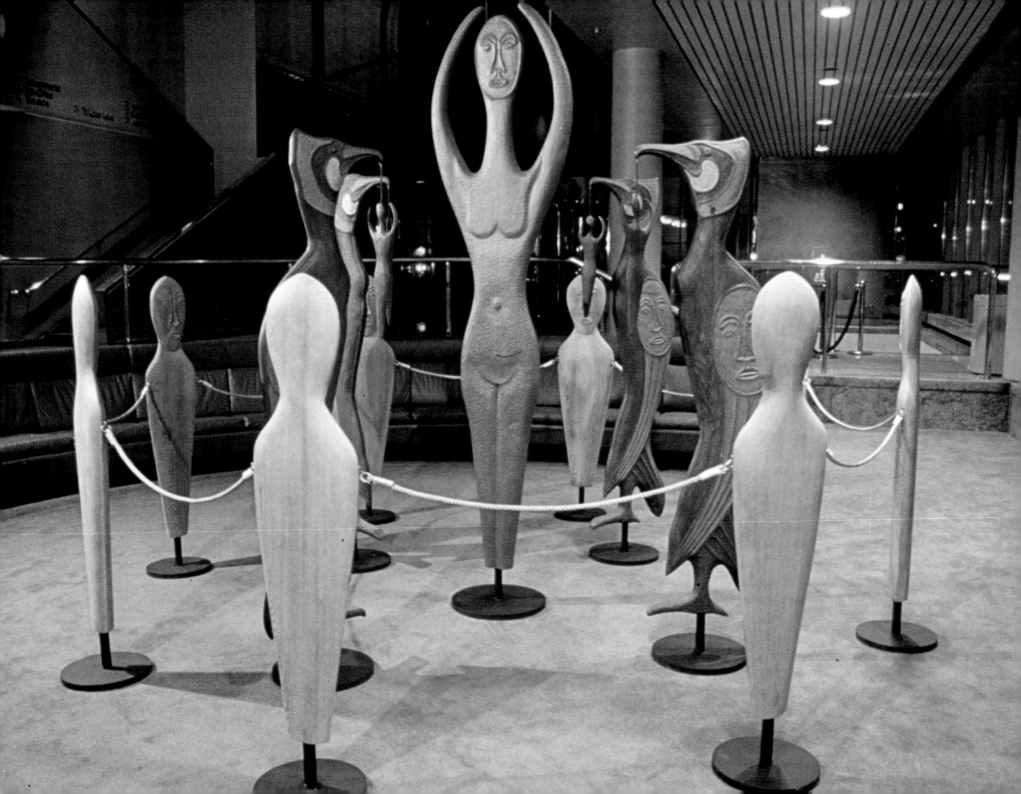

The Northwest Coast

Natives of the Northwest Coast inhabit a rugged, bountiful coastline, stretching from northern California to Alaska's Yakutat Bay, thousands of miles north. Many different tribal groups occupy this coastal environment, each using a high degree of technology which makes efficient use of the region's abundant resources. This resulted historically in leisure time for many people, allowing the pursuit and development of a masterful and consistent artistic style.

Alaskan tribes which make up part of the Northwest Coast culture complex include the Tlingit and Haida, and the Tsimshian, who moved from the lower Skeena River in Canada to Alaska in 1887. The Eyak, just north of Tlingit territory, are members of the Na-Dene language family which includes Tlingit, Haida, Athabascan and other groups, but the Eyak do not share the cultural traits of other Northwest Coast tribes.

South of the Tsimshians are the Kwakiutl, Bella Bella and Bella Coola tribes, and the Coast Salish, who once occupied much of modern coastal Washington state. The Nootka and Makah, expert whalers, inhabited the ocean side of Vancouver Island and parts of Washington; the Chinook resided on the lower Columbia River. A variety of tribes were located on the Oregon coast, including the Coos, Umpqua and Tolowa-Tutuni, who extended into northern California. The Yurok, Karok, Hupa, Wiyot and other groups who were known as fine basketmakers also inhabited coastal

Kerfed or bentwood boxes such as this were made from a single plank and were used to store a variety of materials. Some were watertight, for holding food and liquids; others were used to store household goods. The boxes were decorated with the clan crests of their owners. (Steve McCutcheon)

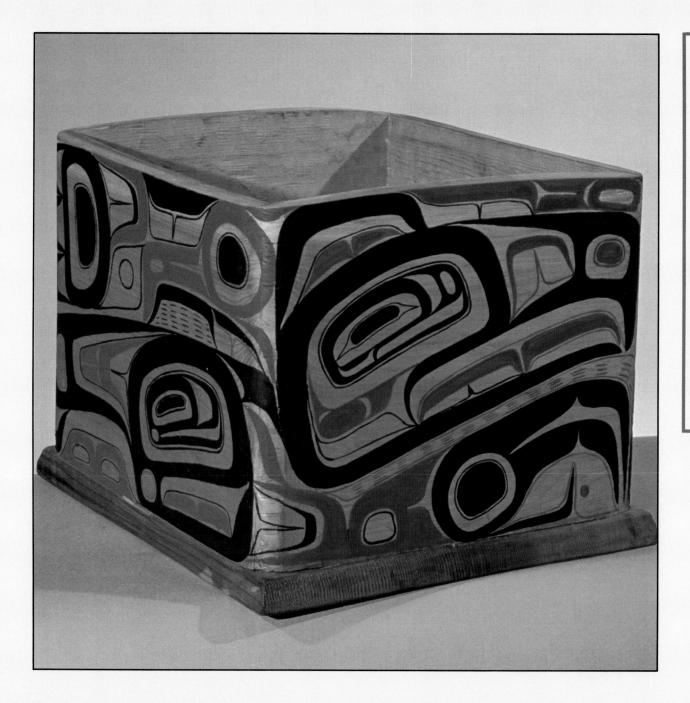

"The movement of the design is entirely self-contained. It may carry to the very edge of the decorated area, but always returns at the last instant, never tempting the viewer to leave the little universe of design."

Bill Holm,
Northwest Coast Indian Art: An Analysis of Form

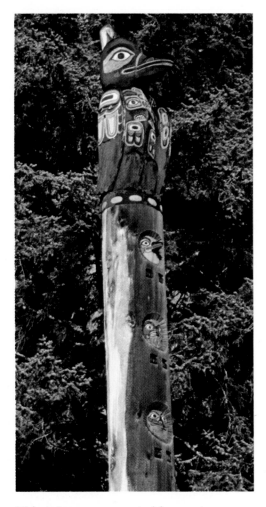

This totem, surmounted by a raven figure, was erected in 1941 to mark the original site of Auke Village. The totem shows the Auke Tlingit's clan symbol, representing the Big Dipper. (Susan W. Fair)

California as far south as Cape Mendocino, where traits of the Northwest Coast culture abruptly stop.

This complicated diversity of tribes and languages suggests that the Northwest Coast was settled by groups who came in a series of migrations, possibly for different reasons. Archaeological evidence hints at a movement from interior to coast; oral tradition of the Tsimshians upholds this theory, describing a migration of their ancestors from a legendary site in Canada's interior.

Tales tell of famine, deep snow and semisubterranean dwellings, all components of life in the interior. Early Tsimshians, for unknown reasons, began at some point to migrate to rich salmon fishing areas near Canada's Skeena River, where they settled and remain today. Other Tsimshian groups moved toward the coast, establishing large winter villages and driving Tlingit inhabitants north. In the mid-1800s a group of Tsimshians and their chiefs converted to Christianity under the dictates of missionary William Duncan, left their home at Fort Simpson, British Columbia, and abandoned most of their traditional ways to resettle eventually at New Metlakatla on Annette Island, Alaska, in 1887.

Tlingit origin legends and linguistic evidence clearly establish the Tlingits as distantly related to interior Na-Dene speakers. Haida tradition, however, apparently recognizes no ancestral home other than the Queen Charlotte Islands. Unfortunately, conditions in the rain forests of the Northwest Coast do not favor preservation of the implements used by its early inhabitants — wooden objects, for example, last fewer than 100 years in the damp climate, and sites are speedily covered by vegetation. Linguistic studies combine with oral histories and archaeological evidence, adding to our knowledge about the origins of people in most regions, though the sequence of their migrations and settlement cannot be fixed accurately in time. Future archaeology alone will determine their sequence of arrival and resulting adoption of Northwest Coast cultural patterns.

The Northwest Coast environment is relatively consistent. The coastline, particularly from Puget Sound north to the Gulf of Alaska and on the larger islands, is characterized by a chain of steep, rugged mountains which descend directly into the ocean, and by rugged valleys, fjords and glaciers to the north.

An attractive feature of this region is its relatively mild climate. The Japanese Current, which flows south along the western shore of the continent, produces even temperatures, heavy precipitation and only slight variation in seasons. The coastal mountains serve as a barrier, forcing warm rising air back to earth in the form of rain and shutting out weather from the subarctic interior. Many areas along the Northwest Coast receive an average of more than 100 inches of rainfall per year.

The rainfall, mild temperatures and thin soils result in a combination of plant life unique in North America. Spruce and fir are common in the northern regions of Alaska's Panhandle, giving way to two species of cedar, yew, hemlock and finally coastal redwood in the south. The size of both red and yellow cedar and their suitability for carving have contributed dramatically to the development of monumental characteristics in Northwest Coast art.

All that remains of many traditional southeastern Alaska native villages are upright posts and beams. Wealthy Northwest Coast groups often built immense, prestigious houses, sometimes as large as 100 feet by 60 feet. (USDA Forest Service, Tongass National Forest, Ketchikan Area)

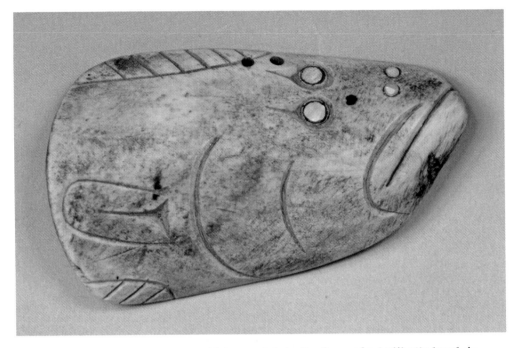

This amulet, in the form of a halibut's head, is carved from bone and ornamented with pieces of abalone shell. 4½" x 1½". (Sheldon Jackson Museum, an Alaska State Museum; photo by Ernest Manewal)

Smaller plants, fish, birds and marine and land mammals contributed an abundance of food to aboriginal inhabitants of the region, just as they do for residents today. Five species of salmon ascend coastal rivers to spawn each year. Halibut, herring, eulachon, cod and many types of mollusks are plentiful. Whales appear off the coast, hunted in the past by Nootka and Makah whalers. Seal, otter and sea lions are common. Land mammals, including mountain goats, grizzly and black bears and many species of fur-bearing animals live in the region. Deer are abundant, as are both migratory and resident birds.

Aboriginal technology along the coast was highly adapted to this rich environment. A dependence on and deep respect for the abundant resources form a framework for Northwest Coast social organization and religious ideologies, and for the art that was an integral part of them.

Some knowledge of the social structure of the tribes who populated the Northwest Coast is critical in achieving a basic understanding of their art and the meaning of its dramatic and unusual symbols.

The house group is perhaps the most basic unit of Northwest Coast social organization, but other larger social structures exist. Tlingit and Haida are separated into two major divisions, called moieties, known as Ravens and Eagles. (Eagles are referred to as Wolves in some villages.) Every member of the tribe is born into one of these two groups, and each individual must marry a member of the opposite moiety. Functionally, this system operates on the theory of checks and balances, keeping wealth, services and bloodlines flowing constantly between opposite poles.

Each moiety possesses totemic crests and each is divided into a number of clans, each with its own crest. These crests, including those of the house groups, are executed and displayed in various forms which we refer to as Northwest Coast art. These complex and beautiful symbols are much more than decorative art. They are visual references and actual possessions tying the entire clan together, linking present members of the group with their ancestors and establishing the clan's place within the larger tribe.

Members of male kin groups and their spouses resided together in large cedar-plank houses which lined the shore of the village and faced the sea. Wealthy house groups often built

immense, prestigious houses, sometimes as large as 100 feet long by 60 feet wide. Household members consisted of as many as 100 individuals, the males all related to common female ancestors. These house groups shared daily activities including the distribution of food. They collectively owned property, myths and legends. They monitored one another's conduct, and worked essentially as a unit.

Each house was governed by a chief, the highest ranking male of the house. Though this individual controlled many group activities and could even wage war or establish peace, he acted only as a trustee of communal property such as totemic house crests or prime berry patches.

These large houses were built in a formal and ceremonial manner by men from the opposite moiety of the house group itself. Each house bears a totemic name and each is a work of art, displaying the elaborate totemic crests and emblems of the kinship group who lives in the house. The walls also surround the mythical ancestral information known to those individuals. In one sense, the Northwest Coast house harbored, nurtured and structured the lives of members of the resident group.

Houses were used for ceremonial functions and normal household activities. The chief and his family generally lived at the rear of the house behind a cedar plank screen painted with household crests. House posts were often elaborately carved and painted and totem poles stood outside some of the houses. Ceremonial property, including woven blankets, carved and painted wooden boxes, and masks, was evident everywhere.

Northwest Coast native societies were socially stratified. Each individual had, and still has, a social position within the larger structure of the

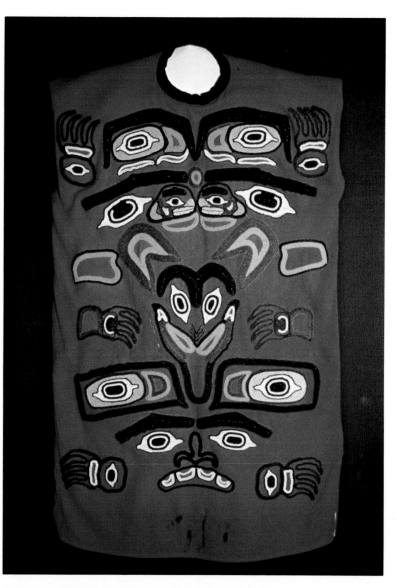

This ornately beaded "wolf shirt" of red woolen trade cloth was worn on ceremonial occasions. The shirt is appliqued with totemic clan crests in yellow, black, blue and green beads. 40" x 22". (Sheldon Jackson Museum, an Alaska State Museum; photo by Alice Hoveman)

Right — *Tlingit chiefs and their families generally lived in apartments at the rear of their houses, behind large cedar plank screens. The screens were carved and painted with totemic crests. This 1890s photo of the Rain Screen and house posts at the Whale House in Klukwan includes many other interesting Tlingit artifacts. (Winter & Pond photo, courtesy of Alaska Historical Library; reprinted from ALASKA® magazine)*

Below — *This Tlingit spruce-root rattle-top basket, collected by Sheldon Jackson in 1888, is decorated with a pattern identified by Frances Paul as "white feet of the sun radiating from clouds." The knob contains pebbles or shot, which produce a rattle. 8" diameter. (Sheldon Jackson Museum, an Alaska State Museum; photo by Ernest Manewal)*

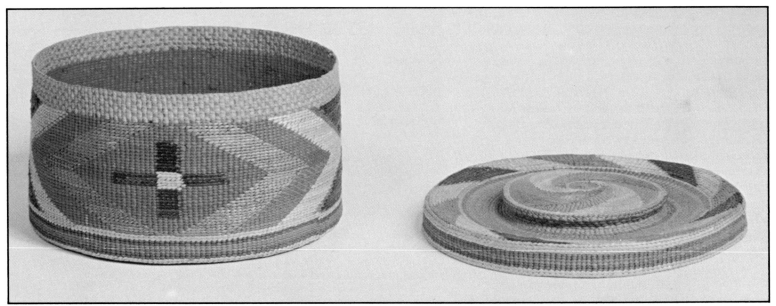

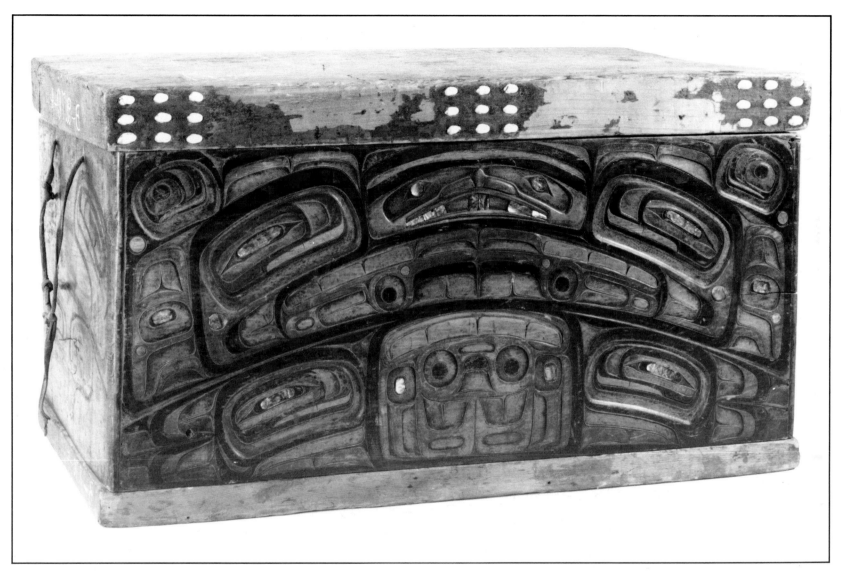

*Large kerfed storage chests were part of every
wealthy Northwest Coast household. This box,
which is painted red and black and inlaid with
shell and operculum, may once have held prized
clan heirlooms. 37¾" long. (Smithsonian
Institution; 274 488)*

tribe. Further, tribes recognized several classes, including nobles and commoners, and a class of slaves mainly made up of outsiders who had been captured in warfare. Membership in the class structure was hereditary. In the northern regions, particularly among the Tlingit and Haida, status — the right and privilege to own and do many things — and material wealth were transmitted through female lines. Inherited rank and wealth were not enough to ensure an individual's continued status in the tribe, however. The custom of potlatching allowed high-ranking chiefs to accumulate wealth and publicly proclaim their status. It also provided stimulus for individuals of lower rank to move up in the social hierarchy, gradually stripping a few of their superiors of privileges reserved for the higher classes.

The Potlatch

The most visible and prestigious display of rank among the tribes of the Northwest Coast was the ceremony known as the potlatch. The term potlatch, which means "to give," originally came from Chinook jargon, a widely used trade language. The term has now been adopted by other culture groups to designate ceremonies in which the deceased are honored and gifts are distributed.

Potlatches of Northwest Coast tribes were ostensibly given to announce social events important to the entire group. These might

This dramatic headdress belonged to "Bebe," a Klukwan Tlingit who died in Juneau in 1929 at the age of 104. She was the wife of Berner's Bay Jim — said to have been a shaman. The headdress is made from dentalium shells, beads of several colors, red flannel strips, red satin ribbons and abalone accents. (Alaska State Museum; photo by Al Blaker)

include a marriage, a death, the building of a large house or the birth of an heir. In reality, however, the ceremony served to publicly and dramatically underline the rank of the giver, revalidating ownership of art and crests, and to unify the local group and clan. Components of potlatches, past and present, include gift-giving, feasting, oratory and sometimes the claiming or transfer of names and positions of rank. Ceremonial items, including clothing, hats and staffs, are worn or brought out during the potlatch, and stories are told about the origin of the crest. Those who received gifts were always members of the opposite clan and gifts given were carefully gauged to reflect the status of the recipient. This strategy immediately created an obligation not only to reciprocate, but to outdo the lavish attention given to the guests. Economically, the potlatch served to redistribute accumulated surplus goods of all kinds among members of the tribe.

Occasionally, dramatic destruction of personal possessions occurred, showing those in attendance how little vast wealth meant to the host, whose status then grew in proportion to his scorn of material goods. Among the Kwakiutl, who were once renowned warriors, potlatching replaced bloodshed and enemies were figuratively (and almost literally) buried under gifts and ensuing obligations. Kwakiutl oral history underscores this aggressive

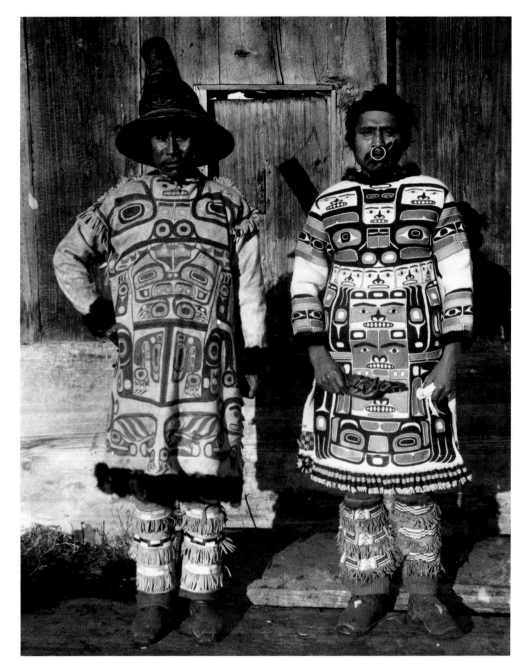

Two Chilkat chiefs in full dancing costume pose for this portrait in 1895. The man on the left wears a ceremonial garment of buckskin, trimmed with fur, and a woven spruce-root hat with potlatch rings. The other man's garment is woven, probably of dyed mountain goat wool. He holds a carved wood raven rattle. (Winter & Pond photo, courtesy of Alaska Historical Library; reprinted from The ALASKA JOURNAL®)

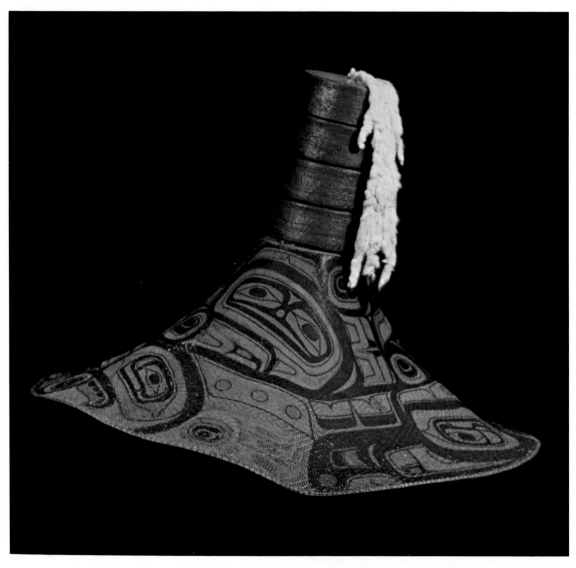

Topped with an ermine skin, this ornate twined spruce-root hat is said to have been taken from the body of a Wrangell chief killed in battle in Sitka in the 1850s. The four hollow potlatch rings at the crest of the hat indicate the number of potlatches given by the hat's owner. 24" diameter.
(Alaska State Museum; photo by Al Blaker)

strategy; the tribe's term for potlatch means "to flatten." Valuable *tinnehs* (highly prized copper plaques) were often broken during potlatches and other public displays of wealth, as a means of emphasizing individual rank through a scorn for personal property. Coppers were also anthropomorphized as dead warriors. Songs sung during the potlatch took their imagery directly from war, according to scholar Helen Codere.

Northwest Coast Art and Its Development

The first examples of Northwest Coast art are petroglyphs found in various locations up and down the coast. Then, about 2,000 years ago, a tradition of crest or totemic painting, now called the Northern Graphic Tradition, appeared on prehistoric artifacts from the region where today's Coast Tsimshian live. This style, in combination with the earlier carved or sculptural tradition, influenced many early Northwest Coast groups.

Historically, the people of the Northwest Coast have welcomed new methods and ideas. Iron tools obtained in trade from visiting mariners effectively replaced aboriginal stone implements, and commercial dyes and paints supplanted many native pigments, which were more subtle in hue. Argillite, a black slate found in the Queen Charlotte Islands, was carved by the Haida into pipes, jewelry and miniature totem poles as early as 1820, forming the beginnings of an art form primarily oriented toward the tourist trade. Argillite pieces are now sought by collectors and museums.

Northwest Coast artists usually began working as teenagers apprenticed to master carvers. Periods of apprenticeship involved many years and required not only complete understanding of the formal application of

prescribed forms, but highly developed technical skills and a sensitive individual style. Most artists apparently did not work full-time, but continued to participate in the seasonal and traditional activities of their tribe. Gifted carvers (carvers were always male) were recognized by all for their unique and important talents and were accorded high status.

Some carvers were supported by patrons, particularly after western contact stimulated the commission of large, expensive pieces from individual artists. Members of the opposite moiety were commissioned to do artwork.

Native patrons of Northwest Coast art were wealthy and farsighted individuals of high rank; the art they commissioned served as a signpost of their own status. Commissioned masks were carefully designed to startle, mesmerize and outshine rivals; totem poles might delineate a clan's history or publicly ridicule an enemy; and price was unimportant. Patrons always held the highest tribal honors and therefore owned many privileges and knew many details about clan histories which were not widely known. The lengthy, open relationship between patron and carver aided in the transmission and preservation of these legends and secrets, thus ensuring not only an artistic celebration of a particular event but entrusting the secrets to a member of the opposite group. This process guaranteed a wider distribution of clan memory and may have helped to strengthen social structure as a whole.

The period between 1860 and 1900 brought enormous and destructive change to the Northwest Coast. Diseases such as smallpox and measles, introduced through western contact, drastically reduced native populations. The powerful Chinook and Bella Bella, as well as other groups, all but disappeared.

With this decimation came other more subtle

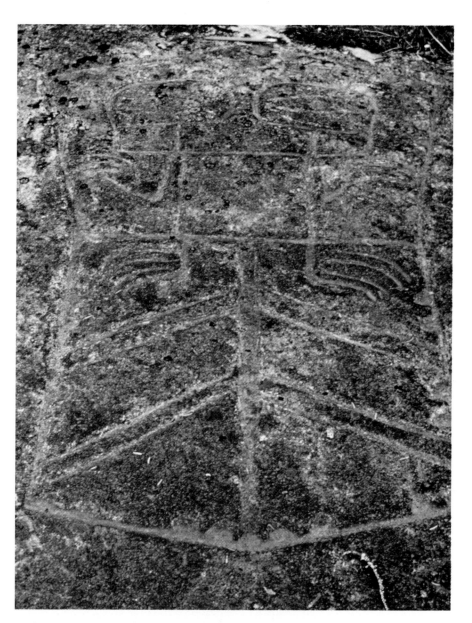

This petroglyph, representing a copper, may have been carved because a debt had not been paid.
(USDA Forest Service, Tongass National Forest, Ketchikan Area)

This pictograph, or rock painting, from the wall of a cave in southeastern Alaska represents a raven in flight. He holds a round object in his beak, possibly illustrating the legend in which Raven stole the sun, thus leaving the world in darkness.
(USDA Forest Service, Tongass National Forest, Ketchikan Area)

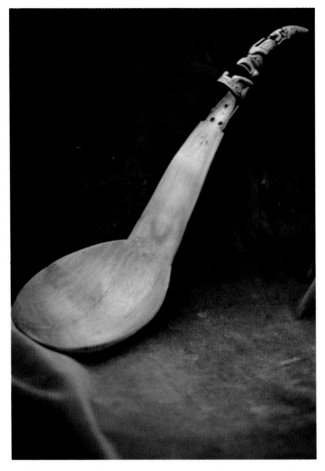

Above — *Horn spoons, used at potlatches, were made by steaming and molding sheep or goat horn. This spoon has a bowl and handle made from sheep horn, and is decorated with darker, intricately carved goat horn. (Collection of Sheldon Jackson Museum, an Alaska State Museum; photo by Lael Morgan, reprinted from ALASKA GEOGRAPHIC®)*

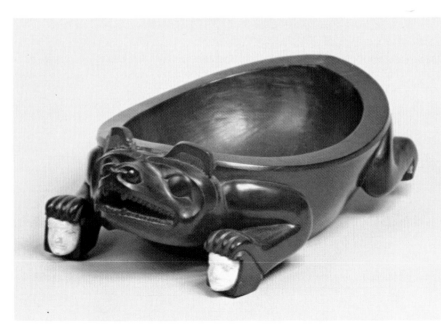

Left — *Miniature faces carved in bone adorn the paws of this Haida argillite dish, thought to represent a bear. The dish was collected by Sheldon Jackson in 1888. 9¾" x 5¾". (Sheldon Jackson Museum, an Alaska State Museum; photo by Ernest Manewal)*

but equally devastating transformations. New Canadian and American laws conflicted with traditional values and caused confusion. The shamans' inability to deal with the new diseases also made the Natives more receptive to Christianity. Missionaries, who believed the Natives were worshipping totems, attempted and sometimes succeeded in smothering native spiritual beliefs. While converting tribes to Christianity, they deliberately destroyed the finest examples of visual art, songs, dance and drama.

The introduction of western goods and alcohol shook the entire social structure of the tribes. Traditional customs began to disappear. The potlatch, outlawed in Canada in the 1870s because missionaries and government agents objected to the extravagant ceremonies, was eliminated in some villages and went underground in others. Traditional leaders were sometimes discredited in their own communities, their values and authority ridiculed or challenged.

By the early part of this century, although a few tribes covertly practiced traditional ways or combined traditional ideology with Christianity, the works of art which had once been the proud and visible hallmark of these tribes had been completely destroyed or lay rotting in villages and forests. New artwork was rarely made. The potlatch, with all of its impetus for the production of new and finer art, was practiced in only a few villages.

Anthropologists, collectors and even some missionaries and educators, such as Sheldon Jackson, aware of the predicament of these cultures, rushed to the region and collected quantities of masks and other ceremonial paraphernalia. Although this practice preserved some of the material for museum collections and future research, at the same time it deprived many communites of all of their prized

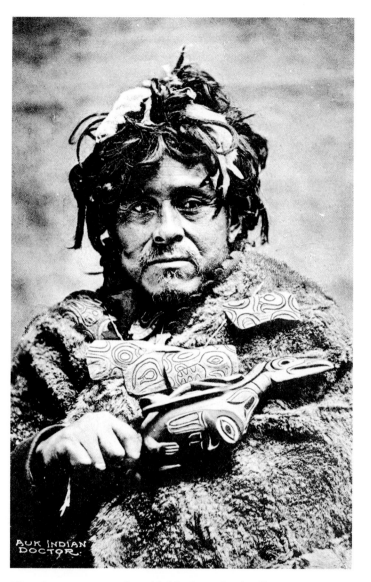

The shaman was a formidable force in the lives of Northwest Coast Natives. This "Auk Indian Doctor" wears carved charms around his neck and holds a raven rattle. (Courtesy of Katheryn E. Marriott; reprinted from The ALASKA JOURNAL®)

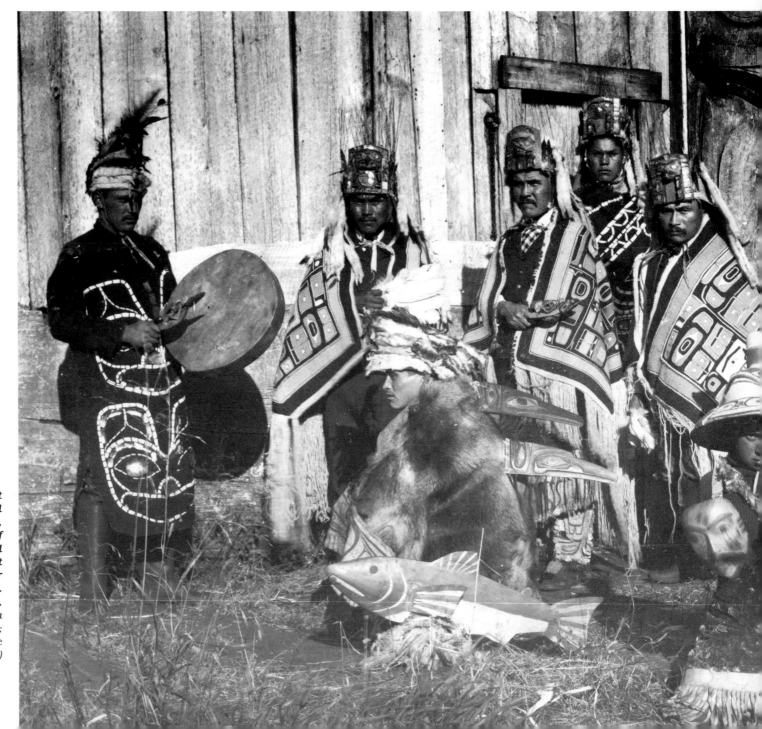

A group of Chilkat dancers, in full ceremonial costume, poses in 1895. Three of the dancers are dressed in woven Chilkat blankets; four wear elaborate frontlets. *(Winter & Pond photo, courtesy of Alaska Historical Library; reprinted from* The ALASKA JOURNAL®*)*

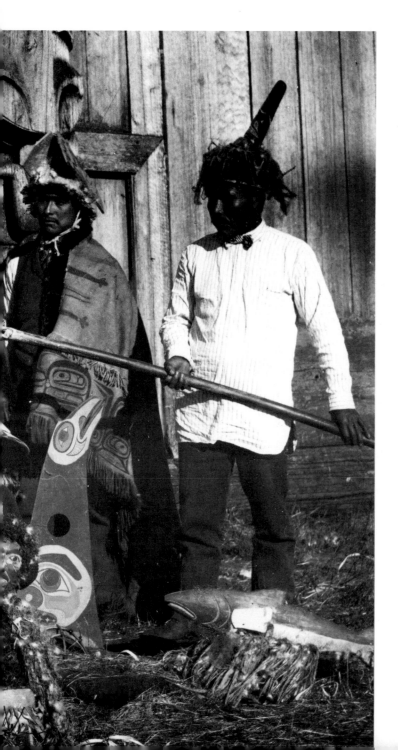

traditional regalia. This eliminated the very material which might have inspired young artists, and left whole groups with no valuable possessions with which to validate rank or stage potlatches.

Some groups, such as the Kwakiutl, endured the onslaught of threats to traditional culture in a canny, businesslike way. The Tlingit regarded an original work of art as an heirloom, completely irreplaceable, while the Kwakiutl did not. An original Kwakiutl piece was often sold for a high price during this period and the reward pocketed in anticipation of future potlatches. In addition, carvers were commissioned to copy old pieces or create innovative new ones, thus ensuring the continuation of several traditional institutions.

Today, potlatches complete with oratory, dance and seating according to traditional rank have been revived. Elders who saw totem poles and masks sold to museums for a pittance, who saw their tribal houses tumble down, can now see new poles erected and the masked dances performed again. Contemporary art forms, like contemporary Northwest Coast artists and the cultures which provide their foundation, have changed from the old forms, but retain a vitality that speaks of their survival and innovation.

Today, design principles of Northwest Coast art are executed in many media, some totally nontraditional. A group of Canadian Indian artists, for example, is working with silk screen prints. These prints successfully combine traditional design elements and contemporary interpretations of the cultural heritage of their makers.

Excellent wood-carvers, some trained traditionally through apprenticeship, exist in every group. These men carefully craft masks, rattles and other items strictly for ceremonies; create totem poles and house posts on commission;

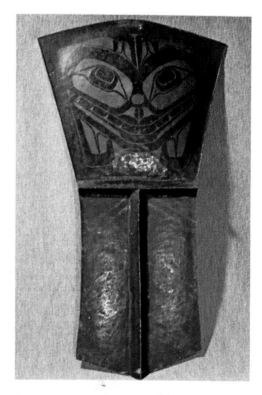

Coppers, carved or engraved with the totemic crests of their owners, were an important symbol of wealth and prestige to tribes of the Northwest Coast.
(The University Museum, University of Pennsylvania, 45.15.1; photo courtesy of Bill Holm)

169

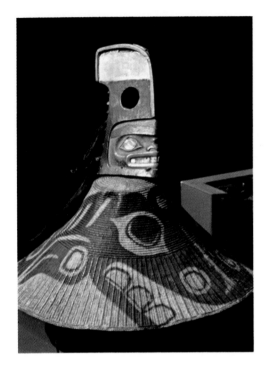

This spruce-root ceremonial hat with a whale crest is adorned with red, green, black and white paint, abalone shell inlays and human hair. The piece was acquired by Louis Shotridge in Sitka in 1925. 14½" diameter. (The University Museum, University of Pennsylvania, NA 10512; photo courtesy of Anchorage Museum)

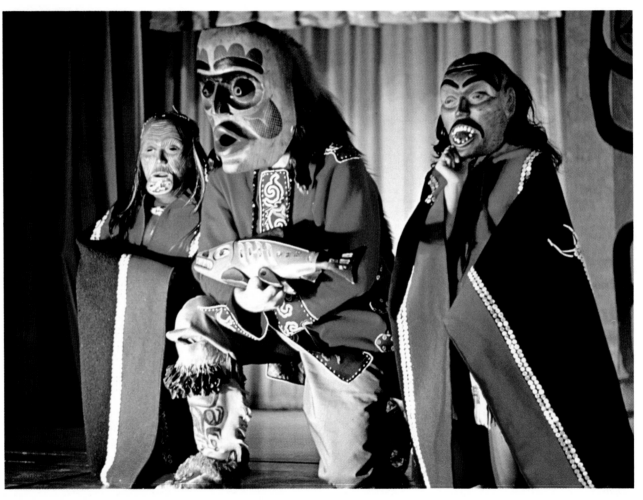

Chilkat dancers, performing here in traditional costumes, still stage both public performances and ceremonial dances. (Steve McCutcheon)

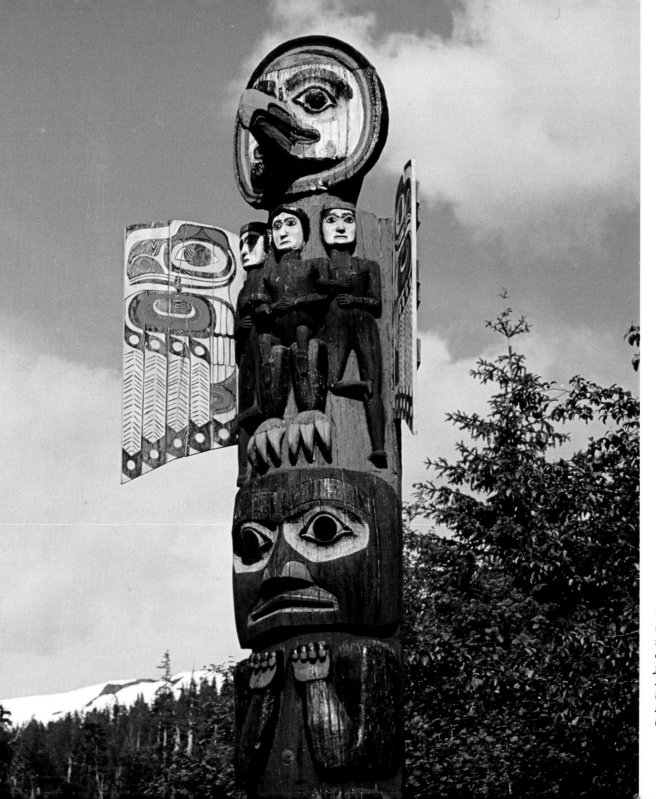

The Sun and Raven Totem
in Ketchikan is a
restoration, with slight
changes, of a pole taken
from a cemetery on Pennock
Island, in Tongass Narrows
between Gravina and
Revillagigedo islands.
(Steve McCutcheon)

171

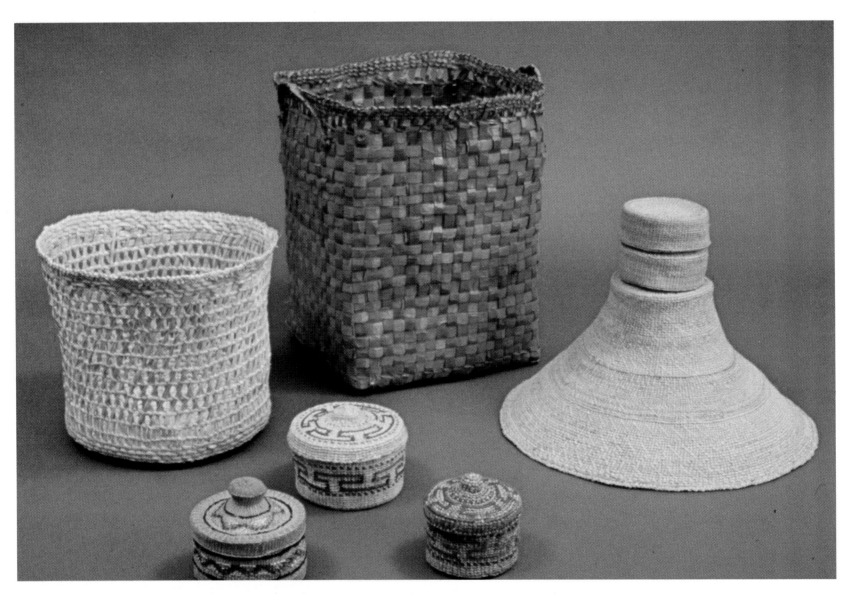

This spruce-root hat and group of baskets, ranging from dainty covered baskets twined of split spruce root to the large, open, plaited cedar-bark container, were made by the late Selina Peratrovich, a Haida from Ketchikan. (Photo by Sam Kimura; courtesy of Alaska State Council on the Arts)

and make flawless objects for sale to collectors and museums.

Haida carver and goldsmith Bill Reid is perhaps the best known of these artists. His meticulous work is considered as outstanding as any of the traditional Haida artists who preceded him. Jim Schoppert and Nathan Jackson, both Tlingit, have been awarded commissions by the state and federal governments to create totemic carvings for various locations around Alaska, as has Carmen Quinto Plunkett, the first Tlingit woman to assume the role of carver. Jack Hudson, a Tsimshian now living and teaching in Metlakatla, is an outstanding mask maker. There are many others, including a large group of talented Kwakiutl carvers.

Women's traditional arts have suffered perhaps more dramatically than those of their male counterparts. All Tlingit groups (which numbered 14 or more) once had many talented basketmakers; now only a handful of such weavers exist. Haida basketry is scarce as well, but the Tsimshians have a small core of weavers who still make cedar-bark baskets. Northwest Coast artists in every medium have always been generous in teaching and interpreting their art to visitors and scholars, and nowhere is this more true than among the makers of Chilkat blankets. Mrs. Jennie Thlunaut of Klukwan and Marie Ackerman of Haines are among the last weavers of these magnificent robes, whose secrets are also known now to a few Caucasian artists.

Some scholars consider the Haida and the Coast Tsimshian to have inspired Northwest Coast art's highest development. Rigid adherence to a standardized totemic form and the tendency to decorate every space prevails in this region. Even famous and innovative artists of this influential central region, such as

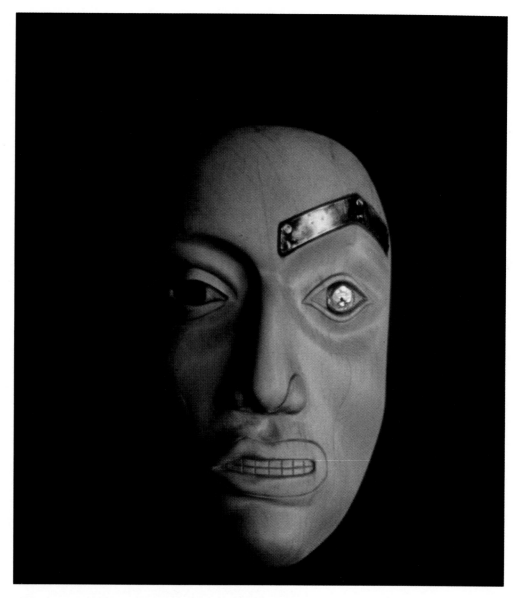

This mask, made by Tlingit artist Carmen Quinto Plunkett, is titled "Self Portrait." The mask is in the collection of the Alaska Contemporary Art Bank. (Photo by Sam Kimura; courtesy of Alaska State Council on the Arts)

173

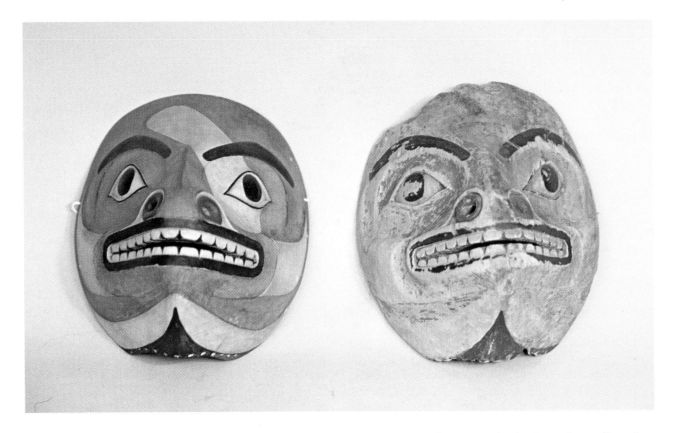

Haida carver Charles Edenshaw, followed traditional precepts yet added recognizable touches of their own. To the north and south, variations on traditional themes may point to cultural influences from outside the tribe.

Symbolism is the foundation of all art in the Northwest Coast complex, though the symbols themselves are applied in a decorative and ornamental way. Placement of the designs is governed by formal principles, so that nothing is ever applied randomly. The placement of a design often requires displacement of certain parts of the design; for example, an animal may be split apart, greatly distorted, or completely rearranged within its space. This abstraction

Under a grant from the Alaska State Council on the Arts, non-native carver Steve Brown created this replica of an old Tlingit mask in 1981. The old mask, from Admiralty Island, represents a bear's face; the mask is quite worn and the original paint has faded. 7½" x 6¾". (Sheldon Jackson Museum, an Alaska State Museum; photo by Ernest Manewal)

makes it difficult at times for someone outside the culture to correctly interpret or even identify the symbolic designs.

According to University of Washington scholar and carver Bill Holm, the design elements used in Northwest Coast art consist of several basic forms. The most characteristic

of these is an ovoid shape which is generally used for eyes and joints. Haida legends liken the design to similarly shaped spots on the bodies of young fish. These ovoids usually create strong areas upon which to focus, linking the larger design together.

Equally important, according to Holm, is use of the formline, the formal method of enclosing or delineating designs. In one sense, the formline is the space generated between patterns; in another, it is actually this formline, usually painted, which delineates the pattern itself. These bold lines rise and fall, swell and fade away, creating a distinct flow to the design which makes it difficult for the eye to rest.

U-shaped forms are also common. This design, whose perimeter is enclosed by a formline which may swell from pencil-thin to very thick, is often used to enclose other designs, or as the ears of certain animals.

Other elements of design, including eyebrow shapes, the S-shape and groupings of various forms, are also used in Northwest Coast art. Human hands, as well as the feet and claws of animals, have been realistically portrayed, though some are abstracted to fit into available space.

A seemingly universal problem for Northwest Coast artists, according to Holm, is control over areas that result when two major design elements come close to each other on the decorated surface. Sensitive methods of transition, such as the slight modification of a formline or a change in its direction, govern these areas, which might otherwise be visually distracting and awkward. As a result, the appearance of a finished piece strikes a balance between positive and negative design elements, all flowing in a pleasing way yet conforming to rigid and traditional artistic principles. The designs move constantly, but always return

This closeup of a Haida canoe steering paddle shows totemic designs which represent an octopus. (Sheldon Jackson Museum, an Alaska State Museum; photo by Ernest Manewal)

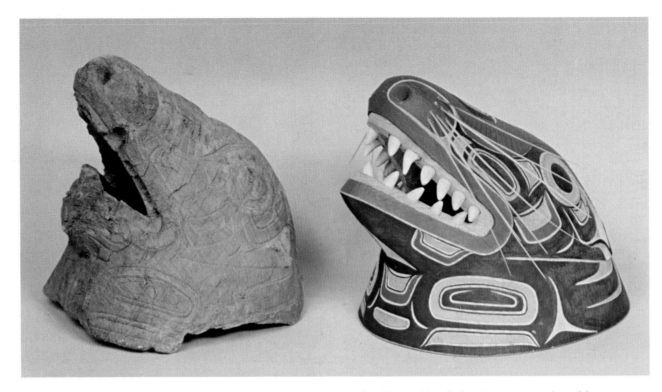

their viewer to a symbolic, symmetrical, central motif.

The use of color is highly formalized among Northwest Coast artists. Before western contact, natural pigments were used. Black was derived from lignite, charcoal and other materials; muted greens and blue-green from copper. Ochre and tones of red were obtained from several sources, including hematite. The mineral was ground to powder with a stone mortar and pestle, then combined with water or oil until it reached the proper consistency. Paints were applied to wood with animal hair brushes. Yellow and white were used only occasionally on painting and sculpture, but were almost always found in woven pieces such as the Chilkat blanket.

This old sea-lion helmet was reproduced by non-native carver Steve Brown under a grant from the Alaska State Council on the Arts. Both helmets are made of wood; all paint is missing from the older piece. 12½" high. (Sheldon Jackson Museum, an Alaska State Museum; photo by Ernest Manewal)

Black, perhaps the most important color, was used almost exclusively for the main formlines, joining the principal areas of design and their symbolic importance over the entire surface of the piece. Reds are generally found in formlines which are less important to the design, often within boundaries already created by black formlines. Red is also used for cheeks and tongues, and often for extremities such as feet

Woven cedar bark was used to make this Haida mantle, from Prince of Wales or the Queen Charlotte islands. The mantle is decorated with stylized totemic faces in red, black and green paint. 35½" wide. (Department of Anthropology, Smithsonian Institution, 361 033; photo courtesy of Anchorage Museum)

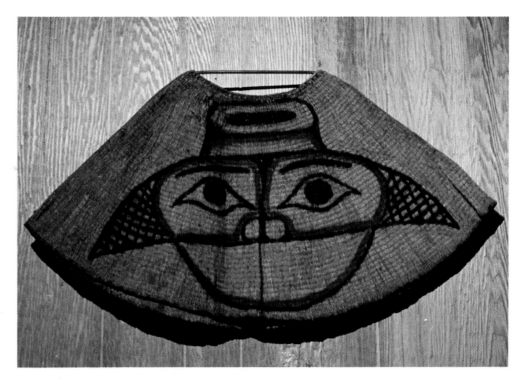

and hands. The inner ovoids of eyes and joints are almost never red, and red is found only rarely in woven materials. Native reds, said to be muddy or rusty in hue, were replaced by Chinese vermillion as soon as it became available in trade. Other colors and conventions remained virtually the same.

Blues and greens are only occasionally used in wood carvings. When they are, they usually highlight eye sockets and spaces between design elements in ears, fins, feathers and other fillers.

The use of color suggests that Northwest Coast artwork may historically have been painted first and carved later. Bill Holm points out that all primary design elements (painted black and/or red) exist on a flat surface and that less important features (blue, blue-green or unpainted) are hollowed out. No examples can be found in which black or red paint dripped accidentally into other areas, which would indicate it had been applied after carving. It is possible, however, that bark stencils were used in applying paint since similar templates were used for establishing some designs. There are also several other indications that Northwest Coast art may originally have been an applied and painted art in the Northwest Graphic Tradition, and that sculptured forms came later.

The Copper

Potlatch goods before western contact consisted of two important items: slaves and coppers *(tinnehs).* Coppers were beaten copper plaques, shaped somewhat like a keyhole, usually two to three feet long and weighing approximately 40 pounds. Coppers varied in value from tribe to tribe and were especially prized among the Tlingit.

Early coppers were made of native ore from the Copper River area, although western traders quickly made sheet copper available. Some scholars believe that Tlingit craftsmen shaped placer copper into the desired form themselves, while others maintain that coppers were formed by Athabascans or may even have been artifacts of some kind. The impressive plaques were engraved or carved in relief with totemic crests by Northwest Coast artists.

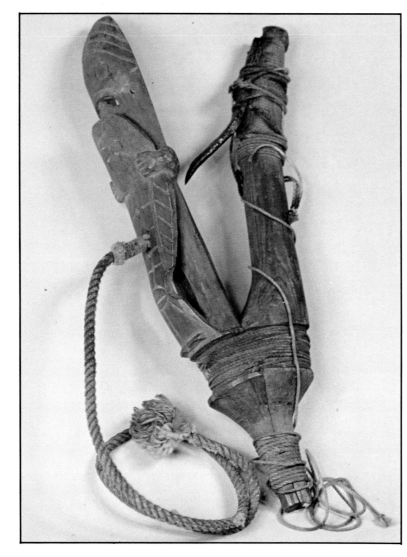

Alder and cedar woods and spruce root lashing were used to make this halibut hook. On one arm of the hook is an anthropomorphic figure holding a flat bottomfish. The figure is said to represent the Land Otter Man of Tlingit legend, feared for his supernatural powers. 12" long. (Sheldon Jackson Museum, an Alaska State Museum; photo by Ernest Manewal)

The value of coppers increased as they were traded or sold, and their transfer implied that a potlatch would be given by the new owner. Coppers were anthropomorphized — given names such as "Cloud," "Point of Island," or "Killer Whale" — and were spoken of in sentimental and respectful terms. The copper power was indisputable and their histories were as well-known as those of the noblest families.

Coppers were often broken and occasionally destroyed during public displays of wealth. Parts of a copper might be broken off in a culturally prescribed manner until only the spine of the central ridge of the piece was left. Some parts of the coppers were valued at nearly as much as the whole, underscoring both the rank of the chief who chose to destroy his property and the importance of his rivals, who might someday buy all the fragments and restore the whole.

To this day, certain coppers which have been part of museum collections for years are still valued highly by some tribes, and are used as symbols of wealth and prestige during marriage ceremonies and potlatches.

Woodworking

Northwest Coast woodworkers used a wide variety of aboriginal tools before the arrival of western trade goods. They included chisels, adzes, hammers, mauls, wedges, drills and knives, as well as small amounts of traded or beach-found iron.

Huge trees, red and yellow cedar in the north and redwood to the south, were felled by pecking away with adz and chisel around their trunks. Fire was used to hollow out sections of trunk to be made into canoes or large containers.

Aboriginal wooden objects from this region

were almost uniformly beautiful and well-made. Forms were symmetrical; corners were squared; pains were taken to smooth, polish and decorate objects far beyond functional necessity. From houses and canoes to the smallest pieces, all were covered with crest designs and finished with great care and attention to detail.

Totem and memorial poles are probably the most popularly known examples of the Northwest Coast tradition of woodworking. Most of these sculptured poles, sometimes more than 60 feet tall, were carved as clan histories or memorials to the dead. The predecessors of these tall poles were house posts and smaller mortuary columns carved with traditional tools. The advent of metal tools facilitated the creation of taller poles. Poles were generally clustered along the village shore in front of clan houses, but were also placed directly on house fronts or erected in cemeteries. Early accounts of Tlingit life state that deceased clan members were cremated and their ashes interred in these poles.

The totem pole is unique to the Northwest Coast region. These monumental sculptures tell the history of individual clans, including stories of how certain crests came to be family property. Poles record the ownership of crests for all to see, underlining and perpetuating the wealth and importance of certain kin groups. The uppermost figure on a pole is nearly always the animal represented on the most important family crest. The story of Gonaqadate, a legendary monster who brings good fortune to all who see him, is typical of these histories, symbolized on both Tlingit and Haida poles.

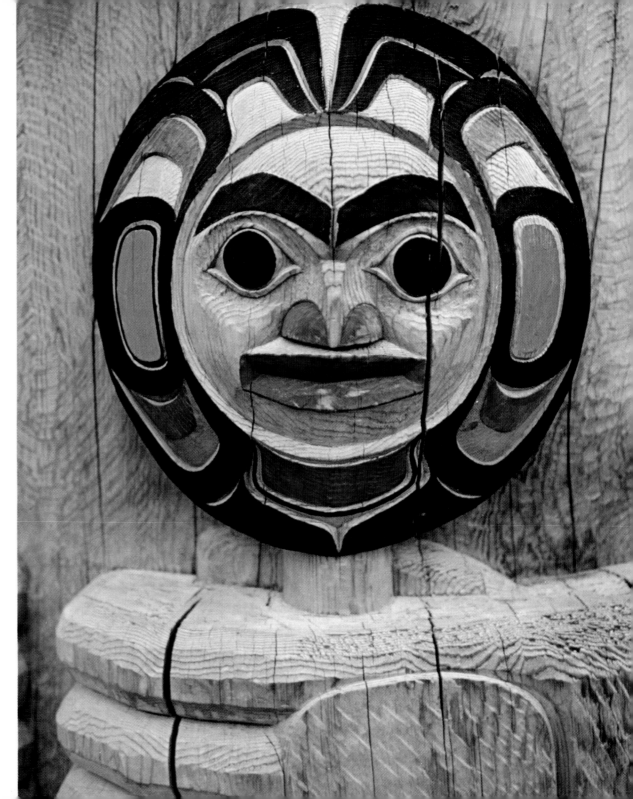

This carved face is a detail of a totem in Ketchikan.
(Steve McCutcheon)

The Story Of Gonaqadate

By Viola Garfield and Linn Forrest

A young man from a very good family married a girl of equally high class from a neighboring village. They lived with his wife's parents in the large community house of which his father-in-law was the head. His mother-in-law disliked the young man very much because she believed that he was lazy and too fond of gambling. As soon as a meal was finished she would instruct the slaves to let the fire go out. As he left the house early in the morning and did not return until after dark the family was through eating before he arrived. He got his own food and sat in the dark to eat it. Then his mother-in-law would say, "I suppose my son-in-law has been felling trees for me, that is why he is so late." The young man did not reply to her scornful remarks.

During the summer when the people went to dry salmon, the gambler went along. He caught and dried salmon and took it with him to a lake away from the camp. There he built himself a house. He had heard that there was a monster in the lake and he was determined to find out. He felled a cedar tree over the water and split it along its length from the top nearly to the roots. Then he made crosspieces to hold the two sections apart. He baited a line with the salmon and let it down between the two sections. When he felt it move he pulled it up quickly, but the line broke. He again baited the line and let it down. When it moved, he pulled it up so rapidly that the monster could not escape. When its head was in the trap, he pushed out the crosspieces and it was caught.

The monster struggled so hard that the tree was pulled under the water, but it finally died. Then the man took it out of the trap and examined it. It had very sharp, strong teeth and claws that looked like copper. He skinned it, dried the skin, got inside, and went into the water. It began to swim away with him, down to the monster's home under the lake. It was a beautiful house with carved posts and many handsomely carved and painted boxes. After he came up again he left the skin in a hole in a tree nearby and went back to camp, but did not tell anyone what he had discovered.

When winter came, the people went back to their village, and during the next spring there was a famine. One evening the young man said to his wife, "I am going away. I will be here every morning before the ravens are awake. If you ever hear a raven call before I get back do not look for me anymore." He went to the lake, got into the monster's skin and swam down to his house. He discovered an outlet to the sea, and swam out. There he caught a king salmon, which he laid on the beach in front of his mother-in-law's house. He put the monster's skin back in the tree and returned home as though nothing had happened.

The next morning his mother-in-law went out early and discovered the salmon. She thought it had drifted there and took it up to her house. She told her husband what she had found and gave the fish to the slaves to cook. Then they distributed the food to all the people in the village, as was the custom. The people were

very grateful to their chief, for they were hungry.

The next night after everyone was asleep the young man again got into the skin and swam out to sea. He brought two fine salmon to the village. When his mother-in-law awoke he was sound asleep. She went down to the beach and found the fish, which she distributed as before.

The young man told his wife what he was doing and made her promise that she would not divulge his secret. The third night he brought more salmon and the fourth a large halibut.

When the mother-in-law found the halibut on the beach she thought, "I wonder what this is that is bringing me luck. It must be my spirit power that brings the fish. I believe I am going to be the richest person in the world." She called her husband and her slaves to carry up the halibut.

She told her husband that she had had a dream and that no one in the village was to go out the next morning until she gave permission. He went through the village instructing the people. Meanwhile the son-in-law lay in bed and listened to all that was going on.

The next morning he left a seal on the beach. When the woman found it she had it brought to the house and cooked. Then she invited all the people of the village to come and eat it. When they finished she announced that her powerful spirits provided the food to save them from starving. The son-in-law lay in bed and listened to the speeches and the insulting remarks that were made about him, for his apparent laziness and gambling were blamed for their plight.

That night the woman said to her husband, "Have a mask made for me, and let them name it 'Food-Finding Spirit.' Have a headdress made of bear claws." The next day carvers were hired to make these things. Rattles of shells fastened to rings and an apron trimmed with puffin beaks were also made. This was a shaman's costume, for the woman was pretending that she had received shaman's spirits. She put on the outfit and began to dance, saying that her spirits told her she would find two seals on the beach the next day. Her son-in-law lay in bed and listened to her. His wife felt very badly because her mother nagged him continually.

"Always listen for the ravens. If you hear them before I return you will know that something has happened to me."

The next morning two seals lay on the beach as the old woman had predicted. The morning after there was a sea lion. The man said to his wife, "Always listen for the ravens. If you hear them before I return you will know that something has happened to me."

The next morning the son-in-law brought a whale and the people were much surprised when the old woman found it. She filled many

boxes with oil and meat after the feast was over. They looked upon her as a great shaman.

This went on for a long time, but the young man did not bring in another whale because he had had a hard struggle with the first one. Meanwhile his mother-in-law said spiteful things about him, and the whole village laughed at him, for, as they thought, his mother-in-law provided food for him and his wife while he slept all day.

"Where are your spirits now? If this is your Food-Finding Spirit, make it come to life again."

One night the young man caught two whales and decided to try to take them ashore. He struggled and worked all night, but just as he got them to the beach the ravens cawed, and he died right there. When his wife heard the raven she immediately got up and dressed, for she knew that soon the people would go down to see the monster. Her mother went to the shore as usual and found the two whales lying there with the monster between them. She called the village to see it. It had two fins on its back, long ears, and a very long tail. The people supposed that it was the old woman's spirit.

The wife then came down to the beach weeping and she said to her mother, "Where are your spirits now? If this is your Food-Finding Spirit, make it come to life again. You are only pretending. This is why this happened to my husband." She then directed the people to bring the monster up, and they found her husband dead inside the jaws. He had almost succeeded in coming out of the Gonaqadate skin when the raven cawed.

They took the skin and the body of her husband to the lake and put them in the hollow tree where he had kept the skin. When the people saw the cedar-tree trap and his tools lying about they were convinced that he was the one who had caught the monster and supplied them with food. His mother-in-law was so ashamed that she remained indoors and soon died. When they found her, blood was flowing from her mouth.

Every evening after this the dead man's wife went to the foot of the hollow tree and wept. One evening he came to her and took her to the monster's former home at the bottom of the lake, where they stayed. From there they swam out to sea, where Gonaqadate may still occasionally be seen. Anyone who sees Gonaqadate will be successful in every undertaking thereafter. It is said that good fortune will also come to anyone who sees their children, the Daughters of the Creek, who live at the head of every stream.

(Reprinted with permission from The Wolf & The Raven, *by Viola Garfield and Linn Forrest, University of Washington Press, Seattle, 1961.)*

Tribal variations in the figures carved on poles resulted from several factors, but depended greatly on the type of wood available. Some tribes had enormous trees nearby to use for totem poles and canoes while others made do with timber which was smaller and scarce. To make a pole, the center of a tree was generally hollowed out so that when the bark was removed a narrow cylinder of wood remained for carving.

The influence of missionaries, decimation of native populations and consequent abandonment of old village sites and traditional ways led to the destruction and neglect of many important totems during the early part of this century. Many rotted or were sold; others were stolen. Beginning in the late 1930s, the Civilian Conservation Corps, working in conjunction with the U.S. Forest Service, made efforts to salvage and restore poles. Local native carvers, including skilled elders and apprentices, were involved in the restoration. Many of the pieces now stand in totem parks near such villages as Klawock and Saxman, as well as the Totem Heritage Center in Ketchikan.

Carved wooden masks represent another important expression of Northwest Coast talent. Just prior to the turn-of-the-century decline of the arts, the region supported a number of specialists in various arts. These men made bentwood boxes, canoes, totem poles or masks, though their work often remains anonymous.

Mask making, along with most Northwest Coast arts, was restricted to a few high-status male artists who were members of the secret societies where masks were used. A young carver who showed particular talent and was of appropriate rank might be apprenticed to an expert mask maker. This type of relationship could continue for many years, and still exists in part today through the encouragement and

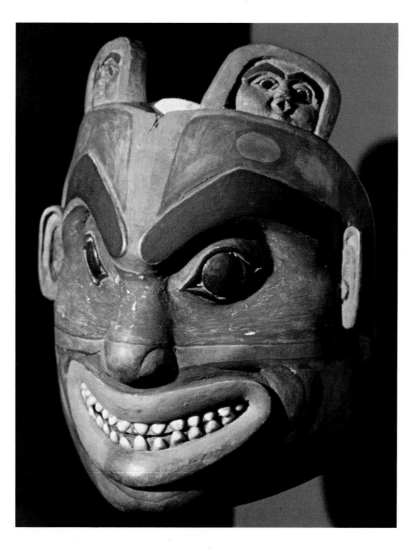

This wooden mask, representing a bear, was collected at either Klukwan or Haines. The mask is painted black, brown, red, tan and green and has copper inlays; each ear is carved with a separate face. The piece is said to represent one of the spirits of a famous Chilkat shaman who assisted some of the first non-native explorers in the region. 9½″ high. (St. Joseph Museum, St. Joseph, Missouri, 143/5608; photo courtesy of Anchorage Museum)

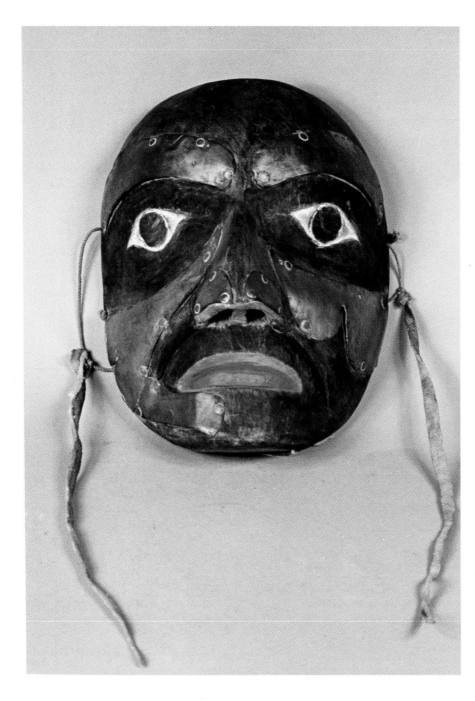

support of state-funded intern programs.

Masks were made primarily of alder, though red and yellow cedar were used at times by some tribes. Masks were generally carved of wet, green wood and then set carefully aside to dry slowly. Several types of masks exist, including the simple single-face mask, occasionally having an elaborately carved totemic border; a variation of the face mask with the addition of moving parts; and transformation masks, which have several faces hidden behind the first. These faces are revealed mechanically as surprise effects during ceremonies, requiring not only care in their construction but skill in their operation.

Masked dances were accompanied by a chorus of tribal singers who sang songs associated with the masks and reflecting the wealth of the host. Masks were the critical element in portraying the relationship of the tribe with spirits and projecting their power to spellbind Northwest Coast audiences. Mask makers carefully created works which played upon this symbolism, building tension during ceremonies.

Masks were always created to be worn, but not all members of the tribe held sufficient status or power to wear them. Ceremonial use of masks generally took place in the fall and winter, when the spirits of the other world were said to be nearby. When masks (and their attendant secrets) were revealed to the tribe, the host was expected to distribute huge payments to his guests. The impact of the masked

This Tsimshian hawk mask is carved from red alder, overlaid with copper on the eyebrows, cheeks, nose and chin. The mask is painted in red, white and black. 10" x 9". (Sheldon Jackson Museum, an Alaska State Museum; photo by Ernest Manewal)

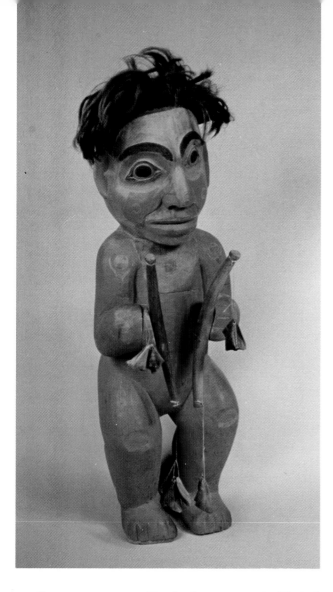

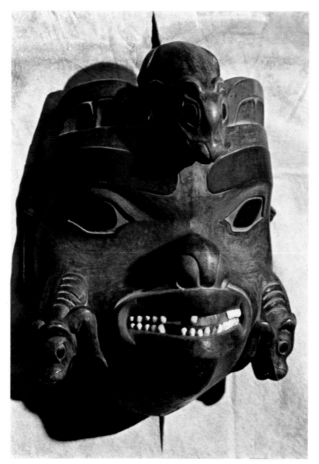

Left — *Human hair adorns this carved figure of a shaman, made at Yakutat in the late 1800s. The shaman holds two curved sticks with deer dewclaws hanging from them. Figures such as this were used in shamanistic performances. 25" tall. (Sheldon Jackson Museum, an Alaska State Museum; photo by Ernest Manewal)*

Below — *This elaborately carved shaman's mask represents a bear, with three smaller bears, perhaps spirits, on cheeks and forehead. The wooden mask has been painted black, red and green. 10¾" high. (Peabody Museum, Harvard University, 69-30-10/1609; photo courtesy of Anchorage Museum)*

performances, particularly on uninitiated children and people of lower rank who did not suspect impersonators behind the drama, must have been overwhelming.

Crudely carved masks created for fun were occasionally made among the Kwakiutl. Masks made as part of shamanistic paraphernalia were common to all groups. Most shamans carved their own masks, and little is known about their

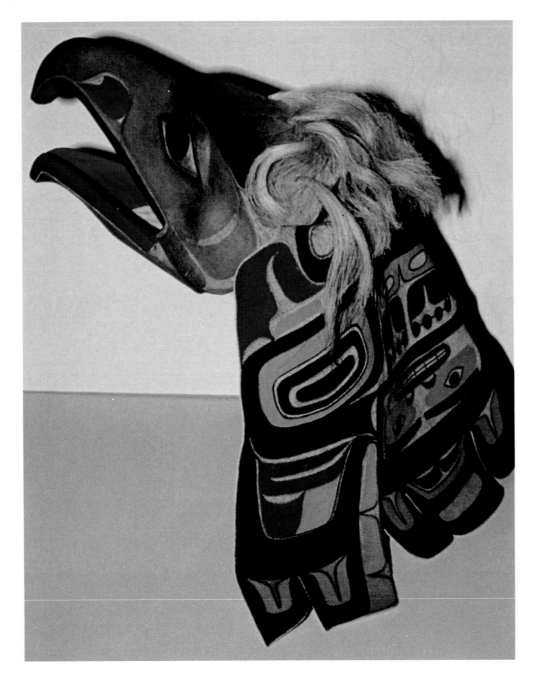

use because shamanistic secrets were not publicly known or disclosed.

Historic and contemporary Northwest Coast masks, which include those of Alaskan groups, are regarded as somewhat less complicated than those made to the south. Mechanical masks are rare in the northern region, and most northern masks are slightly smaller than their southern counterparts. Sensitive, realistic portrait masks with minimal use of paint are common to some tribes of the northern group.

Artfully carved and painted containers in the forms of boxes and bowls make up another category of Northwest Coast art. Bowls and ladles used for containing food were often carved in animal form. All containers were symmetrical in shape, reflecting not only the formal values of the artistic tradition behind them, but also the tendency of the Northwest Coast culture to structure the life and art of its members. Tlingit legends support this theory. *Raven-at-the-head-of-Nass* is said to have kept his wife in a box whenever he went out, and Raven himself is held responsible for opening a box which contained daylight, releasing the sun, and creating elements of Tlingit social structure for the people at the mouth of the Nass River.

Containers of all kinds and the crests they displayed were at their most visible during a potlatch. The dish given to each guest was selected carefully according to his or her rank,

Well-known artist Nathan Jackson of Ketchikan carved this contemporary wooden mask. It represents an eagle; the lower beak is hinged to open and close. The eagle is painted and decorated with abalone-shell eyes and horsehair; the attached tanned leather cape is painted with totemic designs. 11" x 7¾". (Alaska State Museum; photo by Chris Stall)

186

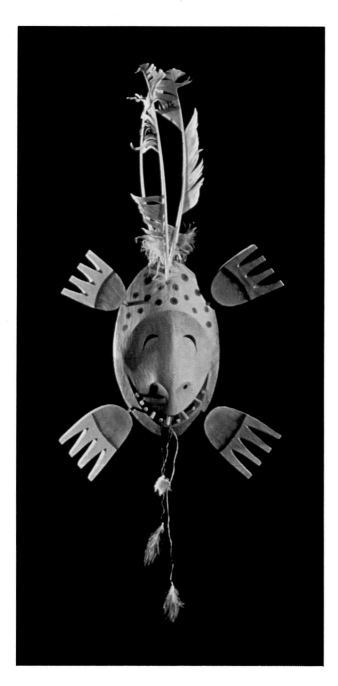

Left — *Tlingit artist Jim Schoppert drew from Yupik motifs to create this contemporary wood mask. The mask is in the collection of the Alaska Contemporary Art Bank. (Photo by Chris Arend; courtesy of Alaska State Council on the Arts)*

Below — *Rudolf Walton, an early student at Sheldon Jackson School, made this wooden feast bowl in 1926. Bear heads are carved at the ends of the bowl; it is painted black and decorated with abalone shell and bone, and inset with bone teeth. 14½" x 7½". (Sheldon Jackson Museum, an Alaska State Museum; photo by Ernest Manewal)*

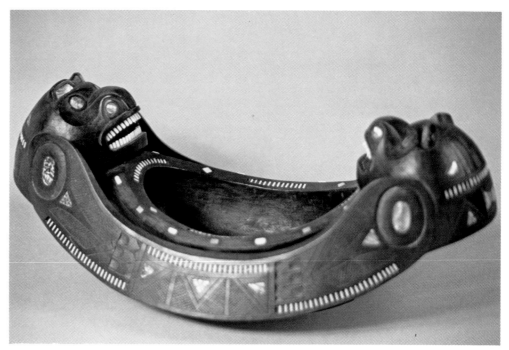

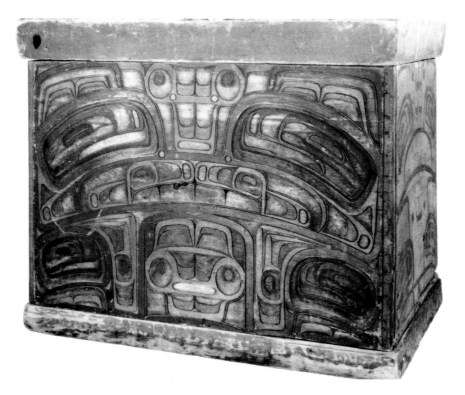

This kerfed storage chest was collected on Portland Inlet in southeastern Alaska in the mid-1800s. These chests were made from a single plank of wood which was steamed, bent and sealed with waterproof glue. Some were used for holding water, others for cooking. 38" long. (Smithsonian Institution; 66 638)

Kerfed or bentwood boxes were made from single planks for storing various materials. Some were watertight, for cooking and storing liquids and foods, or for holding fresh water on ocean voyages; others were stacked in houses as furniture and containers for valuable clan property. These boxes were decorated heavily with the crests of their owners, demonstrating their wealth. Boxes were thought to be alive, guardian receptacles for the spirits of their valuable contents and the totemic animals portrayed on the boxes' walls.

Kerfing was achieved by making carefully shaped grooves at three prescribed points along a single plank. Planks were then steamed, bent at the grooves and formed into squares or rectangles. The fourth corner, the only open joint, and the bottom of the box were carefully drilled, then pegged or sewn, and pressed together until the box was watertight. Containers were fitted with lids which were frequently studded with shells. Chests and boxes were carved and painted with totemic crest designs, often in red, although a few purely functional boxes were left undecorated.

Bent bowls are made on the same kerfed principle. They do not have lids, however, and typically have a sweeping, boatlike shape with a curved rim, particularly among northern cultures. The bowls are made primarily of alder and maple, and many are rectangular with parallel vertical grooves at each corner. The grooves and the shapes of the bowls themselves may indicate that bent and folded birch-bark baskets traded from the Interior (or remembered during the early migrations to the coast) were the prototype for bent bowls.

Carved rattles made of wood and occasionally of metal or sheep horn punctuated song, dance and oratory. Raven rattles are the most common type and among the most elaborately carved forms. The body of a raven rattle

and guests took home any remaining food in specially made wooden containers. The sizes of dishes used during a potlatch varied. Often, the first food prepared for the feast was presented in huge dishes, up to 20 feet long, from which portions were served communally to smaller groups. Individual dishes were often reserved for persons of high status.

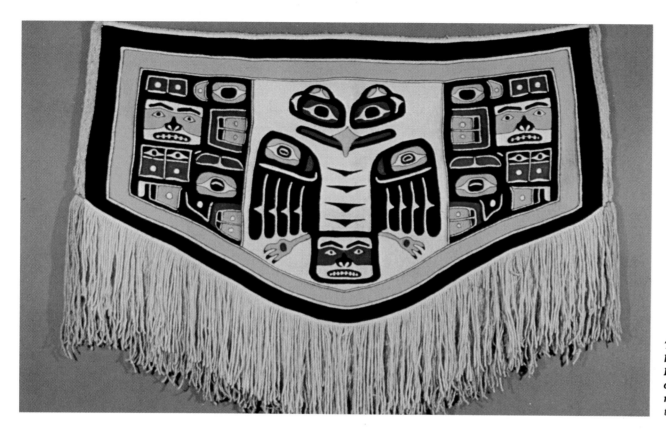

This Chilkat robe was made by Jenny Thlunaut of Klukwan, one of only a few artists who still weave such robes. (Alaska State Council on the Arts; photo by Chris Arend)

is the carved bird itself, covered with totemic designs. Raven is usually surmounted by a reclining human figure, commonly thought to be a shaman. The long tongue of this figure connects to another creature, usually a bird or frog. All elements in the rattle are symbolically united.

Chilkat Weaving

The origin of the dancing blanket is pinpointed by legend to the Tsimshian. Knowledge of the technique apparently diffused north to the Tlingit, where it reached its highest form among the Chilkat. Visiting traders coined the blanket's name during the late 19th century.

Yarn for Chilkat blankets was spun primarily from the wool of the mountain goat. Tlingit hunters provided goat skins from which village women removed and cleaned the inner fleece. Fleece from at least three goats was necessary to produce a single blanket. The warp, or vertical strands, was composed of spun wool twisted together with strands from the inner bark of the yellow cedar tree. Weft yarn, the horizontal strands, was generally spun on wooden spindles, resulting in yarn finer than that of the warp.

Dyes used to color the yarn included a combination of hemlock bark, iron and old urine for black; wolf moss boiled in fresh urine for yellow

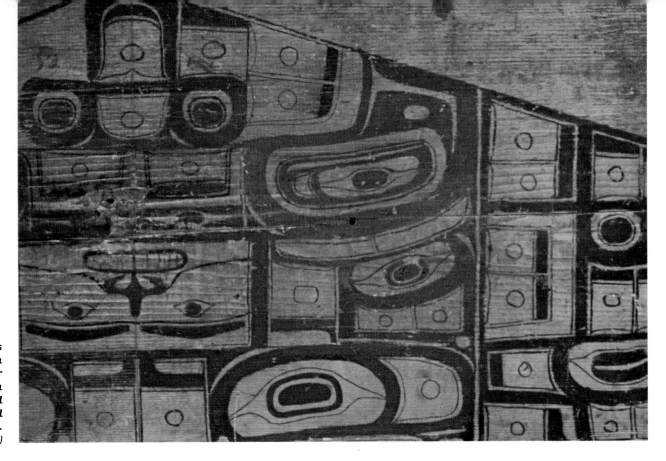

Pattern boards such as this were used by Chilkat women to weave blankets and other articles. The boards, which were designed and painted by men, were treasured and used for many years.
(Anchorage Museum)

dye. Blues were obtained very early from a variety of woolen trade cloths which were boiled in a urine bath. Early trade cloth came from England, and provided a beautiful blue made from indigo.

The designs woven into Chilkat blankets consist of geometric totemic shapes which can be reproduced by the method known as twining. Early blankets are unadorned or display geometric patterns lacking curvilinear elements. Three twined central patterns are featured in panels on the five-sided garments; these panels display major and minor totemic crests and are surrounded by borders, fringes and braids. Often, the placement of totemic crests on painted house posts and the designs woven into garments are quite similar.

Pattern boards used to create woven articles were made and painted by male artists. The smooth cedar boards were painted in black with only half of the necessary design — Chilkat weavings were flat and bilaterally symmetrical, so a weaver could simply reverse the pattern to supply the missing half. Boards were cherished and reused by weavers.

Time, technical skill and inherited privileges were required for a woman to weave Chilkat blankets and other ceremonial garments. Both men and women wore the blankets and heavily decorated aprons and tunics. Some dances were performed by individuals wearing this type of regalia, and many historic photos exist which show Tlingits of high status in full, impressive dress.

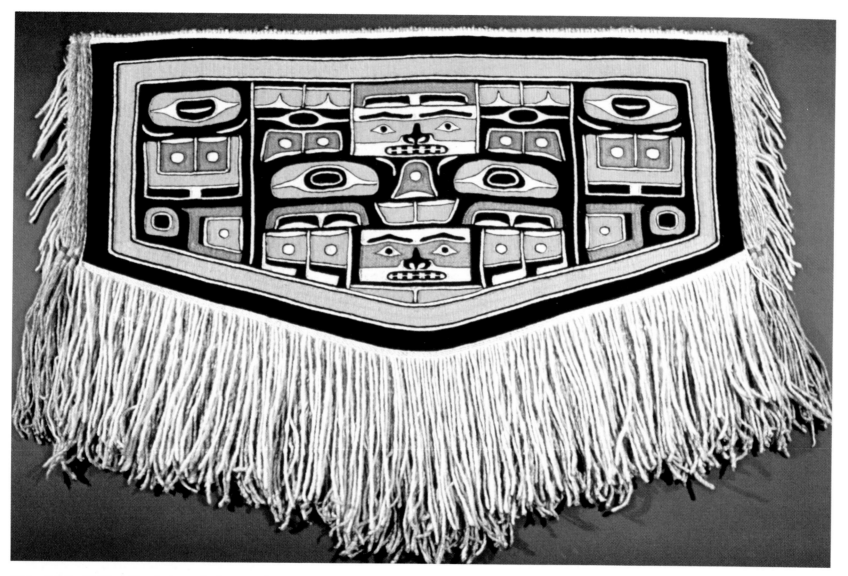

This child's Chilkat blanket, made by Maggie Kadanaha and her associates in Klukwan in 1934, is twined of mountain-goat wool and shredded cedar bark. The pattern is said to represent a bear. 43" x 30". (University of Alaska Museum; photo by Barry McWayne)

The Work of A Weaver

By Cheryl Samuel

Editor's note: *Cheryl Samuel is a writer, teacher and weaver who lives in Victoria, British Columbia. Her Chilkat weavings are much in demand and have been displayed in the Field Museum of Natural History in Chicago. The following story is about the anonymous weaver to whom her book,* The Chilkat Dancing Blanket, *is dedicated.*

One weaver, one pair of hands, producing one, two, three robes. Chilkat dancing blankets are now found in museum collections and private homes far from their point of origin.

These robes, created by very skillful weavers, were once worn on ceremonial occasions, giving acclaim not only to the owner but also to the women who wove them. Rarely is there a record of who the weaver was, who the owner was, or even the name of the village from which the robe came. Some weavers, however, have special characteristics which identify their work; personal techniques which reflect their skill, their flair, their own inimitable style of weaving.

Three examples of the work of one splendid Chilkat weaver are shown here. Two of the robes now hang side by side in the National Museum of Man in Ottawa, and one is sheltered by Dr. Giles Mead in California. The three robes were woven from the same pattern board, one which has been described as a bear family. There are a number of robes woven from this design, but these three in particular have been chosen because they illustrate the skill and finesse of the woman who wove them.

How is it possible to discern the work of one weaver? Although the techniques used in all Chilkat weavings are basically the same, skill in using these techniques is one clue. In some instances there are various ways to treat a certain area: continuity of treatment is another personal mark. The tension under which the threads are held determines the success of a shape; a particular tension will be maintained by a weaver throughout all of her work. Skill may develop with experience, but the essential

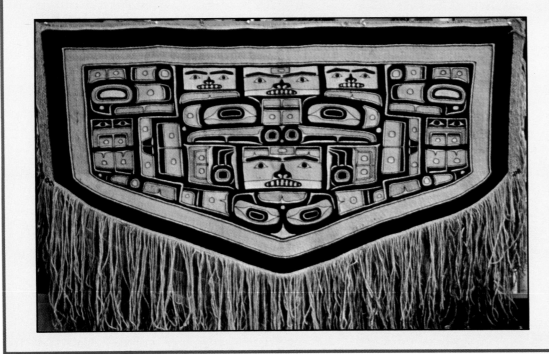

The three dancing blankets shown here are the work of the same weaver. The blanket at left belongs to Dr. Giles Mead of California; the two blankets on the right are in the National Museum of Man in Ottawa. (All by Cheryl Samuel)

spirit of a talented woman's work will characterize every weaving she does.

In these three weavings there are specific areas which illustrate the above points. Many techniques can be used to create the borders, the side braids and the fringes of a robe. Which style to use is the weaver's decision and is not dependent on the design on the pattern board. A weaver tends to adopt favorite techniques in doing these areas and is not likely to deviate from them. For example, when the warp yarns are hung on the loom, the arrangement of the first rows of twining establishes the rhythm and the lay of the weaving. The treatment of these rows in the three robes is identical. The overall shape of each of the robes shows a very pronounced 'V' at the bottom border. This 'V' is more pointed than in most Chilkat blankets and is a result of the weaver's personal interpretation of what this border should look like.

Another treatment which is similar on all three robes is the method of attaching the side braid fringes. They are laced to the front half of the side braids, which is unusual because in most robes they are attached to the centerfold of the braid. Continuity in the use of a chosen technique is also shown in the method of joining the black and yellow borders. In all three robes the weaver uses an interlock join between these borders. This is atypical; a variety of dovetail patterning is most commonly used. And finally, it is interesting to note that the tie-off on each of the side braids is a yellow and black checkerboard design.

Skill and finesse in workmanship are also exemplified in the actual woven design forms. An obvious example of this can be seen in the small faces depicted in these weavings — the weaver of these faces has a definite style, similar in all of them but subtly different from the same faces woven by other weavers. A com-

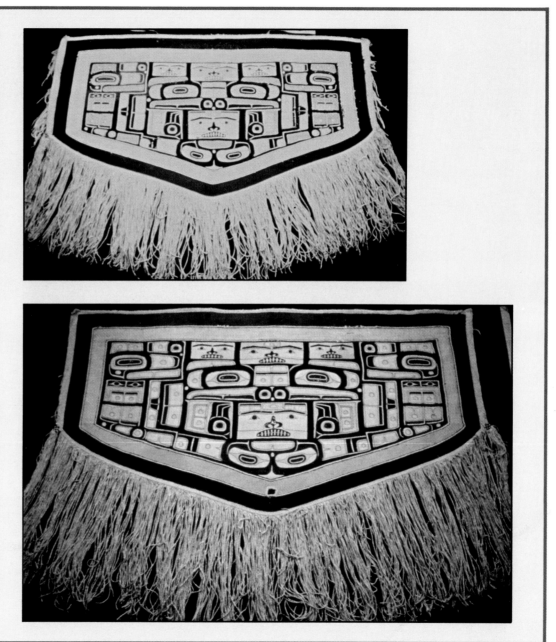

The shaping of the human eye is an example of a weaver's individual style. The two eyes shown below (one from a blanket at the National Museum of Man in Ottawa and the other from Dr. Mead's blanket) are identical, the work of the same weaver. Comparing them with eyes from two other blankets illustrates the different styles of weavers. (All by Cheryl Samuel)

parison of the faces in the central body in two of her robes shows a marked similarity in the weaving style, especially in the mouths and eyebrows.

Placing the robes side by side, comparing the techniques and marveling at the skill of this weaver is most inspiring. She knew her craft well, perfected the technique and developed a style which is easily recognizable to the discerning eye. She was aware of the basic principles of design used in creating the painted pattern; thus the integrity of the design is successfully translated into wool. She could handle any form exquisitely, regardless of the size of her threads or the complexity of the figure. She was indeed a Master Weaver.

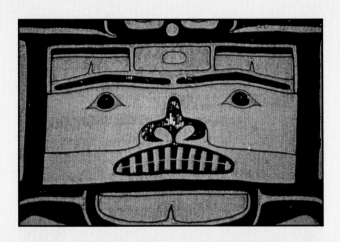

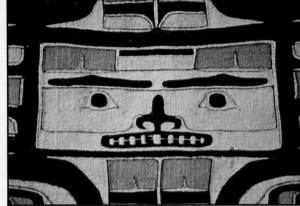

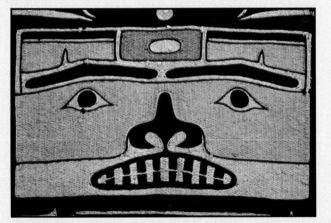

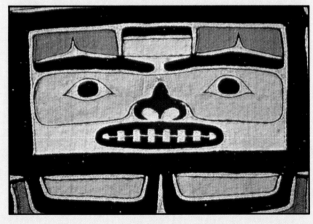

A comparison of the faces in the central body in two of the weaver's robes (above) shows an obvious similarity in weaving style, especially in the mouths and eyebrows. The similarities become more apparent when the faces are compared with those from two other robes (right). (All by Cheryl Samuel)

The only signature left by the anonymous weaver was a yellow and black checkerboard design on the tie-off on each of the side braids. (Cheryl Samuel)

Basketry

Tlingit legends say that Yakutat women were the makers of the first spruce-root baskets, although no specimens of the original baskets exist. Eventually, women of all Tlingit groups became weavers, as did Tsimshian and Haida women, though many baskets of the central tribes were woven with cedar bark instead of spruce root. Today, only a few women from any of these tribes still weave baskets. The late Selina Peratrovich and her daughter, Delores Churchill, are responsible for perpetuating the art of making spruce-root and cedar-bark baskets among Haida women, and have taught weaving to students of many other cultures as well. A small group of Tsimshian weavers still produces plaited cedar-bark baskets in Metlakatla.

Tlingit baskets were originally made of spruce root or cedar bark to use as fish nets, mats, water jars, berry baskets and many other items. Most baskets were a simple cylindrical shape, and almost all were decorated. Open cylinders were used as cooking vessels, berry baskets and water buckets; flattened bags held spoons; and several types of strainers and screens were made. Covered baskets, prized in the past and very collectible today, were used for storage. These lidded baskets often have pieces of shot (small pellets of lead) or tiny pebbles from the gizzards of certain birds contained in the knobs on their lids, and are now referred to as ''rattle-top'' baskets. Spruce root was also used to produce hats of several types, including a ceremonial hat capped by a series of woven cylinders called potlatch rings.

Tlingit baskets are all twined, though the technique is expressed in at least five distinctive ways. Native terms for the patterns created by different weaving techniques are descriptive, comparing the textures achieved to natural

Delores Churchill of Ketchikan is one of only a handful of contemporary Haida basketmakers. Here, she splits spruce roots she has gathered for making baskets. (Photo by Tom Sadowski; courtesy of Alaska State Council on the Arts)

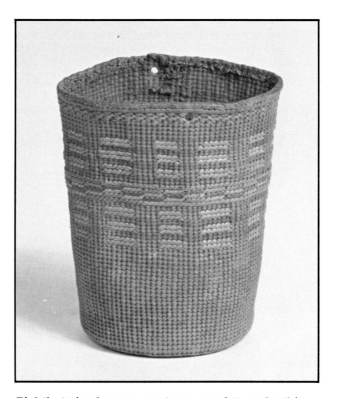

Tightly twined spruce root was used to make this small basket, which served as a drinking cup and would have been hung on the wall of the house. Only men used these cups, drinking ritually from them at times to ensure success in hunting and other pursuits. 4" high; 3" diameter (top). (Sheldon Jackson Museum, an Alaska State Museum; photo by Ernest Manewal)

phenomena such as the skin on the back of a frog. A few baskets were painted, but most had surface designs produced by overlaying grasses and stems (called false embroidery), or by alternating various weaving techniques. Traditional geometric patterns were most often used for decoration; some of the patterns were originally colored with mineral and vegetal dyes. Names associated with the geometric patterns relate

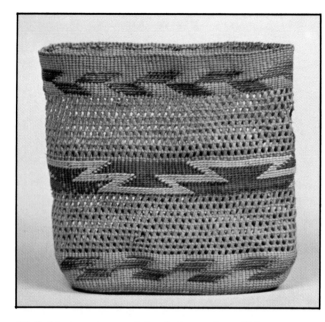

Wallet-type openwork baskets such as this were used for storing goat-horn spoons. A spoon bag was said to hang in every Tlingit household during the early part of this century. 6¼" high; 6¾" wide. (Sheldon Jackson Museum, an Alaska State Museum; photo by Ernest Manewal)

Tlingit legends and interpret the design as it tracks its way around the basket: "mouth-track of the woodworm," "the footprint of the brown bear," "the butterfly," "the hood of the raven" and "wild celery" are only a few of the patterns, according to an early publication (recently reprinted) on spruce-root basketry by Frances Paul.

Other Materials

Pipes, daggers and jewelry were made all or in part from various metals. Double-ended knives made of native copper existed before western contact; after the introduction of iron, the variety of such weapons increased. Dagger

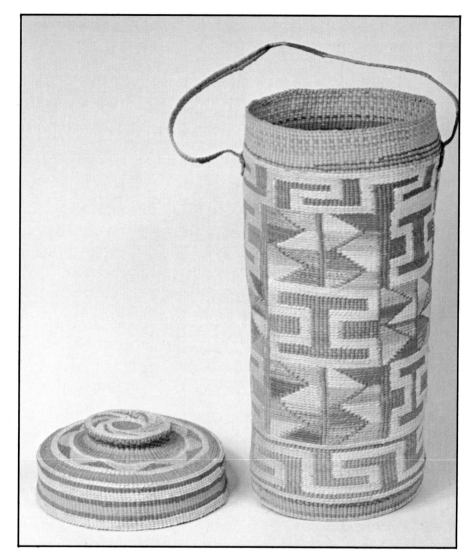

This unusual decorated spruce-root basket was made for use as a knitting basket, in a form generally used by a shaman for holding charms and ceremonial paraphernalia. It has alternating dice and tattoo patterns and was woven flat then sewn together to form a cylinder. 14¾" high; 7¼" diameter. (Sheldon Jackson Museum, an Alaska State Museum; photo by Ernest Manewal)

This covered spruce-root basket, shaped like a ginger jar, was collected in the late 19th century. The basket is decorated with the "half a head of a salmonberry" design. 7½" high; 5" diameter (mouth.) (Sheldon Jackson Museum, an Alaska State Museum; photo by Ernest Manewal)

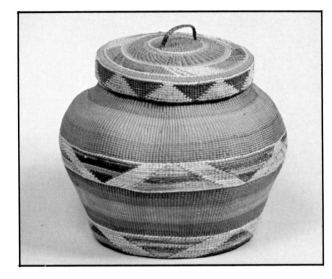

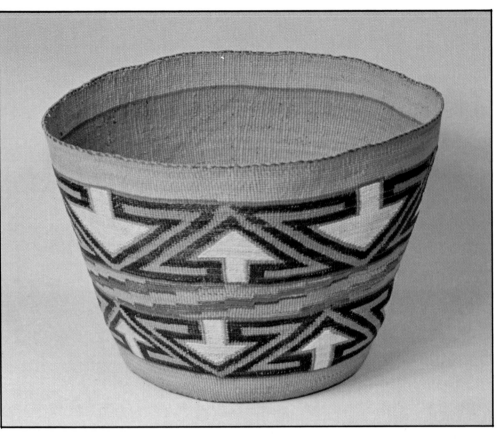

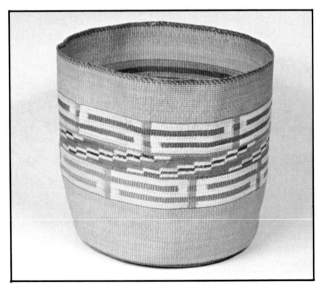

Above — *Bold designs cover the entire surface of this recent berry basket. The primary pattern is known as "half a head of a salmonberry." This is probably the smallest of three sizes of berry baskets — the largest could hold nearly two bushels and was used communally by all pickers in a certain area. 9" high; 12" diameter. (Sheldon Jackson Museum, an Alaska State Museum; photo by Ernest Manewal)*

Left — *Two wide rows of "blanket pattern" design decorate this Chilkat berry basket. Three sizes of open cylindrical baskets were used by Tlingit women when picking berries. 10" high; 11½" diameter. (Sheldon Jackson Museum, an Alaska State Museum; photo by Ernest Manewal)*

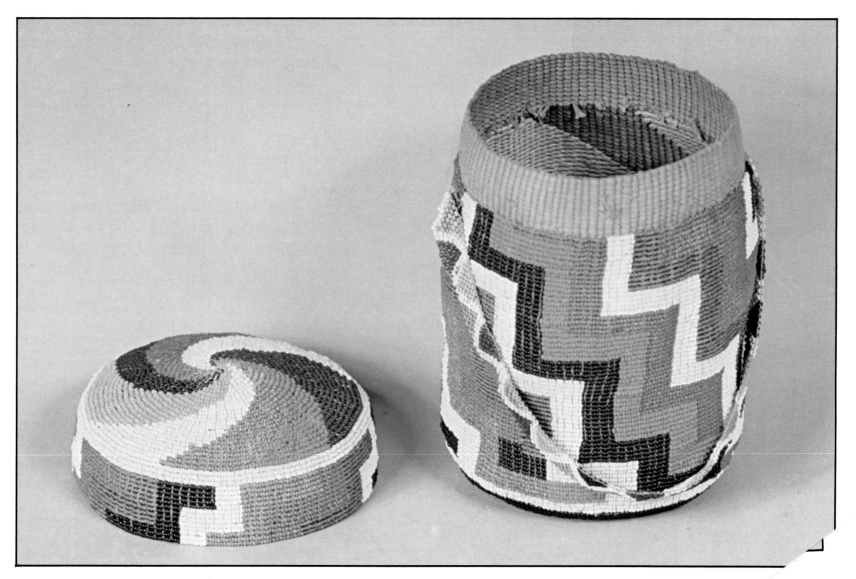

This unusual basket from the Chilkat Tlingits is twined of finely split spruce root and covered with beadwork. The ornamental basket was collected by Sheldon Jackson in the late 1880s. 5" high; 3½" diameter. (Sheldon Jackson Museum, an Alaska State Museum; photo by Ernest Manewal)

Preserving Your Baskets

By Alice R. Hoveman

Finely made baskets, if properly cared for, can provide many years of enjoyment. Keys to preservation are proper temperature and humidity and careful handling. These three twined spruce-root baskets from the Alaska State Museum are embroidered with dyed grass. Fannie James of Angoon made the basket on the left; the makers of the other two are unknown.
(Alaska State Museum; photo by Alice Hoveman)

Editor's note: *Alice Hoveman is the conservator at the Alaska State Museum. For more information about caring for your baskets, contact her at the Conservation Department, Alaska State Museum, Pouch FM, Juneau, AK 99811.*

Baskets come in many shapes, sizes and styles of weave. The materials from which a basket can be made vary widely, though traditional Alaskan baskets are woven from split beach grass, spruce or willow root, cedar or birch-bark fibers, or combinations of these materials. Sometimes basketmakers add other materials as decorations, such as dyed wool, glass or plastic beads, dyed grass or dyed animal skin. Understanding how these materials act or react under varying conditions is the first step in knowing how best to preserve your baskets.

Split grass, root and bark fibers are composed of a woody substance, the constituents of which vary in the way they react or deteriorate. Although the deterioration process is complex, heat, light and oxygen, acids, biological organisms and physical stress are the chief causes of injury.

The most obvious damage to baskets results from rough handling. If a basket is used regularly, the surface will soon show signs of wear. Think of a single blade of grass. How much tension does it take to tear it? Though it is true that many blades of grass woven into a basket are much stronger, baskets are still relatively fragile objects and areas like knobs or rims are especially vulnerable to damage from constant use. Even brushing the surface of a basket can abrade it, so cleaning with a soft-haired brush is the most one should attempt, and even this should be kept to a minimum.

As baskets age and inevitably weaken, they become even more fragile and susceptible to physical damage. Light and heat accelerate this problem by causing the fibers to dry and weaken, resulting in irreversible damage.

Too much humidity, above the 60 percent range, can also result in damage by causing the fibers to swell. Humidity also encourages the growth of mold, which can stain baskets. If caught in time, simply place the basket in a place which will allow it to dry out, then gently brush or blow the mold away. Some insects, especially wood-boring beetles, can be very

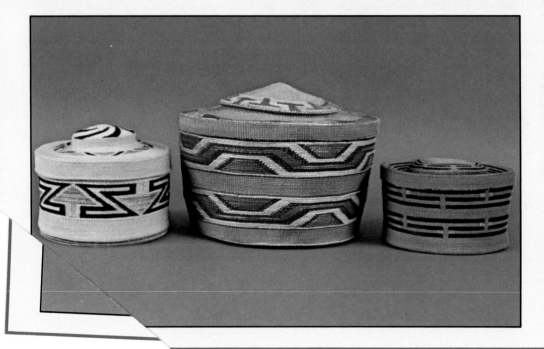

damaging to baskets. Watch for signs of insects such as tiny holes in the basket and fine sawdust, or "frass," that appears to have fallen from the holes. If possible, catch a live culprit and have it positively identified before attempting any remedy, then seek recommendations for treatment from a conservator.

To keep your baskets in a well-preserved state, always avoid excessive heat from stoves, fireplaces or radiators, avoid excessive humidity from exposure to water or steam (a relative humidity around 50 to 55 percent is best), avoid excessive light from direct exposure to sunlight or hot lamps, and most of all, handle with care. In this way, your baskets will provide many years of beauty and enjoyment.

Dirt, not always as visible as on this large, open-twined Aleut basket, can lead to the eventual deterioration of basketry fibers. (Alaska State Museum, photo by R.S. Lee; reprinted from The ALASKA JOURNAL®)

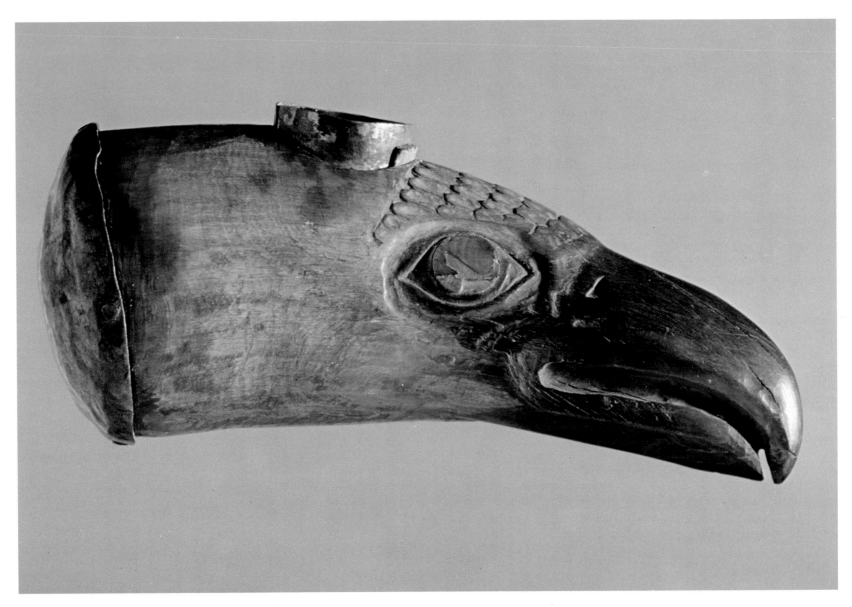

This pipe bowl, carved in the form of an eagle, was made around 1890 from domestic cow horn accented with abalone shell and copper. 5" long. (University of Alaska Museum; photo by Barry McWayne)

hilts were generally carved of ivory, bone or wood and inlaid with shell or covered with totemic crest designs.

After tobacco was introduced, pipes of carved stone and exotic hardwoods acquired in trade were used by Northwest Coast men. The hardwood pipes were often lined with copper or brass, their exteriors covered with crest designs.

Engraving on metal was not an aboriginal technique in this region, although working with metal occurred in a few forms before western contact. Silver and gold, and techniques of metal engraving, were probably introduced by fur traders and explorers in the late 18th century, and metalsmithing began truly to flower after the introduction of gold and silver coins.

Many talented Russian craftsmen, including silversmiths and goldsmiths, were among those who settled at Sitka in 1793. Because of the constant interaction between Russian settlers and the Tlingits, it is likely that metalsmithing by native artists began in Sitka about this time.

An examination of how a new art form becomes popular within a group sometimes shows that a single innovator is responsible. It is possible that a particularly talented, creative Tlingit artist, perhaps already skilled at the manufacture of coppers or other metal objects, learned the art by watching or apprenticing with a Russian metalsmith. The tradition of Northwest Coast silversmithing which exists today could have become firmly established when this artist began to apply traditional design motifs from his own culture to the pieces he made, and when he taught other local artists the techniques he had learned.

Metalsmithing is thought to have spread southward during the next 50 years, although it is not known precisely how information about

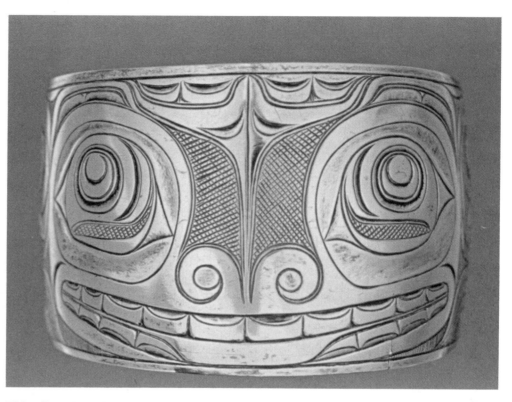

This silver bracelet was made by Haida carver Charles Edenshaw in the late 19th or early 20th century. Metalsmithing flourished among Northwest Coast artists following the introduction of silver and gold coins by traders. 2½" x 2". (Museum of Anthropology, University of British Columbia; A8094)

the technique reached some Northwest Coast tribes.

At least one scholar asserts that members of the Eagle moiety once owned exclusive rights to practice the art of metalsmithing, and that this inherited privilege may have been transmitted in the mid-19th century to Eagles of the Haida tribe and eventually became known to Ravens of both tribes.

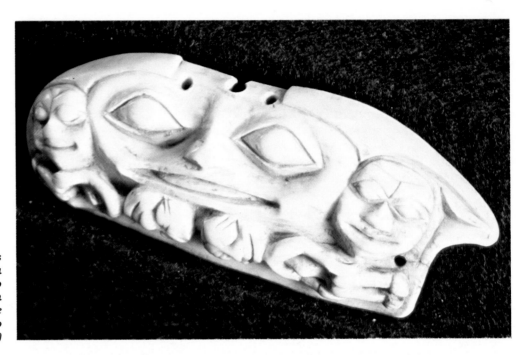

Shamans wore carved ivory charms such as this one, collected on Chichagof Island, attached to a necklace or dance cape. The charms are said to have represented spirits which aided the shaman and were used in healing. 4½" long. (Museum of the American Indian, Heye Foundation, 9/7953; photo courtesy of Anchorage Museum)

This Chilkat shaman's ivory charm represents a sea monster or sea wolf; the tentacles and peering face of an octopus are carved on one end. Such a charm might be touched to a specific part of an ailing patient's body, to bring about a cure. 5" x 2¼". (Sheldon Jackson Museum, an Alaska State Museum; photo by Ernest Manewal)

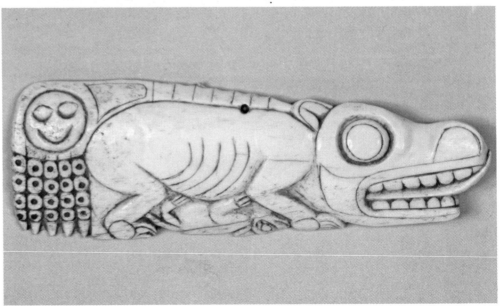

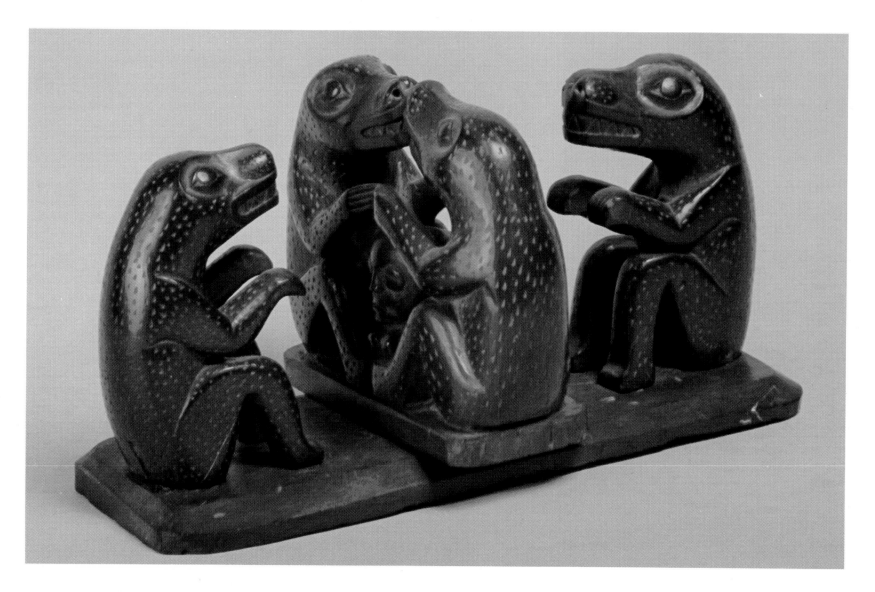

Four mythical bear figures are the subject of this Haida argillite carving. In the center, beneath two bears whose mouths are touching, is the small figure of a crouching woman. 8½" x 3½"; 4½" high. (Sheldon Jackson Museum, an Alaska State Museum; photo by Ernest Manewal)

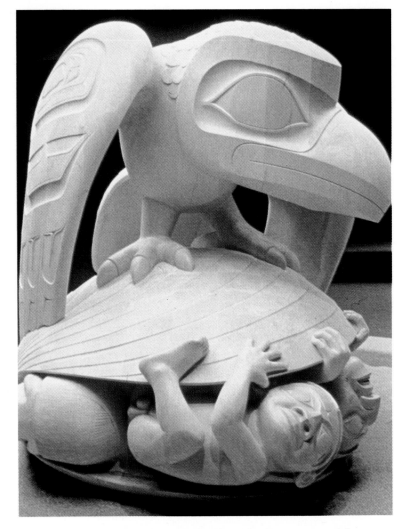

"The Raven and the First Men" was carved from yellow cedar by Haida artist Bill Reid, with the assistance of four other carvers — George Norris, George Rammell, Gary Edenshaw and Jim Hart. The piece illustrates an incident from Haida mythology when Raven, the culture hero, discovers the first Haida men in a clamshell. The impressive carving was commissioned in 1970 for the rotunda at the University of British Columbia's Museum of Anthropology. 126" x 126". (Museum of Anthropology, University of British Columbia; Nb1.481)

Jewelry and cutlery were the items most commonly produced by metalsmiths during the 19th century. Cutlery was designed for and sold almost exclusively to the European curio trade; but jewelry, particularly bracelets of various widths decorated with incised crest designs, were made for local markets. Some jewelry was, and still is, made for sale or trade, but bracelets engraved with the totemic crests of their owners are the pride of Northwest Coast women.

Gold and silver jewelry functioned somewhat like collateral does in our culture; perhaps even more like a savings account. Coins were transformed into jewelry for safekeeping — a wearable investment which also spoke publicly of the owner's status. Jewelry was also a popular potlatch good. Some accounts tell of the distribution of hundreds, even thousands, of bracelets during some Kwakiutl potlatches.

Carved spoons were the only serving and eating utensils used on the Northwest Coast. Larger spoons were often used as small bowls. The spoons used for feasting and ceremony were highly decorated with crest designs, cherished by families as a symbol of the size and quality of a feast they might give in the future. Spoons and ladles were carved from wood, mountain goat horn or sheep horn, and were painted or decorated with metal, shell or ivory inlay.

Ceremonial clothing made of animal hide was used in addition to woven garments such as Chilkat blankets. Deer or caribou skins were most common. Most pieces were heavily fringed and ornamented with puffin beaks, porcupine quills, strips of trade cloth, fur and other materials. Painted totemic crests usually covered their outer surfaces. Some skin garments are thought to have been part of a shaman's gear.

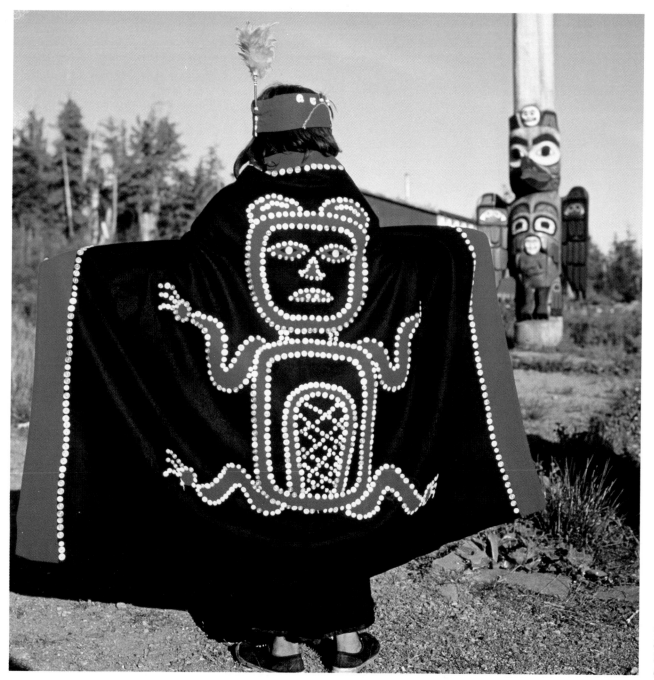

This Tlingit dancer at Saxman wears a button blanket with a bear motif.
(Steve McCutcheon)

Bibliography

ARCHAEOLOGY:

Dumond, Don E. *The Eskimos and Aleuts.* Thames and Hudson, London, 1977.

Giddings, J. Louis. *Ancient Men of the Arctic.* Secker & Waterburg, London, 1967.

Oswalt, Wendell H. *Eskimos and Explorers.* Chandler & Sharp, Novato, CA, 1979.

Powers, W. Roger, R. Dale Guthrie, and John F. Hoffecker. *Dry Creek: Archaeology and Paleoecology of a Late Pleistocene Alaska Hunting Camp.* Report submitted to the National Park Service Contract CX-9000-7-0047, 1983.

Wenner-Gren Foundation for Anthropological Research (81st: Burg Wartenstein, Austria). *Paleoecology of Beringia.* Academic Press, New York, 1982.

West, Frederick Hadleigh. *The Archaeology of Beringia.* Columbia University Press, New York, 1981.

Willey, Gordon R. and Philip Phillips. *Method and Theory in American Archaeology.* University of Chicago Press, Chicago, 1958.

ALEUT:

Black, Lydia T. *Aleut Art.* Aleutian/Pribilof Islands Association, Inc., Anchorage, 1982. *Atka: An Ethnohistory of the Western Aleutians.* The Limestone Press, Kingston, Ontario, 1984.

Jochelson, Waldemar. *History, Ethnology, and Anthropology of The Aleut.* Carnegie Institution, Washington, D.C., 1933.

Lantis, Margaret. "The Aleut Social System, 1750 to 1810, From Early Historical Sources." *Ethnohistory in Southwestern Alaska and the Southern Yukon.* University Press of Kentucky, Lexington, 1970.

Lynch, Kathy. *Aleut Basket Weaving.* Adult Literacy Laboratory, Anchorage Community College, 1974.

Morgan, Lael. *The Aleutians.* Volume 7, No. 3, The Alaska Geographic Society, Anchorage, 1980.

Ray, Dorothy Jean. *Aleut and Eskimo Art.* University of Washington Press, Seattle, 1981.

Shapsnikoff, Anfesia T. and Raymond L. Hudson. "Aleut Basketry," *Anthropological Papers of the University of Alaska 16,* (No. 2), Fairbanks, 1974.

ATHABASCAN:

Bifelt, Selina M. "Athabaskan Clothing Before European Contact," Unpublished manuscript, Fairbanks, 1983.

Clark, Annette M. *The Athabaskans: Strangers of the North.* Ottawa: National Museum of Canada, 1974.

Herbert, Belle and Bill Pfisterer. *Shandaa: In My Lifetime.* Alaska Native Language Center, Fairbanks, 1982.

Nelson, Richard K. *The Athabaskans: People of the Boreal Forest.* Alaska Historical Commission Studies in History No. 27, University of Alaska Museum, Fairbanks, 1983.

Osgood, Cornelius. *Contributions to the Ethnography of the Kutchin.* Yale University Publications in Anthropology No. 14, 1936. *Ingalik Material Culture.* Yale University Publications in Anthropology No. 22, 1940.

Simeone, William E. *A History of Alaskan Athabaskans.* Alaska Historical Commission, Anchorage, 1982.

Steinbright, Jan. "Athabaskan Art of Alaska," Institute of Alaska Native Arts, Fairbanks, 1983.

Titus, Dorothy & Matthew. *Dats'en Lo K'eytth'ok Tr'eghonh: This Is the Way We Make Our Baskets.* Alaska Native Language Center, Fairbanks, 1979.

Van Stone, James W. *Athabaskan Adaptations.* Aldine Publishing Co., Chicago, 1974.

ESKIMO:

Carpenter, Edmund. *Eskimo Realities.* Holt, Rinehart, and Winston, New York, 1973.

Fair, Susan W. "Eskimo Dolls" in *Eskimo Dolls.* Alaska State Council on the Arts, Anchorage, 1982.

Fienup-Riordan, Ann. *Nick Charles: Worker in Wood. The Artist Behind The Work.* Oral History Project, University of Alaska, Fairbanks, 1983.

Fitzhugh, William W. and Susan A. Kaplan. *Inua: Spirit World of the Bering Sea Eskimo.* Smithsonian Institution Press, Washington, D.C., 1982.

Kaliikaq Yugnek. Volume 2, Number 1. Fall-Winter 1975, Bethel, AK.

Larsen, Dinah & Terry Dickey. *Setting It Free.* University of Alaska Museum, Fairbanks, 1982.

Lee, Molly. *Baleen Basketry of the North Alaskan Eskimo.* North Slope Borough Planning Dept., Barrow, 1983.

Lipton, Barbara, ed. *Survival. Life & Art of the Alaskan Eskimo.* Newark Museum and American Federation of Arts, Morgan and Morgan, Inc., Dobbs Ferry, N.Y., 1977.

Nelson, Edward W. *The Eskimo About Bering Strait.* Annual report Bureau of American Ethnology, vol. 18, pt. 1, Washington, D.C., 1899.

Oswalt, Wendell H. *Alaskan Eskimos.* Chandler Publishing Co., New York, 1967.

Ray, Dorothy Jean. *Artists of the Tundra and the Sea.* University of Washington Press, Seattle, 1961. *Eskimo Art: Tradition and Innovation in North Alaska.* University of Washington Press, Seattle and London, 1977. "Happy Jack: King of the Eskimo Ivory Carvers" *American Indian Art.* Winter, 1984. Scottsdale, AZ.

Ray, Dorothy Jean and Alfred A. Blaker. *Eskimo Masks: Art and Ceremony.* University of Washington Press, Seattle and London, 1967.

NORTHWEST COAST:

Boas, Franz. *Kwakiutl Ethnography.* University of Chicago Press, Chicago, 1966.

Boxes and Bowls. Smithsonian Institution Press, Washington, D.C., 1974. Compiled by William C. Sturtevant.

Codere, Helen, *Fighting With Property.* University of Washington Press, Seattle, 1972.

Drucker, Philip. *Cultures of the North Pacific Coast.* Harper and Row, New York, 1965.

Duff, Wilson. "The Impact of the White Man." Volume 1, *The Indian History of British Columbia.* Provincial Museum of Natural History and Anthropology. Anthropology in British Columbia Memoir No. 5, Victoria, 1964.

Gunther, Erna. *Art in the Life of the Northwest Coast Indians.* The Portland Art Museum, Portland, OR, 1966.

Hall, Edwin S. Jr., Margaret B. Blackman and Vincent Rickard. *Northwest Coast Indian Graphics.* University of Washington Press, Seattle, 1981.

Halpin, Marjorie M. *Totem Poles: An Illustrated Guide.* Museum Note No. 3, University of British Columbia Press, Vancouver, 1981.

Hawthorn, H.B., C.S. Belshaw, and S.M. Jamieson. *The Indians of British Columbia: A Study of Contemporary Social Adjustment.* University of California Press and the University of British Columbia, Berkeley, 1960.

Holm, Bill. *Northwest Coast Indian Art.* University of Washington Press, Seattle, 1965.

Holm, Bill and Bill Reid. *Indian Art of the Northwest Coast.* University of Washington Press, Seattle, 1975.

Krause, Aurel. tr. by Erna Gunther. *The Tlingit Indians.* University of Washington Press, Seattle, 1956.

McFeat, Tom, ed. *Indians of the North Pacific Coast.* University of Washington Press, Seattle, 1966.

Malin, Edward. *A World of Faces.* Timber Press, Portland, OR, 1978.

Oberg, Kalervo. *The Social Economy of the Tlingit Indians.* University of Washington Press, Seattle, 1973.

Paul, Frances. *Spruce Root Basketry of the Alaska Tlingit.* Education Division, United States Indian Service, Haskell Institute, Lawrence, Kansas, 1944.

Reid, William. *Out of the Silence.* Harper and Row, New York, 1971.

Samuel, Cheryl. *The Chilkat Dancing Blanket.* Pacific Search Press, Seattle, 1982.

Van Dyke, Beth. "The Development of Gold and Silversmithing on the Northwest Coast: AD 1700-1900." In *Primitive Art and Technology,* University of Calgary Archaeological Association, Calgary, 1975.

Wardwell, Allen. *Objects of Bright Pride.* Center for Inter-American Relations and The American Federation of Arts, New York, 1978.

GENERAL:

Alaska State Council on the Arts *Annual Report,* Bulletin No. 31, October 1983. Alaska State Council on the Arts, Anchorage.

Attenborough, David. *The Tribal Eye.* W.W. Norton & Co. Inc., New York, 1976.

Collins, Henry B. "Eskimo Art." *The Far North: 2000 Years of American Eskimo and Indian Art.* Indiana University Press, Bloomington, 1977.

Feder, Norman. *American Indian Art.* Harry N. Abrams, Inc., New York, 1969.

Frost, Orcutt William, ed. *Cross-Cultural Arts in Alaska.* Alaska Methodist University Press, Anchorage, 1970.

Graburn, Nelson H.H., ed. *Ethnic and Tourist Arts: Cultural Expressions from the Fourth World.* University of California Press, Berkeley and Los Angeles, 1976.

Jones, Suzi, ed. *Native Arts Issues 81/82.* Alaska State Council on the Arts, Anchorage, 1982.

Morgan, Lael. *Alaska's Native People.* Alaska Geographic, Volume 6, No. 3, The Alaska Geographic Society, Anchorage, 1979.

Otten, Charlotte M., ed. *Anthropology and Art.* The Natural History Press, Garden City, New York, 1971.

Smoke Signals. No. 50-51/fall-winter 1966. Indian Arts and Crafts Board of the U.S. Department of the Interior, Washington, D.C.

Theata Magazine. *Native Alaskan Art.* Volume Eight, 1980. Cross-Cultural Communications and the College of Arts and Science, University of Alaska, Fairbanks.

Alaska Geographic® Back Issues

The North Slope, Vol. 1, No. 1. The charter issue of *ALASKA GEOGRAPHIC®* took a long, hard look at the North Slope and the then-new petroleum development at "the top of the world." *Out of print.*

One Man's Wilderness, Vol. 1, No. 2. The story of a dream shared by many, fulfilled by a few; a man goes into the Bush, builds a cabin and shares his incredible wilderness experience. Color photos. 116 pages, $9.95.

Admiralty . . . Island in Contention, Vol. 1, No. 3. An intimate and multifaceted view of Admiralty: its geological and historical past, its present-day geography, wildlife and sparse human population. Color photos. 78 pages, $5.00

Fisheries of the North Pacific: History, Species, Gear & Processes, Vol. 1, No. 4. The title says it all. This volume is out of print, but the book, from which it was excerpted, is available in a revised, expanded large-format volume. 424 pages. $24.95.

The Alaska-Yukon Wild Flowers Guide, Vol. 2, No. 1. First Northland flower book with both large, color photos and detailed drawings of every species described. Features 160 species, common and scientific names and growing height. Vertical-format book edition now available. 218 pages, $12.95.

Richard Harrington's Yukon, Vol. 2, No. 2. The Canadian province with the colorful past *and* present. *Out of print.*

Prince William Sound, Vol. 2, No. 3. This volume explores the people and resources of the Sound. *Out of print.*

Yakutat: The Turbulent Crescent, Vol. 2, No. 4. History, geography, people — and the impact of the coming of the oil industry. *Out of print.*

Glacier Bay: Old Ice, New Land, Vol. 3, No. 1. The expansive wilderness of southeastern Alaska's Glacier Bay National Monument (recently proclaimed a national park and preserve) unfolds in crisp text and color photographs. Records the flora and fauna of the area, its natural history, with hike and cruise information, plus a large-scale color map. 132 pages, $11.95.

The Land: Eye of the Storm, Vol. 3, No. 2. The future of one of the earth's biggest pieces of real estate! *This volume is out of print,* but the latest on the Alaska lands controversy is detailed completely in Volume 8, Number 4.

Richard Harrington's Antarctic, Vol. 3, No. 3. The Canadian photojournalist guides readers through remote and little understood regions of the Antarctic and Subantarctic. More than 200 color photos and a large fold-out map. 104 pages, $8.95

The Silver Years of the Alaska Canned Salmon Industry: An Album of Historical Photos, Vol. 3, No. 4. The grand and glorious past of the Alaska canned salmon industry. *Out of print.*

Alaska's Volcanoes: Northern Link in the Ring of Fire, Vol. 4, No. 1. Scientific overview supplemented with eyewitness accounts of Alaska's historic volcano eruptions. Includes color and black-and-white photos and a schematic description of the effects of plate movement upon volcanic activity. 88 pages. *Temporarily out of print.*

The Brooks Range: Environmental Watershed, Vol. 4, No. 2. An impressive work on a truly impressive piece of Alaska — The Brooks Range. *Out of print.*

Kodiak: Island of Change, Vol. 4, No. 3. Russians, wildlife, logging and even petroleum . . . an island where change is one of the few constants. *Out of print.*

Wilderness Proposals: Which Way for Alaska's Lands? Vol. 4, No. 4. This volume gives yet another detailed analysis of the many Alaska lands questions. *Out of print.*

Cook Inlet Country, Vol. 5, No. 1. Our first comprehensive look at the area. A visual tour of the region — its communities, big and small, and its countryside. Begins at the southern tip of the Kenai Peninsula, circles Turnagain Arm and Knik Arm for a close-up view of Anchorage, and visits the Matanuska and Susitna valleys and the wild, west side of the inlet. *Out of print.*

Southeast: Alaska's Panhandle, Vol. 5, No. 2. Explores southeastern Alaska's maze of fjords and islands, mossy forests and glacier-draped mountains — from Dixon Entrance to Icy Bay, including all of the state's fabled Inside Passage. Along the way are profiles of every town, together with a look at the region's history, economy, people, attractions and future. Includes large fold-out map and seven area maps. 192 pages, $12.95.

Bristol Bay Basin, Vol. 5, No. 3. Explores the land and the people of the region known to many as the commercial salmon-fishing capital of Alaska. Illustrated with contemporary color and historic black-and-white photos. Includes a large fold-out map of the region. *Out of print.*

The Aurora Borealis, Vol. 6, No. 2. Here one of the world's leading experts — Dr. S.-I. Akasofu of the University of Alaska — explains in an easily understood manner, aided by many diagrams and spectacular color and black-and-white photos, what causes the aurora, how it works, how and why scientists are studying it today and its implications for our future. 96 pages, $7.95.

Alaska's Great Interior, Vol. 7, No. 1. Alaska's rich Interior country, west from the Alaska-Yukon Territory border and including the huge drainage between the Alaska Range and the Brooks Range, is covered thoroughly. Included are the region's people, communities, history, economy, wilderness areas and wildlife. Illustrated with contemporary color and black-and-white photos. Includes a large fold-out map. 128 pages, $9.95.

Alaska Whales and Whaling, Vol. 5, No. 4. The wonders of whales in Alaska — their life cycles, travels and travails — are examined, with an authoritative history of commercial and subsistence whaling in the North. Includes a fold-out poster of 14 major whale species in Alaska in perspective, color photos and illustrations, with historical photos and line drawings. 144 pages, $12.95.

Alaska's Native People, Vol. 6, No. 3. In this edition the editors examine the varied worlds of the Inupiat Eskimo, Yup'ik Eskimo, Athabascan, Aleut, Tlingit, Haida and Tsimshian. Included are sensitive, informative articles by Native writers, plus a large, four-color map detailing the Native villages and defining the language areas. 304 pages, $24.95.

A Photographic Geography of Alaska, Vol. 7, No. 2. An overview of the entire state — a visual tour through the six regions of Alaska: Southeast, Southcentral/Gulf Coast, Alaska Peninsula and Aleutians, Bering Sea Coast, Arctic and Interior. Plus a handy appendix of valuable information — "Facts About Alaska." Approximately 160 color and black-and-white photos and 35 maps. 192 pages. Revised in 1983. $15.95.

Yukon-Kuskokwim Delta, Vol. 6, No. 1. This volume explores the people and life-styles of one of the most remote areas of the 49th state. *Out of print.*

The Stikine, Vol. 6, No. 4. River route to three Canadian gold strikes in the 1800s. This edition explores 400 miles of Stikine wilderness, recounts the river's paddle-wheel past and looks into the future. Illustrated with contemporary color photos and historic black-and-white; includes a large fold-out map. 96 pages, $9.95.

The Aleutians, Vol. 7, No. 3. Home of the Aleut, a tremendous wildlife spectacle, a major World War II battleground and now the heart of a thriving new commercial fishing industry. Contemporary color and black-and-white photographs, and a large fold-out map. 224 pages, $14.95.

Alaska Mammals, Vol. 8, No. 2. From tiny ground squirrels to the powerful polar bear, and from the tundra hare to the magnificent whales inhabiting Alaska's waters, this volume includes 80 species of mammals found in Alaska. Included are beautiful color photographs and personal accounts of wildlife encounters. 184 pages, $12.95.

Alaska's Glaciers, Vol. 9, No. 1. Examines in-depth the massive rivers of ice, their composition, exploration, present-day distribution and scientific significance. Illustrated with many contemporary color and historical black-and-white photos, the text includes separate discussions of more than a dozen glacial regions. 144 pages, $10.95.

Klondike Lost: A Decade of Photographs by Kinsey & Kinsey, Vol. 7, No. 4. An album of rare photographs and all-new text about the lost Klondike boomtown of Grand Forks, second in size only to Dawson during the gold rush. Introduction by noted historian Pierre Berton: 138 pages, area maps and more than 100 historical photos, most never before published. $12.95.

The Kotzebue Basin, Vol. 8, No. 3. Examines northwestern Alaska's thriving trading area of Kotzebue Sound and the Kobuk and Noatak river basins. Contemporary color and historical black-and-white photographs. 184 pages, $12.95.

Sitka and Its Ocean/Island World, Vol. 9, No. 2. From the elegant capital of Russian America to a beautiful but modern port, Sitka, on Baranof Island, has become a commercial and cultural center for southeastern Alaska. Pat Roppel, longtime Southeast resident and expert on the region's history, examines in detail the past and present of Sitka, Baranof Island, and neighboring Chichagof Island. Illustrated with contemporary color and historical black-and-white photographs. 128 pages, $9.95.

Wrangell-Saint Elias, Vol. 8, No. 1. Mountains, including the continent's second- and fourth-highest peaks, dominate this international wilderness that sweeps from the Wrangell Mountains in Alaska to the southern Saint Elias range in Canada. Illustrated with contemporary color and historical black-and-white photographs. Includes a large fold-out map. 144 pages, $9.95.

Alaska National Interest Lands, Vol. 8, No. 4. Following passage of the bill formalizing Alaska's national interest land selections (d-2 lands), longtime Alaskans Celia Hunter and Ginny Wood review each selection, outlining location, size, access, and briefly describing the region's special attractions. Illustrated with contemporary color photographs. 242 pages, $14.95.

Islands of the Seals: The Pribilofs, Vol. 9, No. 3. Great herds of northern fur seals drew Russians and Aleuts to these remote Bering Sea islands where they founded permanent communities and established a unique international commerce. Illustrated with contemporary color and historical black-and-white photographs. 128 pages, $9.95.

Alaska's Oil/Gas & Minerals Industry, Vol. 9, No. 4. Experts detail the geological processes and resulting mineral and fossil fuel resources that are now in the forefront of Alaska's economy. Illustrated with historical black-and-white and contemporary color photographs. 216 pages, $12.95.

Adventure Roads North: The Story of the Alaska Highway and Other Roads in *The MILEPOST* ®, Vol. 10, No. 1. From Alaska's first highway — the Richardson — to the famous Alaska Highway, first overland route to the 49th state, text and photos provide a history of Alaska's roads and take a mile-by-mile look at the country they cross. 224 pages, $14.95.

ANCHORAGE and the Cook Inlet Basin . . . Alaska's Commercial Heartland, Vol. 10, No. 2. An update of what's going on in "Anchorage country" . . . the Kenai, the Susitna Valley, and Matanuska. Heavily illustrated in color and including three illustrated maps . . . one an uproarious artist's forecast of "Anchorage 2035." 168 pages, $14.95.

Alaska's Salmon Fisheries, Vol. 10, No. 3. The work of *ALASKA*® magazine outdoors editor Jim Rearden, this issue takes a comprehensive look at Alaska's most valuable commercial fishery. Through text and photos, readers will learn about the five species of salmon caught in Alaska, different types of fishing gear and how each works, and will take a district-by-district tour of salmon fisheries throughout the state. 128 pages, $12.95.

Koyukuk Country, Vol. 10, No. 4. This issue explores the vast drainage of the Koyukuk River, third largest in Alaska. Text and photos provide information on the land and offer insights into the life-style of the people who live and have lived along the Koyukuk. 152 pages, $14.95.

Nome: City of the Golden Beaches, Vol. 11, No. 1. The colorful history of Alaska's most famous gold rush town has never been told like this before. With a text written by Terrence Cole, and illustrated with hundreds of rare black-and-white photos, the book traces the story of Nome from the crazy days of the 1900 gold rush. 184 pages, $14.95.

Alaska's Farms and Gardens, Vol. 11, No. 2. An overview of the past, present, and future of agriculture in Alaska, and a wealth of information on how to grow your own fruit and vegetables in the north. 144 pages, $12.95.

Chilkat River Valley, Vol. 11, No. 3. Its strategic location at the head of the Inside Passage has long made the Chilkat Valley a corridor between the coast and Interior. This issue explores the mountain-rimmed valley, its natural resources, and those hardy residents who make their home along the Chilkat. 112 pages, $12.95.

The Alaska Geographic Society

Box 4-EEE, Anchorage, AK 99509

ALASKA STEAM, A Pictorial History of the Alaska Steamship Company, Vol. 11, No. 4. An inspiring story by Northwest history writer, Lucile McDonald, of men and ships who pioneered the hazardous waters of the northern travel lanes to serve the people of Alaska. Over 100 black-and-white historical photographs. 160 pages, $12.95.

Alaska's Forest Resources, Vol. 12, No. 2. This issue examines Alaska's majestic and valuable forests, which cover about one-third of the state's land area. Contributing editor Walt Matell presents an in-depth look at the subject, with informative, easy-to-read text and nearly 200 historical black-and-white and contemporary color photos. Topics include silviculture, the science of growing trees; a history of the timber industry in Alaska; how to identify the state's 33 native tree species; forest fires; traditional uses of Alaska's forests; and modern timber-harvesting techniques. 200 pages, $14.95.

Membership in The Alaska Geographic Society is $30 (U.S. funds), and includes the following year's four quarterlies which explore a wide variety of subjects in the Northland, each issue an adventure in great photos, maps, and excellent research. Members receive their quarterlies as part of the membership fee at considerable savings over the prices which nonmembers must pay for individual book editions.

NEXT ISSUE:
Our Arctic Year, Vol. 12, No. 4. Vivian and Gil Staender's simple, compelling story of a year in the wilds of the Brooks Range of Alaska, with only birds, nature and an unspoiled land. They share their discoveries, and their reactions to a year of isolation with time to sense their surroundings. Over 100 color photos. $12.95.

The Northwest Territories, Vol. 12, No. 1. This issue takes an in-depth look at Canada's immense Northwest Territories, which comprise some of the most beautiful and isolated land in North America. Supervising editor Richard Harrington has brought together informative text and color photos covering such topics as geology and mineral resources, prehistoric people, native art, and the search for the Northwest Passage. Also included is a look under the ice of the Canadian Arctic. 136 pages. $12.95.

All prices U.S. funds.